DOWN SOUTH TWO

More Homes and Interiors in South Africa

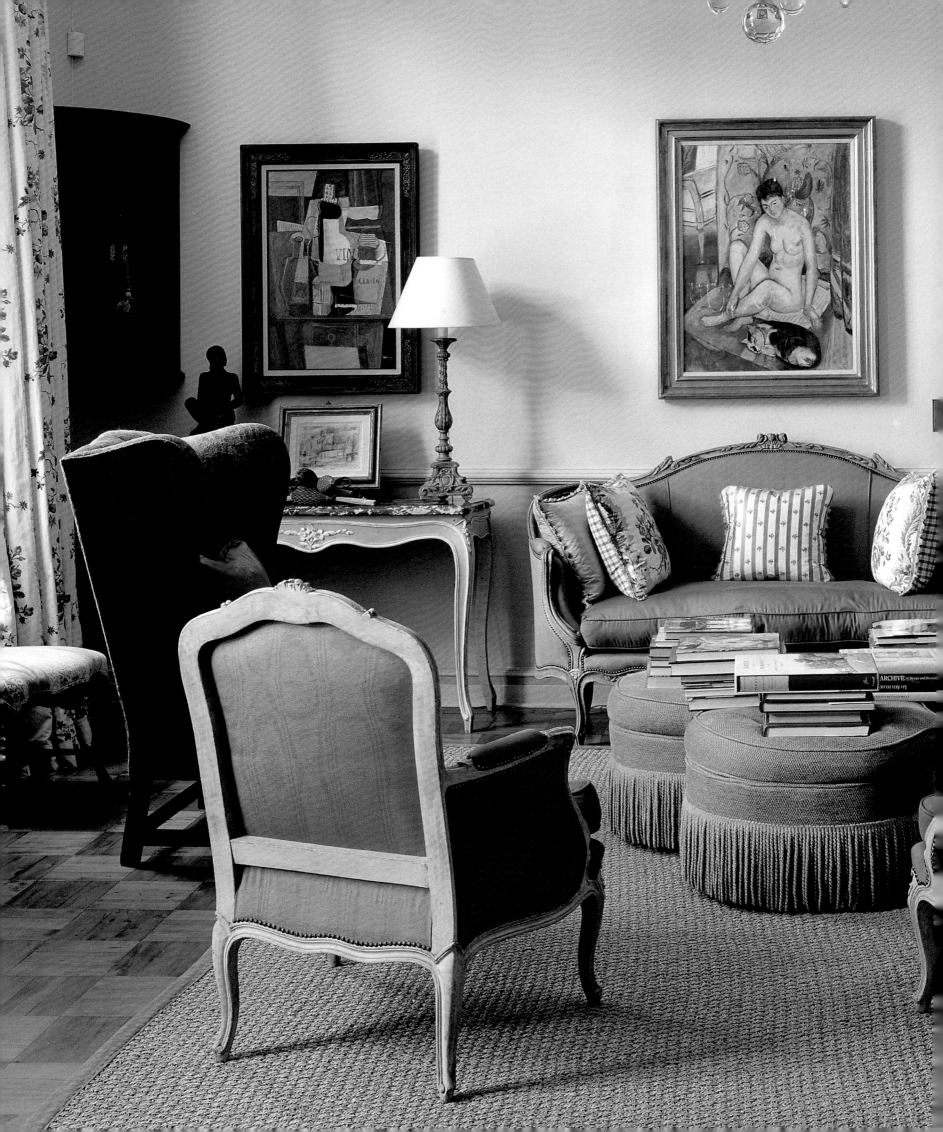

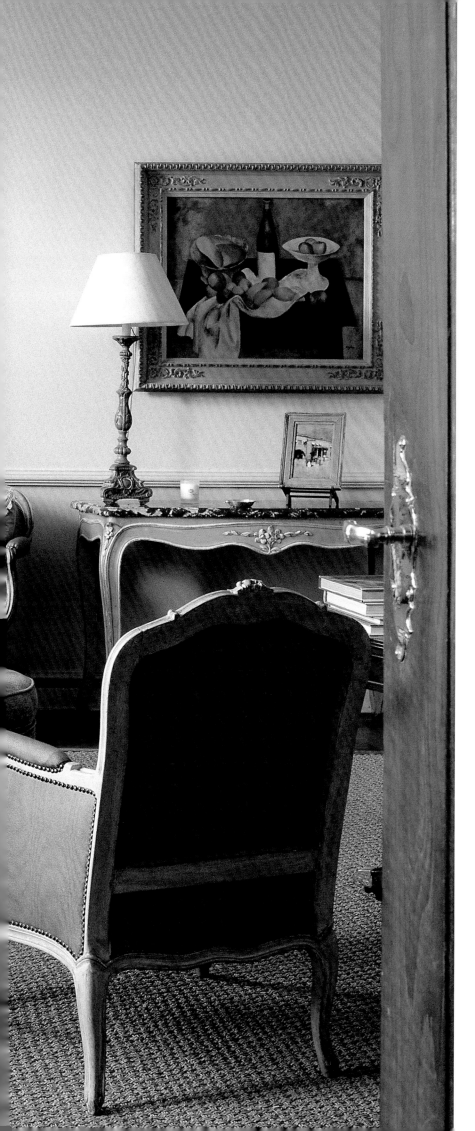

DOWN SOUTH TWO

More Homes and Interiors in South Africa

Paul Duncan

PHOTOGRAPHED BY
Fritz von der Schulenburg

JONATHAN BALL PUBLISHERS

JOHANNESBURG & CAPE TOWN

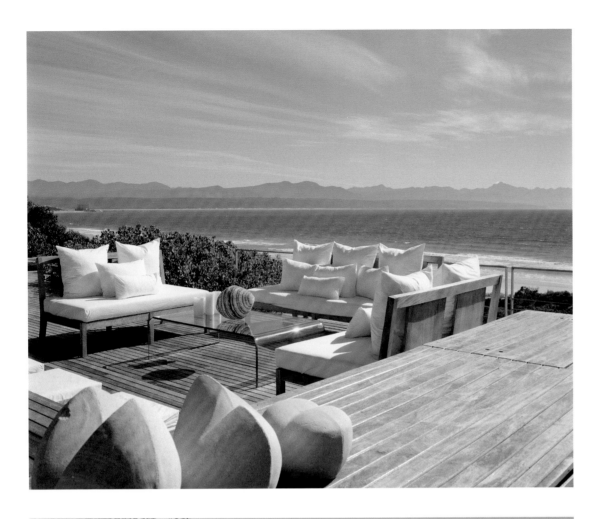

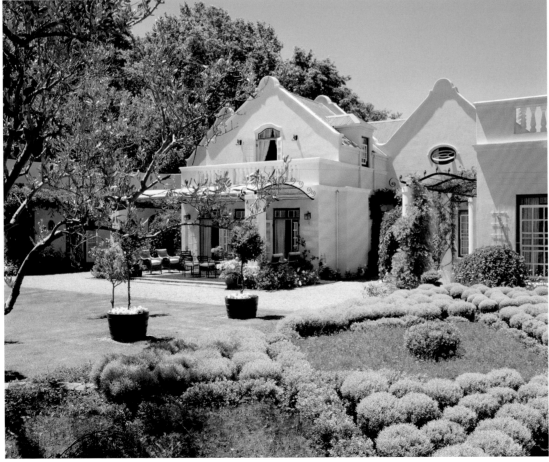

Text and photographs © Paul Duncan and
Fritz von der Schulenburg 2007

Published in 2007 by
Jonathan Ball Publishers (Pty) Limited
PO Box 33977
Jeppestown 2043

ISBN 978-1-86842-254-8

Edited by Mary Armour
Designed by Triple M Design, Johannesburg
Set in 9/18pt Myriad Pro
Printed by CTP Book Printers, Cape

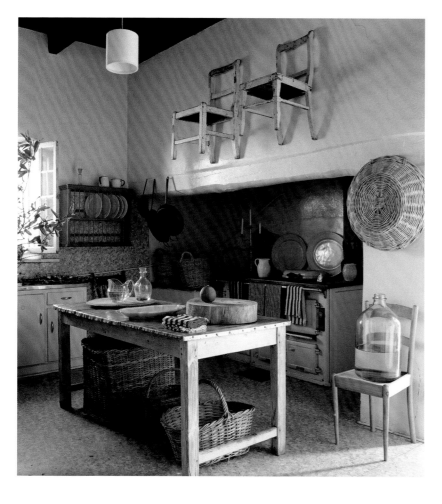

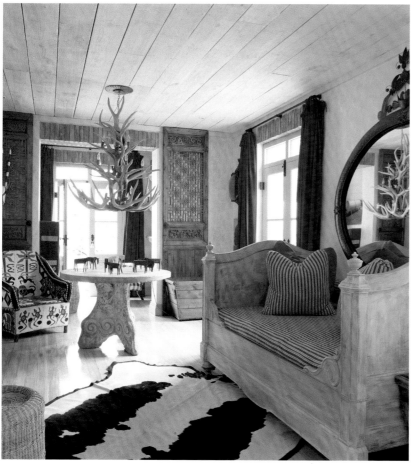

Contents

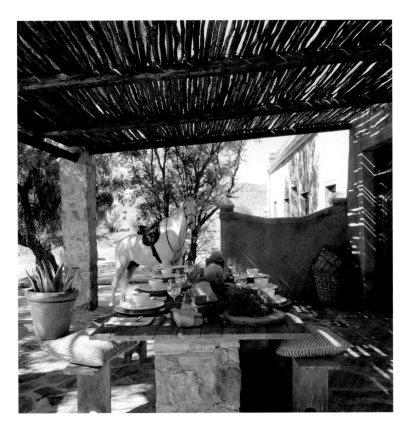

Introduction

When it first appeared in 2004, *Down South: Homes and Interiors in South Africa* was a huge success because at the time there wasn't another book on South African interiors available anywhere. We weren't reinventing the wheel when we brought that book out, but we did open the door to uncharted territory that, once explored, revealed a design world brimming with variety and style. Many of the homes were originally featured in the *Condé Nast House & Garden* magazine. The original *Down South* paved the way for this second collection, *Down South Two: More Homes and Interiors in South Africa* as what was not available to us then was opened up to us this time around. This new book reveals even more of the newfound confidence with which homemakers around the country have put – and in some cases have thrown – their looks together. Every single interior in this book is a gutsy evocation of the lifestyle of its inhabitants and the sheer individuality of each in response to locale, materials and a specific design ethos is what makes this collection so special. However varied, each of the homes is indubitably South African.

Photographer Fritz von der Schulenburg worked on both books. His pictures of South African interiors are the best that exist anywhere and here they leap exuberantly from the pages. We're lucky to have them. It helps that the extent of this book is bigger than the first. There are more houses than before and we've given each one more pages. It also helps that as Fritz worked, he always found the subject matter interesting and rewarding. We hardly ever moved the furniture about and we certainly never 'styled' the shoots. In our opinion there's little point in photographing someone's home if you have changed it all around to get the right picture. Rather shoot it as you find it, warts and all. And that's what we did. In any given week Fritz could find himself photographing places as varied as it was possible to get: magnificent Cape Dutch Stellenberg on the Monday, then Michael and Anthea Methven's tribal market-cum-homestead-cum-artist's-studio in the Boland on the Tuesday, followed by a flight to Royal Malewane and full-on bushveld by Wednesday night. In between we'd stop to admire and to photograph a view or vista. Landscape is an important contextual element for some of the houses included. From Johannesburg to Graaff-Reinet, Cape Town to Plettenberg Bay, back to Barrydale, Franschhoek and away to Timbavati: every trip we made was a whirlwind of all that matters (to us at any rate) in South African interiors. Fritz's visits here from his home in Austria, taking time out between

Above: The terrace at Steenhuis, Middelburg.

Opposite: The terraced veranda leading out from the living area of Beach House at Plettenberg Bay.

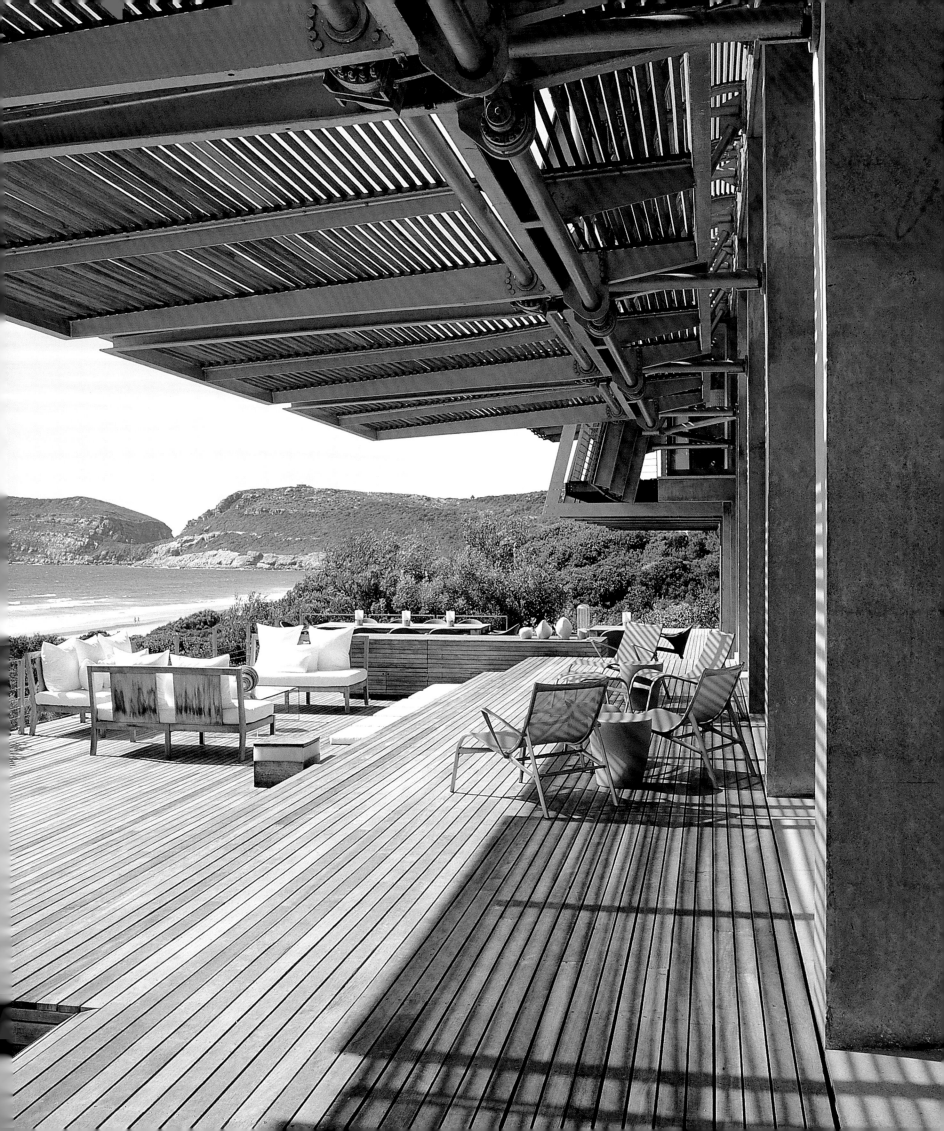

assignments for the *World of Interiors* or British *House & Garden*, never had a single dull moment.

As usual we've given South Africa's decorators a run for their money. We have some of the best interior designers in the world and most of them are creatively prolific both at home and in other countries. There's Stephen Falcke's House Brink; there's Graham Viney at Noordhoek Manor, Stellenberg and Petrava House; there's Boyd Ferguson and his sister Geordie at Beach House, Plettenberg Bay; and there's Head Interiors whose sleek, worldly projects at Illovo Penthouse were masterminded by the Fihrers, Sharon and Shereen. Newcomers are the impossibly stylish Charlotte Daneel (already well known for her Franschhoek store, La Grange) at Steenhuis in the Great Karoo, Tessa Proudfoot (who won the award at Rooms on View 2006 for the best decorated stand) with the lovely Montpellier Farm in Franschhoek and Geordie Ferguson who has two projects in *Down South Two* – her own place in Green Point and House Mostert in Cape Town. Suzy Lubner is here for the first time with her own luxuriously laid-back beach house in Plettenberg Bay and John Zwiegelaar makes a first appearance at Sarah Tompkins's Samara Private Game Reserve in the Great Karoo. Prolific for a newcomer, most of his projects are still under construction and thus did not make it into this book. His Cape Town-based company and shop on Bree Street, John Jacob Interiors, sets him apart as the designer to watch.

As a team, Fritz and I are enormously lucky to have been given access to all of the places we wanted to photograph, whether by the owner or the decorator. Even homeowners who've always carefully guarded their privacy welcomed us in, opened up their homes, organised flowers, gave us lunch and, in some cases, invited us to stay the night – or sometimes two, as was the case at Gail Behr's The Grand Café & Rooms, Steenhuis, Samara and Royal Malewane – so that we could be up at dawn to catch that fleeting light that really always makes a story, or to get a night shot, under the stars or with lanterns lit around the pool, as at Liz Biden's new spa at Royal Malewane. We've driven up vertical mountains in a hot open Land Rover under an umbrella held aloft, been frighteningly tossed about a thunderous sky in minuscule private aircraft and even fallen into a swimming pool backwards in the quest for the perfect picture. I won't forget the time when Fritz was chased by a man with a knife on a hot Karoo evening, the outraged rhino in KwaZulu-Natal that came between him and his camera, or the deafening crash from the next room when, one night in Plettenberg Bay, he fell out of a particularly high bed which earlier that afternoon he'd photographed to such good effect. We photographed our way around South Africa, driven by the knowledge that our project would be worth it in the end.

This book has been such a pleasure to produce. It marks the culmination of my time as editor of *Condé Nast House & Garden* in South Africa, where the sourcing of inspiring houses was what I enjoyed doing most. For me it was all about the thrill of the hunt, and each house that revealed itself was only of interest if it had a real South African context. That Fritz von der Schulenburg agreed to work for us at all was a stroke of good fortune. These books, I hope, mark a unique and creative moment in South African design and lifestyle.

In the first *Down South* the enormous range and diversity of contemporary South African interiors was there for all to see. Opulent or simple, decorated or unadorned, contemporary or old-fashioned, each of the places featured was a comment on the art of living stylishly and appropriately given that the landscape, climate and conditions vary dramatically wherever you go whether it's to the bush, the coast or the desert. Nothing's really changed with *Down South Two* except that you will almost certainly be overawed by the sheer in-your-face panache with which all the homes illustrated here display their various charms. A Karoo house is quite different from one on the Highveld, just as a beach house on Durban's coast never looks quite like one in the Cape. This is *Down South* at full throttle. This is who we are, and this is our way of doing things. As South Africans we do travel and we like to look at how things are done elsewhere, but right now this is *our* moment and we'll do it *our* way. We don't look nervously over our shoulder as we used to, looking for leads. There's a new confidence pervading our lives and the vagaries of fashion notwithstanding, we simply get on with it and do it our way.

I'm sure that when you ask people who don't live here what landscape springs to mind when they think of South Africa, they'll say it's the bush. In the north, the fabled bushveld is a part of the psyche of those who live there. Down here we have the Karoo, our lovely mountains and the coast. Up there, they're the descendants of those who trekked north, enduring on the way unimaginable hardships out in the open bush. Nowadays the bush is virtually a state of mind and up there they do bush properly. They wear the right clothes to venture into it and dress their homes appropriately so that now we really do have a 'bush style'. Southerners don't know how to do it, in my opinion. It's in a northerner's DNA; it reminds them of their pioneering past and has them, in their mind's eye at least, reaching for a hunting rifle or scaling an acacia thorn tree. The sentiments are still the same: the need to tame the wilds, and contain them. And if you can view them from a comfortable and safe perch – even better.

Quite naturally then, this book features one or two bush interiors. One is Royal Malewane, a private game lodge located in a concession on the edge of the Kruger National Park. Our first book featured its rooms and bomas; as a hotel it's perfected the bush look to such an extent that it's become a favourite of Elton John and David Furnish. This time we've photographed its luxurious Waters at Royal Malewane, the new spa magically inserted into virgin terrain and right in

the path of wandering game. This really is wild territory, the kind of place where you defy common sense if you walk from your bush suite to the spa at night unaccompanied by a bush-savvy ranger. Wild animals roam about the unfenced camp after dark and you could encounter one or two. Imagine coming face to face with a pride of hungry lions just because you dashed back for your glasses. But when you've been delivered safely to your room after dinner you could well have the additional thrill of a private viewing of live, wild game from the safety of your raised terrace. You may even see a leopard in the tree in front of you, or spot – practically touch – a herd of elephant on its way past to the water hole. At the spa imagine yourself having a massage while watching a huge rhino lumber past, or an eland drinking from the water feature while a therapist gives you a facial. The new spa at Royal Malewane does all of that, and more and it's the kind of place you'll go back to over and over again because it does for the bush what the ha-ha did in the 18th-century for the English garden: it keeps the reality of the wilds at bay and makes them palatable, even delightful.

Some South Africans are rediscovering that great swathe of country deep within the interior called the Karoo, one of the world's oldest and greatest deserts. We feature three houses in that vast mysterious region, two in the Great Karoo and one in the Little Karoo. 'Often the only visible boundary in the Great Karoo is the horizon,' wrote Lawrence Green in his book *Karoo*. For many travellers it has always been those forbidding and, according to Eve Palmer, 'lonely, sparse, wind-swept, treeless flats' that you passed as you sped up to Johannesburg from Cape Town on the N1, the national highway that bisects the country. Writing in the foreword of her book *The Plains of Camdeboo*, Palmer who grew up at Cranemere, the lovely family farm near Graaff-Reinet, tells of a 'countryside either completely overlooked or greatly slandered: few people visit it and none has ever written of it'. But things are changing. What was a blur of wasteland, or grayish scrub as far as the eye could see, punctuated now and again by a dilapidated Victorian homestead or the odd ostrich running dementedly backwards and forwards, is now being eagerly revisited because here lies the soul of this vast country. There are the fossils of ancient reptiles that lived here millions of years ago. There are tales left behind by explorers and adventurers. There are traces of vanished Khoisan herders and there have been night sightings of UFOs in its dark starlit skies. 'To those who know it is a land of secret beauty and infinite variety, sometimes fierce, sometimes hostile, but exercising a fascination that makes the rest of the world seem strangely tame,' as a reviewer of *The Plains of Camdeboo* once wrote.

Klein Doornrivier in the Little Karoo, at the heart of an old, once flourishing fruit farm, is a homestead in the middle of a walled *werf*. It sits on a slope in the foothills of the Langeberg that separate the Little Karoo from the sea. The house, an extended and re-oriented *langhuis* embellished in the 1850s and again at

the end of the 19th century, provided relief – and protection – for its occupants from the rough landscape all around and from the extremes of temperature throughout the year. Thick whitewashed walls, small windows and thatch but, inside, elegant double doors, high ceilings, an enfilade of old chambers, and an abiding sense of propriety that Martin Rekker in Louis Leipoldt's trilogy *The Valley* would have recognised: 'A more satisfying farm than that of the Rekkers it would have been impossible to find even in the Valley itself. Its neatly whitewashed gables gleamed cool under the greenery of the overarching oaks; its attendant barns, sheep kraals, low walled threshing floor … impressed one with their cleanliness, their neatness, and their manifest utility combined with charm.' Houses like this, and the families that occupy them are the real backbone of the Karoo and, like Klein Doornrivier, there are many that survive intact, much loved and happily lived in.

Steenhuis, in the Great Karoo, is quite different. Once life here was a very harsh hand-to-mouth existence indeed, and in the end the farming occupants of the house simply gave up, defeated, and left and their homestead became derelict. Today it's the summer home of Charlotte Daneel whose family has been away from the country for half a generation but who have returned to it, not as farmers but as custodians of a romantic notion of life in the grand, immense Great Karoo. They've identified with a way of life – even though it's not a full-time home – and they're fulfilling a yearning to return to the places she knew and loved as a child. The lands are being restored, the plains game is being brought back onto them and the old stone farm buildings dotted about are being renovated.

Life here, in the summer, is lived out on the stoep, around a stone table focused on the view. Equally, in the 40-degree heat, you might prefer to lie under the cooling blades of a whirring ceiling fan, or pad about barefoot on the cool stone floors, in hand a glass that's full of lovely ice from a machine in the kitchen. This is lifestyle luxury in the Great Karoo as opposed to a subsistence way of life at the remote heart of a great tract of emptiness. Here the weather's the only regulator you might consider keeping an eye on, and here you don't mess with nature because it will turn around and bite you if you're not careful. This is not a place for the faint-hearted, as Charlotte Daneel realised as she began to rebuild the derelict *langhuis* hundreds of kilometres from anything at all, at the bottom of a barely-there dirt road encircling the foothills of the formidable Sneeuberg famous for its icy winter winds and unremittingly hot summers.

The third of the Karoo properties is Samara Private Game Reserve, near Graaff-Reinet, on the very edge of the mythological Plains of Camdeboo. One of the largest private ranches in the country (28 000 hectares), the huge tracts of savannah and forest, mountain, valley and grassy plateaux were silenced and emptied of game by early European explorers and hunters as they pushed deeper

and deeper into the interior. The owners, Mark and Sarah Tompkins, have torn up all the old farm fences criss-crossing the property and they've allowed the land to come back to life, even restocking it with the kind of wildlife once seen there in abundance – although lion, once so prevalent it was regarded as a pest, is not on their shopping list, nor is elephant. The lodges at Samara are a comfortable, even glamorous, 21st-century version of the pioneering interior that you will have found in the region, and it's been put together with the help of John Zwiegelaar.

And then there's the other side of the coin. Some of the most lovely houses in South Africa are found in the suburbs of its cities. The word 'suburb' implies order and uniformity and conjures up images of neighbours pressing cheek by jowl. The Cape Town houses featured here are anything but; they're only semi-suburban in the sense that they – Houses Constantia, Mostert and Prospect House – all lie at the heart of large gardens in Bishopscourt and Constantia, occupying lands that were once the vineyards, fields or pastures of old Dutch farms, and attractive even now for their semi-rural qualities. They're peppered with old groves of oak, orchards of craggy old fruit trees and copses of ancient indigenous trees and shrubs sometimes close to the very epicentre of one of the world's most important – and flourishing – floral kingdoms, Kirstenbosch. They're at the pinnacle of the suburban hierarchy, and for the most part they're social houses, built for entertaining. A unifying factor is a luxury of space. They're outward-looking houses because the breathtaking topography of the Cape Peninsula demands to be incorporated in the planning of dwellings in this part of the world and choice of site and effective orientation of big windows and stoeps is key, if not the reason for buying the property in the first place. The owners of these houses could have lived anywhere; some have come from abroad bringing treasures with them, in one instance from the family palazzo in Venice, in another an ancestral English stately home.

These homes evoke the kind of lifestyles to which many South Africans aspire. Easy on the eye, cosmopolitan, amongst these often decorated houses you'll find a wide range of styles including the English country manor, the Bel Air palace, the Italian villa, even the French chateau complete with porte-cochere and turrets. These houses are smart, glossy fantasies made manifest in brick and stone and for the most part they depend on a sense of the past to give them, and their owners, a context in the present. Even the Cape Dutch style is represented – perhaps most famously by Groote Schuur, built in the 1890s in Rondebosch for Cecil John Rhodes by Herbert Baker, with Cape Dutch-ish gables and clever borrowings from the Cape vernacular.

In Johannesburg, Aberfeldy 9 by Stefan Antoni Olmesdahl Truen Architects quite consciously sets out to be the exact opposite of its neighbours' stylised homes which had borrowed so freely from all kinds of traditions, including Mali and Bali, Provence and Tuscany. Here is a sleek contemporary home that makes the most of its Highveld situation and allows all kinds of lifestyle possibilities taking into account lots of sun, dry winters, space and light. There's no point in living in the Highveld if you don't get the inside-outside aspect right. It should be integral to the experience of living here, and so this house is laid out on a series of barely-there terraces interjected with planted courtyards. Every single space opens fully to garden, water or sky; and you can always slide a wall or two walls of a room away, explains project architect Greg Truen.

Crossing town, Illovo Penthouse is a collaboration between the owner, Ingrid Wingrove, and Sharon and Shereen Fihrer of Head Interiors. It's an apartment that has all the streamlined sexiness of a 1930s cruise ship. Balcony railings mimic the generous curvature of on-board railings, there are 'porthole' mirrors above the vanities in the bathroom and there's a deck where the furniture is clad in pristine white leather and, propped up by a mast clad in aluminium, a great soaring sail sheet rather than more predictable umbrellas. Inside, pearlised paints give a lustre offset with grey felts or velvets, and there's a magical glamour that comes alive, particularly at night. Smart, sexy, slick, this interior epitomises cosmopolitan Johannesburg. It has an edge, a sharpness, you'd never find in Cape Town or Durban.

All over Johannesburg there are wonderful interiors to shoot. Karen Newman's home has an urbane colonial chic where South African antiques are displayed on stone floors as if this was the contemporary descendant of the Cape Dutch farmhouse. At House Brink, decorator Stephen Falcke uses a daring red which he offsets with black and white cowhides and surprising farmhouse finishes. Deep in a smart section of suburban Johannesburg, this is also the most casual of houses. Falcke has asked himself, 'How are these people going to use this home?' They aren't the 'sitting formally in the living room' types; so what might have been the living room becomes an anteroom to the real living spaces – the kitchen, where there's a massive dining table and chairs in front of the hearth, and the stoep where, overlooking pool and garden, you'll find another big dining table as well as large comfortable sofas and armchairs. This house epitomises unceremonious, casual living.

Some houses featured contain exceptional collections of furniture, art and artefacts. Some, like the remarkable Cape Dutch homestead of Stellenberg, are historical homes restored and decorated for contemporary living. Here the interiors reflect the layered influences of Dutch, French and English cultures at the Cape. House Rabe, in contrast, is a modern design built specifically to display Piér and Jo-Marie Rabe's brilliantly curated collection of largely 18th-century South African furniture and art combined with Modernist pieces from Mies van der Rohe and Le Corbusier. Bridge House is furnished with European 20th-century furniture and couldn't be more contemporary. Then there's the home of painter Christo

Coetzee, again in vogue for his outlandish conceptual artworks, whose Tulbagh Cape Dutch homestead survived both earthquakes and Coetzee's idiosyncracies. House Methven near Faure in the Cape is where Pan-African Market art dealer and artist Michael Methven and his wife Anthea could create their own wonderful eclectic tribute to the Africa they have explored with such passion.

So much of South African life is lived out beside the sea. Two of the country's great cities, Durban and Cape Town, straddle magnificent coastlines, while some of the places in between – Plettenberg Bay and Hermanus in particular – have become popular resorts simply because of wonderful locations. In Plettenberg Bay Suzy Lubner's beach house is an exercise in easy beachside simplicity, while Gail Behr's The Grand Café & Rooms is a smack to wake up the senses and not at all what you might expect to find by the sea. While the Lubner home is all screeded floors, cool gentle colours and large uncluttered spaces, The Grand, with its hip chocolate palette, massive silver candelabra and a very sophisticated Boho-chic only acknowledges its marine location in that nobody gives a damn if you wander in from the beach in a sarong with sandy feet, leaving damp patches on the furniture. Bring the dog. Check in for lunch, stay the night and enjoy the relaxed atmosphere. The Grand Café & Rooms takes languid no-style style to new heights as a triumph of casual living.

Cape Town has a particularly varied coastline. Overlooking the huge arc of False Bay to the south of the peninsula, Petrava House was built for an admiral who wanted to spend his retirement gazing down at his beloved former base at Simonstown. There's a nostalgic pre-war look about the place, an easy 1930s elegance redolent of a life of leisure and entertainment, of balmy evenings and steamy soirées. And inside Petrava House there's a raffish glamour you don't often find in this country; the high staircase hall with its shiny spiralling stairs, white-painted balustrade and ebony banisters, 1930s German furniture, even the entrance portal adorned with lotus capitals smacks of an iridescent end of Empire sociability, martinis and gin slings.

While life at Petrava House gave rise to a few legends in its lifetime, the exotic pavilion-like Villa La Mer at Clifton in Cape Town intrigues. It's the house that everybody wants to see inside. It sits almost out of sight below Kloof Road and although it rises into view as you approach from below, on Victoria Road, it then vanishes the closer you get. Making full use of the view, architect Richard Perfect arranged the building on terraces and its axis, running east-west, takes in not just the ocean below with the series of charming coves that characterise Clifton's coastline, but the peak of Table Mountain behind it, specifically the one on which the cable-car station is built. A counter axis takes in Lion's Head to the north and

Oudekraal to the south. This is a romantic seaside holiday house, an exotic pavilion from which the owners and their friends can dip gently in and out of life in Cape Town in the summer.

One of the most extraordinary beach houses ever built in this country straddles the entire length of a sea-facing dune above the eight-kilometre curve of the Robberg Beach at Plettenberg Bay. The architectural award-winning work of architects Andrew Makin and Janina Masojada of Durban's Design Workshop, and interior designers Boyd and Geordie Ferguson together with interior architect Joy Brassler, it is a daring solution to a lifestyle quandary: The owners wanted full-on beachside living on a notoriously windy site and they wanted a new way to live on holiday as a family by the sea. In the end, not only does the building itself become the mechanism for climate control, but the massive main open-plan living space houses everything you need for your daily activities and this area becomes the open 'space' between the living pods which flank it. Glazed doors sealing the living area fold away to reveal a seamless inside-outside terrace effect. You're outdoors, but not really. Controversial it may be, but the team really got it right and this house will in time become a benchmark design for holiday living.

Another important contemporary house at Plettenberg Bay is House Lewin, sensuously wrapped in eucalyptus cladding that weathers to silver-grey. What could be simpler or more site-sensitive? Yet the cantilevered architecture, shadow gaps between ceiling and floors and the pulley system with counterweights – the house folds itself up at night – along with sharply framed views have made it another design triumph from international architect Seth Stein.

Down South Two might be described as a lusty rampage through the very best of South African interiors. As we travelled around the country, more and more places revealed themselves and all those we've missed, or haven't included, will feature in the next book. In many ways we've scarcely begun to appreciate all that is already on offer. South African architecture and décor is a thriving force and numerous homeowners are making the most of what's all around us to create homes which are distinctively South African and at the same time world-class interiors able to stand alongside the best homes anywhere else. So, in conclusion, this book is dedicated to the owners of the various houses we've featured, and to the decorators and architects who worked on them. Without their innovative and stylish designs, along with their support for this project, this book could never have happened.

Paul Duncan
Barrydale 2007

Villa La Mer
Clifton

One of the most striking and seductive houses in Cape Town is Villa La Mer at Clifton, the house that everybody wants to see inside – a secluded and intriguing coastal home. It hovers above Fourth Beach, Clifton, making full use of the spectacular sea and mountain views all around it. Cape-based architect Richard Perfect, working with Parisian interior designer Serge Robin to follow the owner's brief, rebuilt an existing 1920s house that took little advantage of its location, and rearranged the building over terraces descending through the fynbos-covered hillside below Table Mountain towards the sea. You can see Lion's Head on one side and Oudekraal on the other, while laid out below is one of the most coveted stretches of real estate in Africa. When purchased by the present owner, an international businessman and passionate collector of 18th- and 19th-century art and antiques from Europe and the Far East as well as the souks of Morocco, the intention was to renovate. Such extensive upgrading was never anticipated at the outset: 'I'm a perfectionist and soon realised that minor remodelling wouldn't satisfy me,' says the owner. So he commissioned Robin and Perfect to conjure up a building that would make the most of the site and the view, and come up with a house in which entertaining would be a priority – entertaining, that is, in great style. After all, visiting grandees from Europe and North Africa would expect the very best of the Cape. 'It's not easy to find a view this remarkable anywhere in the world, especially overlooking such a volatile ocean,' remarks the owner, who once flew his guests on a day trip to Maputo to buy fresh fish for dinner. Villa La Mer is seaside living wrapped in cashmere. This is seaside chic such as Cape Town has never known it before. At the same time the emphasis here is on relaxed living and pulling up loungers beside the pool or sinking into deep armchairs as everyone wants to do on holiday. True, there are truffles for dinner, fun chat with luminaries from the international art or antiques world or exotic socialites from Marrakech, and a dinner service that's museum-quality Ardmore sourced from KwaZulu-Natal. The furniture, the paintings and the interior accessories are the best found in Paris's Clignancourt markets and there's 18th- and 19th-century Cape Dutch furniture in glowing and polished yellowwood, lacquered and glazed pieces from China and Cambodia, Argentinian silver and lots and lots of lovely rattan.

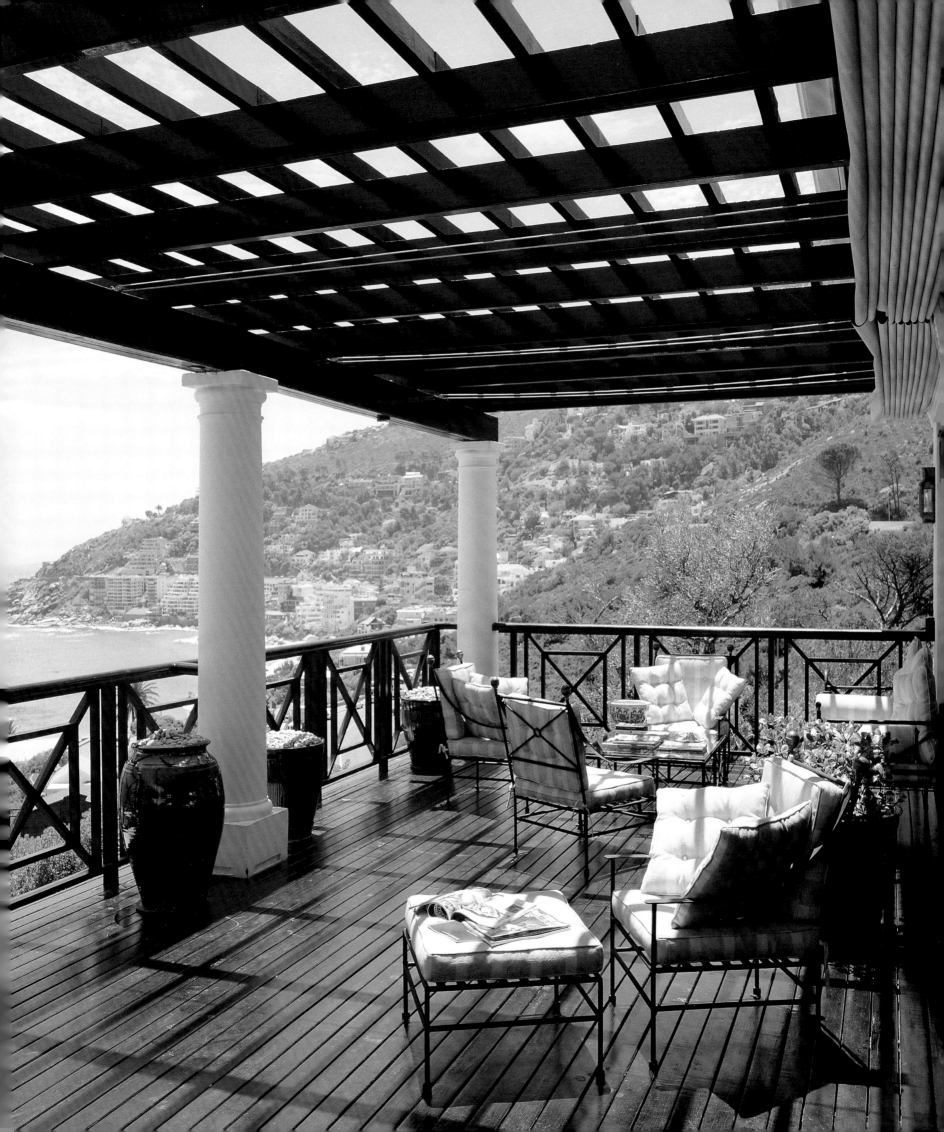

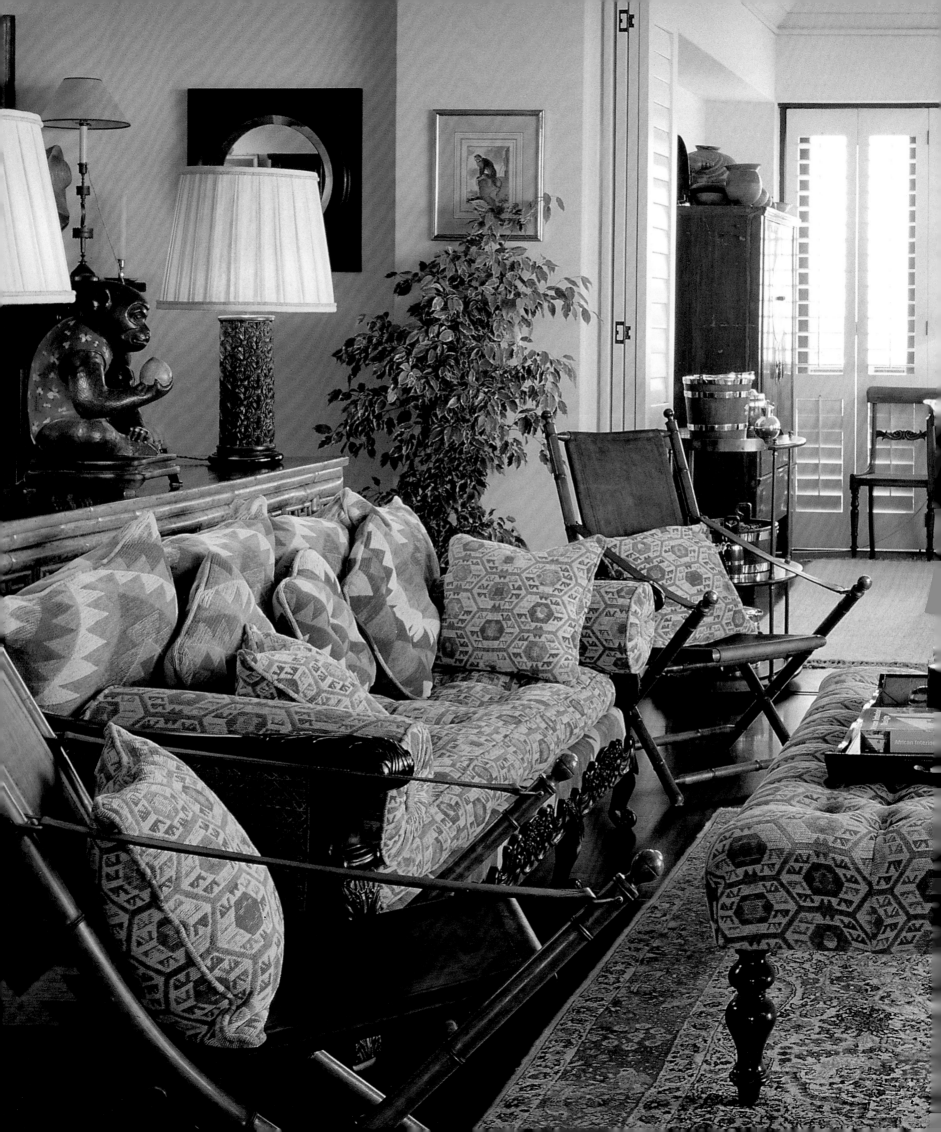

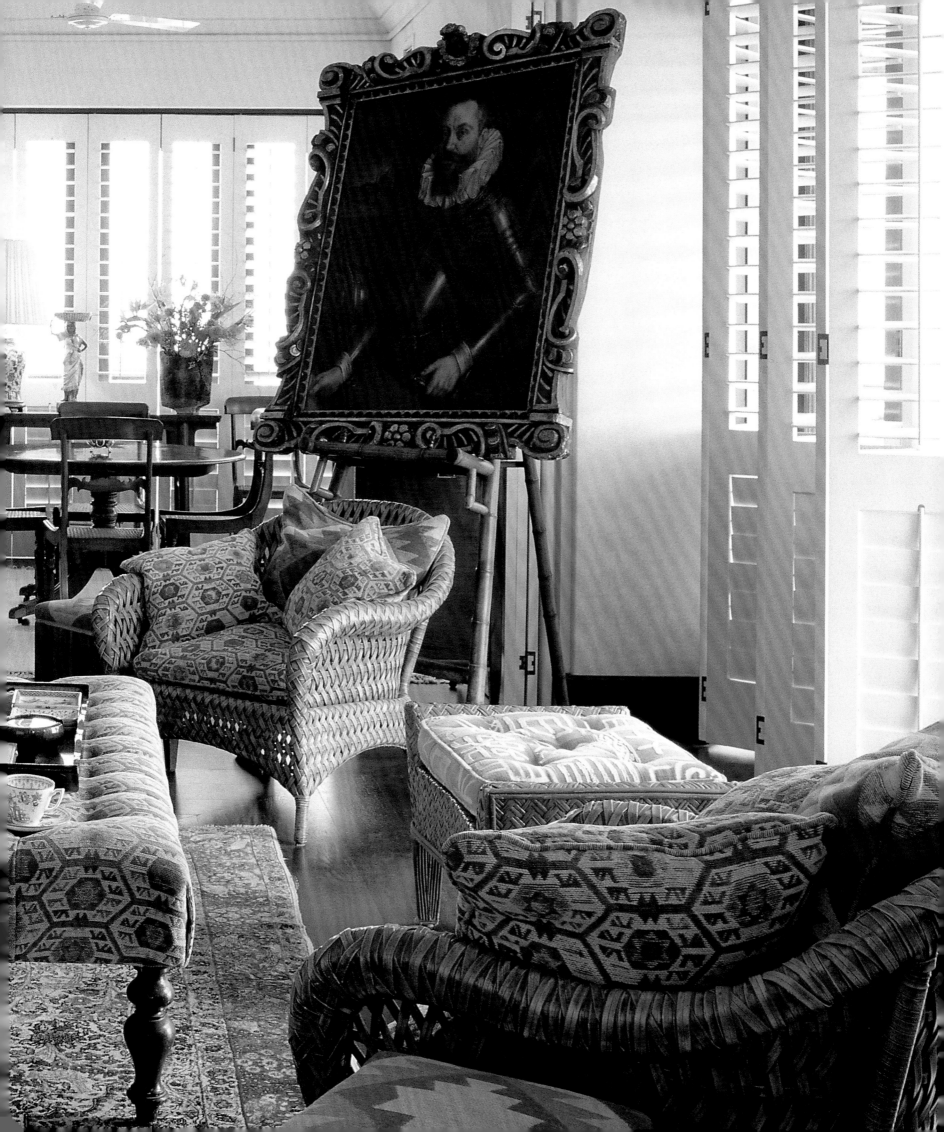

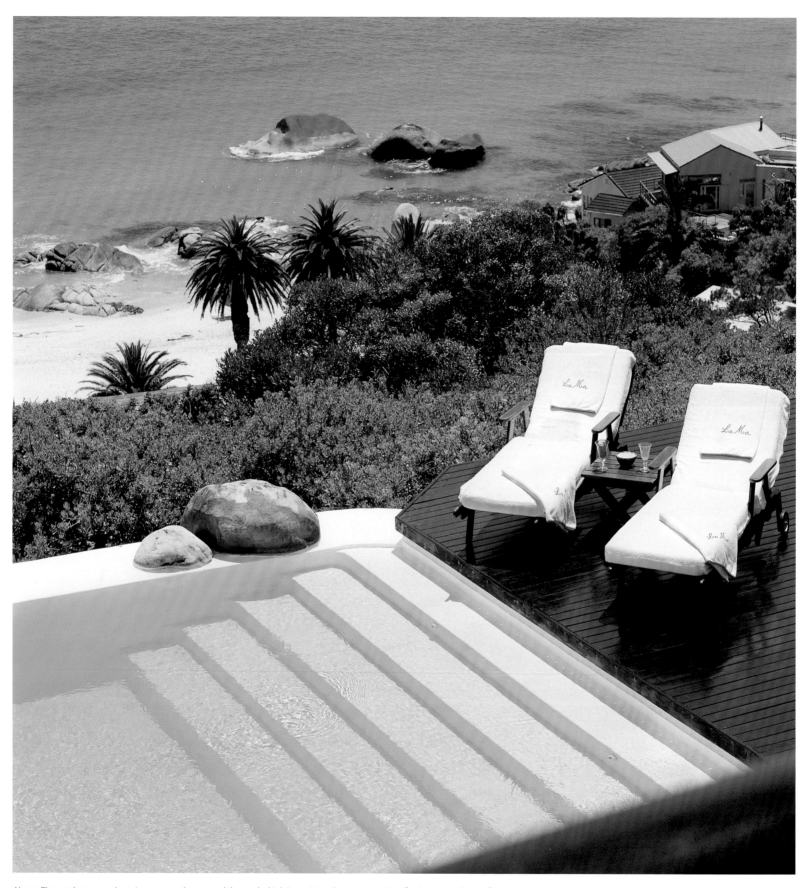

Above: The garden terrace has views across the sea and the pool which is positioned to create a vista of uninterrupted azure from terrace to horizon. The chairs are vintage ocean-liner sundeck chairs made in Madeira.

Opposite: The lower terrace with eclectic Moroccan, Indian and wicker chairs is casually elegant. Its old-fashioned 'holidays in Africa' style brings an irreverent note to this luxuriously appointed home.

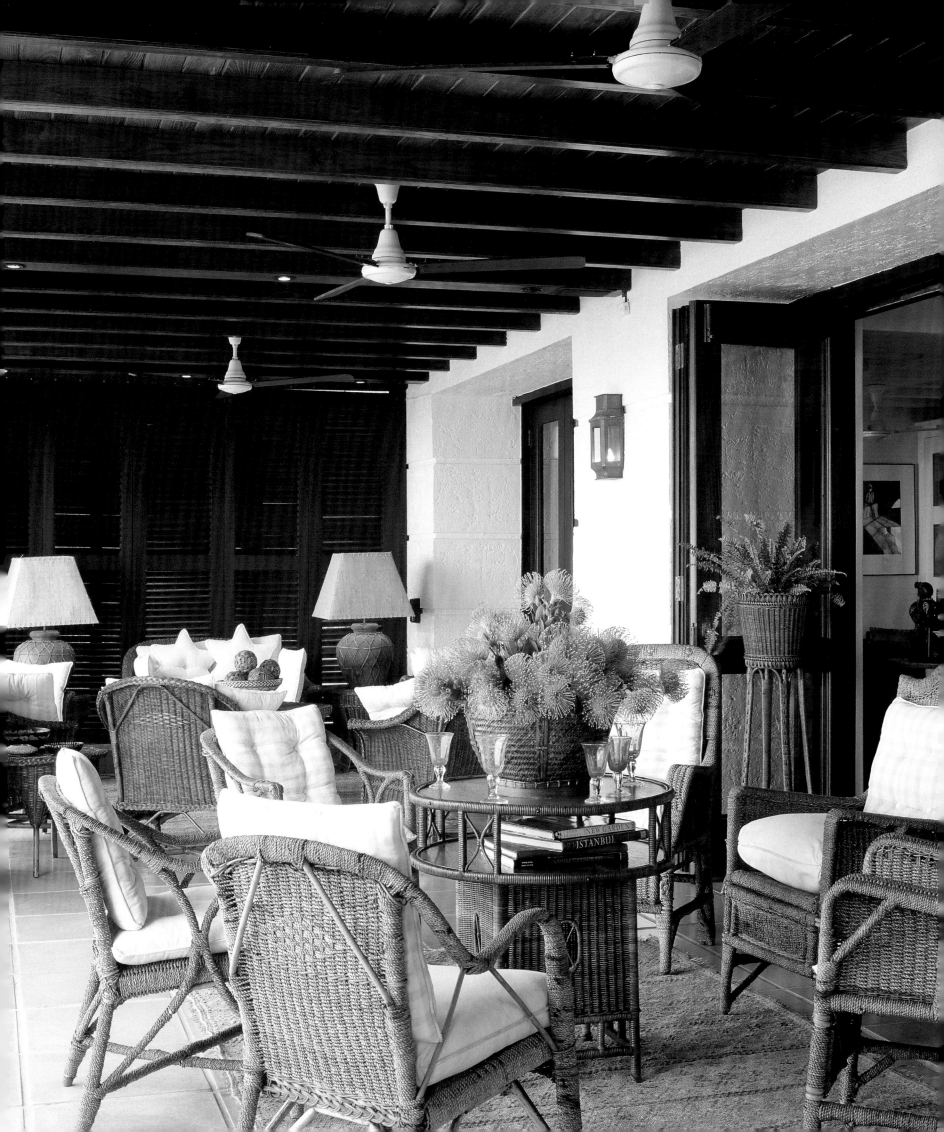

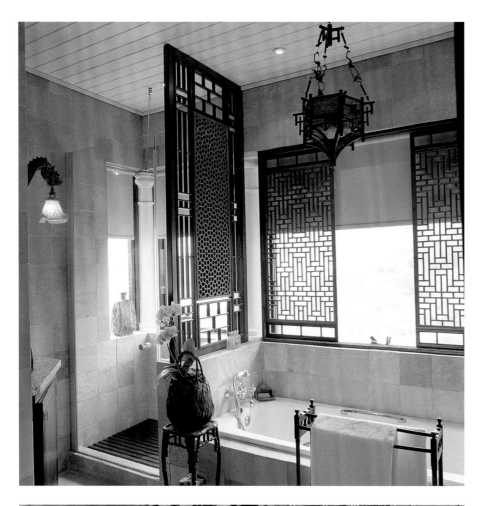

Above: In the bathroom, Chinese screens form the window treatment and serve as a divide between the shower and the bath.

Below: Cushions in Kuba cloth and other African geometric prints bring the colours of Africa to the seaside.

Opposite: The oriental-style master bedroom opens directly onto the bathroom.

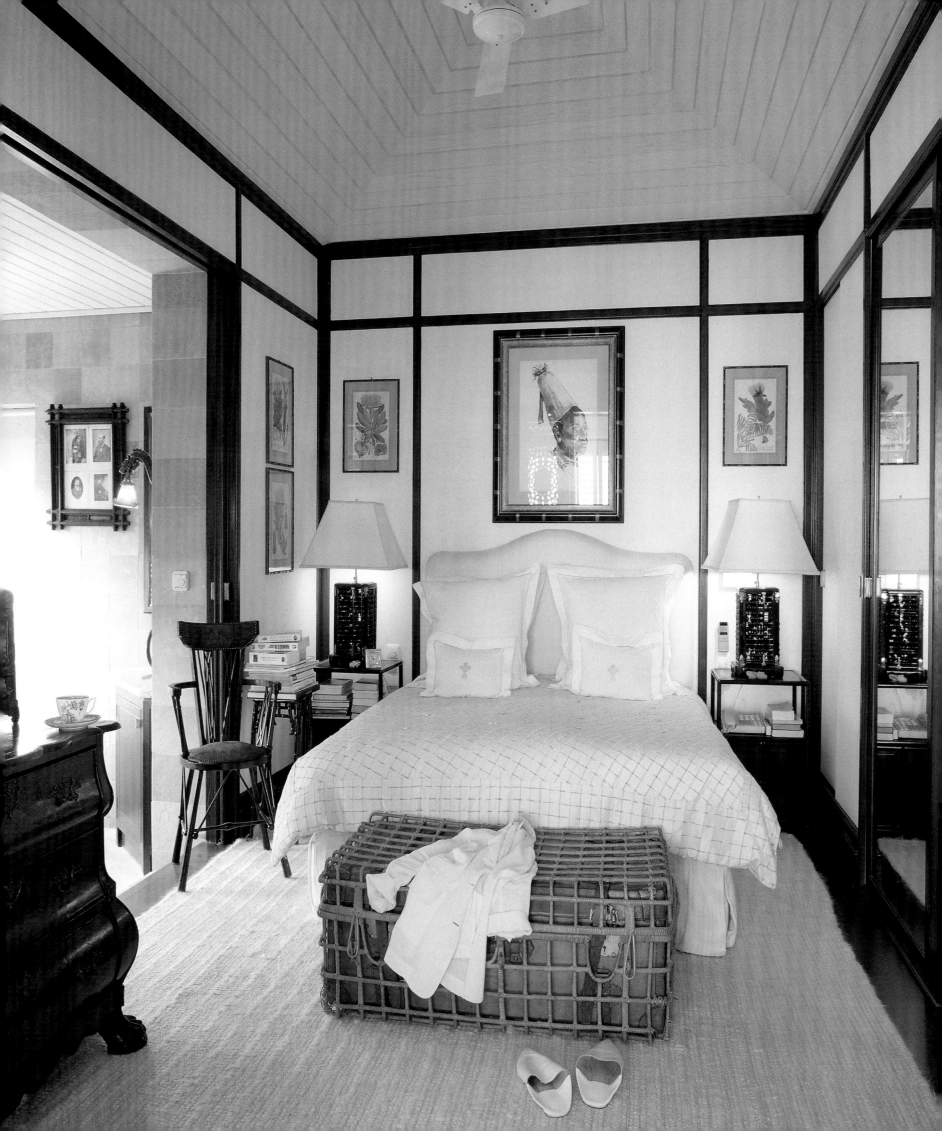

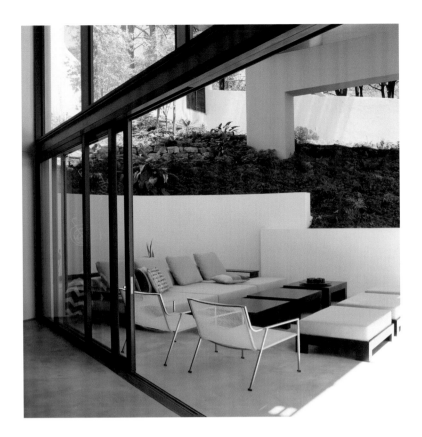
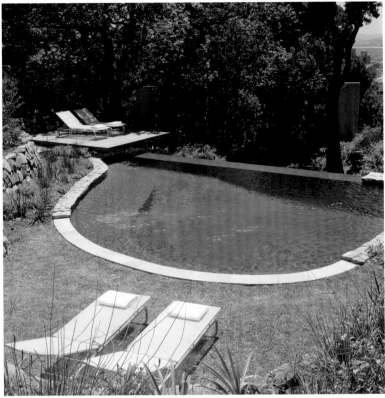

Bridge House
Higgovale

Above left: The uppermost level is a partially covered 'pause' area. The light, textured furniture is sparse and sculptural.

Above right: The pool occupies a part of the former riverbed.

Opposite: The entrance pavilion at street level. Behind the bookcase is the kitchen; in front of it the dining area.

Page 12: The cocooned bedroom looking outward: curtains are weighted parachuting material running on wire cables.

Page 13: The house straddles a series of terraces. At the top the entrance pavilion opens up the views.

Page 14: The staircase is brilliantly sculptural.

Page 15: Adjacent to the entrance pavilion, this deck has magnificent views.

Bridge House in Cape Town, designed by the prestigious firm of Van der Merwe Miszewski Architects, is impossible to take in at a glance. 'It unfolds,' suggests Macio Miszewski, 'like a composition, with different intonations and pauses between the drama.' The entrance is a strong overture and the declaration of a style that invites the eye to move between immediate structural detailing and the sweep of natural surroundings. 'We wanted to live in nature,' confirms the Dutch owner. A slice of pristine Cape vegetation and spectacular views were an absolute must. After spending years living in a 16th-century house on the banks of Utrecht Canal, he and his partner yearned for a reprieve from flatness and low urban skies. Here they saw the potential in three plots overrun with wild vegetation, traversed by a dry riverbed and sloping at gradients of up to 30 degrees way above Cape Town's city centre on the slopes of Table Mountain. There were only three directives to the architects: to maximise the view, to preserve the site as far as possible and to build three separate structures. Simple but challenging. The result is a skilful integration of separate pavilions positioned at different angles and levels in the natural setting of the Table Mountain valley. The top structure bridges the valley to open up views of city, ocean and harbour, while the riverbed was filled with water to form little pools at different levels. 'Here the sensual narrative of nature is matched by the drama of the buildings,' says Macio. 'Both the top and bottom pavilions are like bookends, floating on pilotis.' Cape-based landscape architect Tarna Klitzner made the garden unfold as gradually as the buildings. Little narratives happen downstream, taking us past the dark charcoal-coloured pool that looks more like a weir into meditational niches such as that featuring Jasper Morrison's 'Thinking Man's Chair' for Capellini, before the visitor arrives at a large koi pond at the far end. Views are big, but the attention to small secluded spaces brings intimacy. Inside the interior is a juxtaposition of spaces: some are more contained, like the bedrooms that are cocoons of privacy, while public spaces open dramatically upward and outward creating a sense of vastness. The colours of Africa are found in dark wood cabinets and floors or steel the colour of charcoal, contrasting with crisp white textures and the occasional dash of sharp colour.

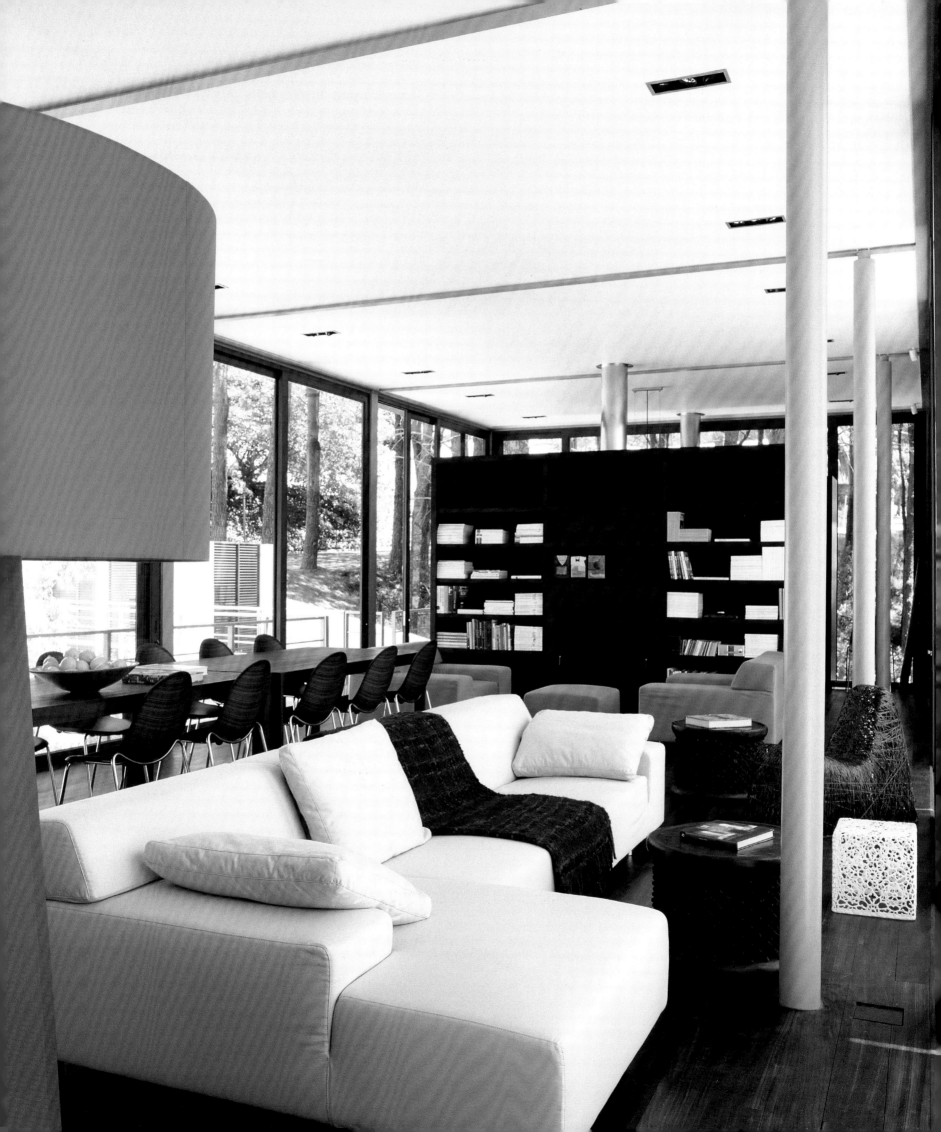

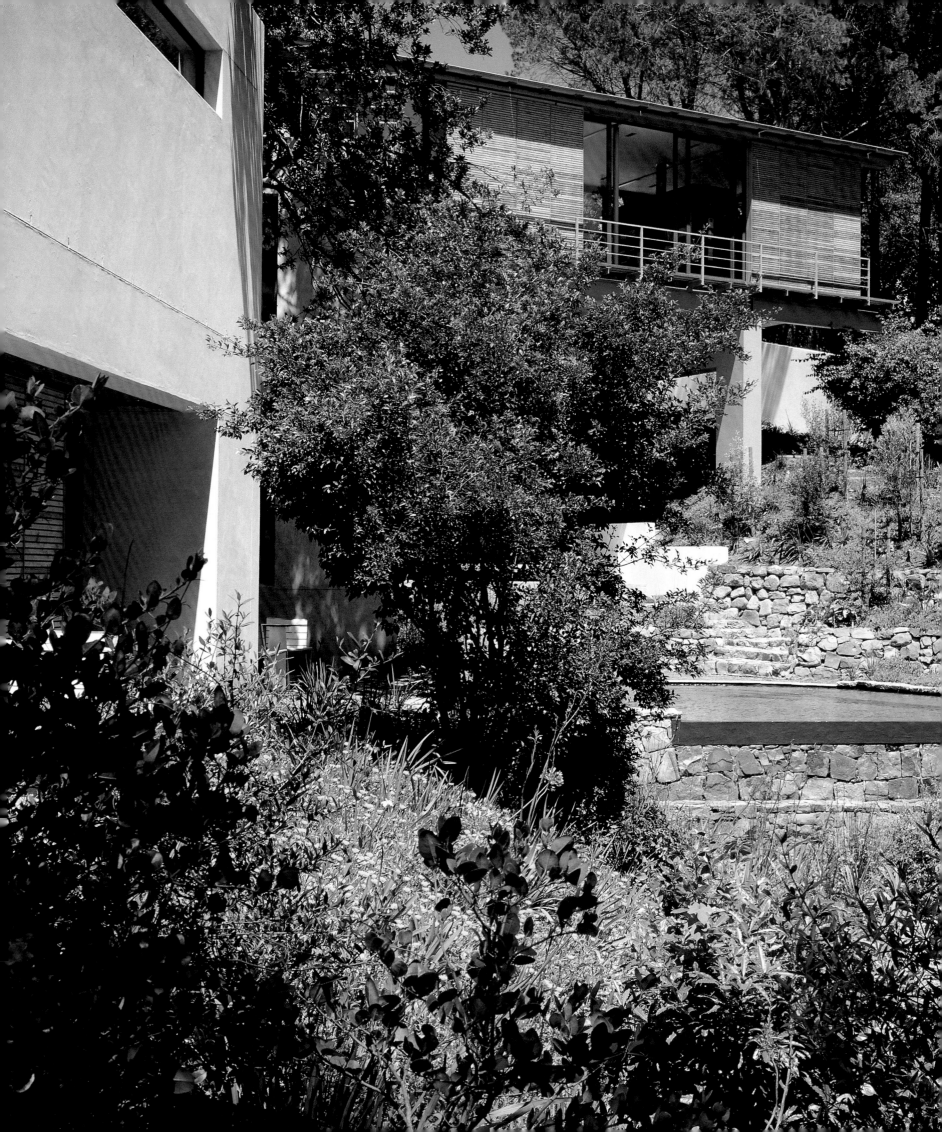

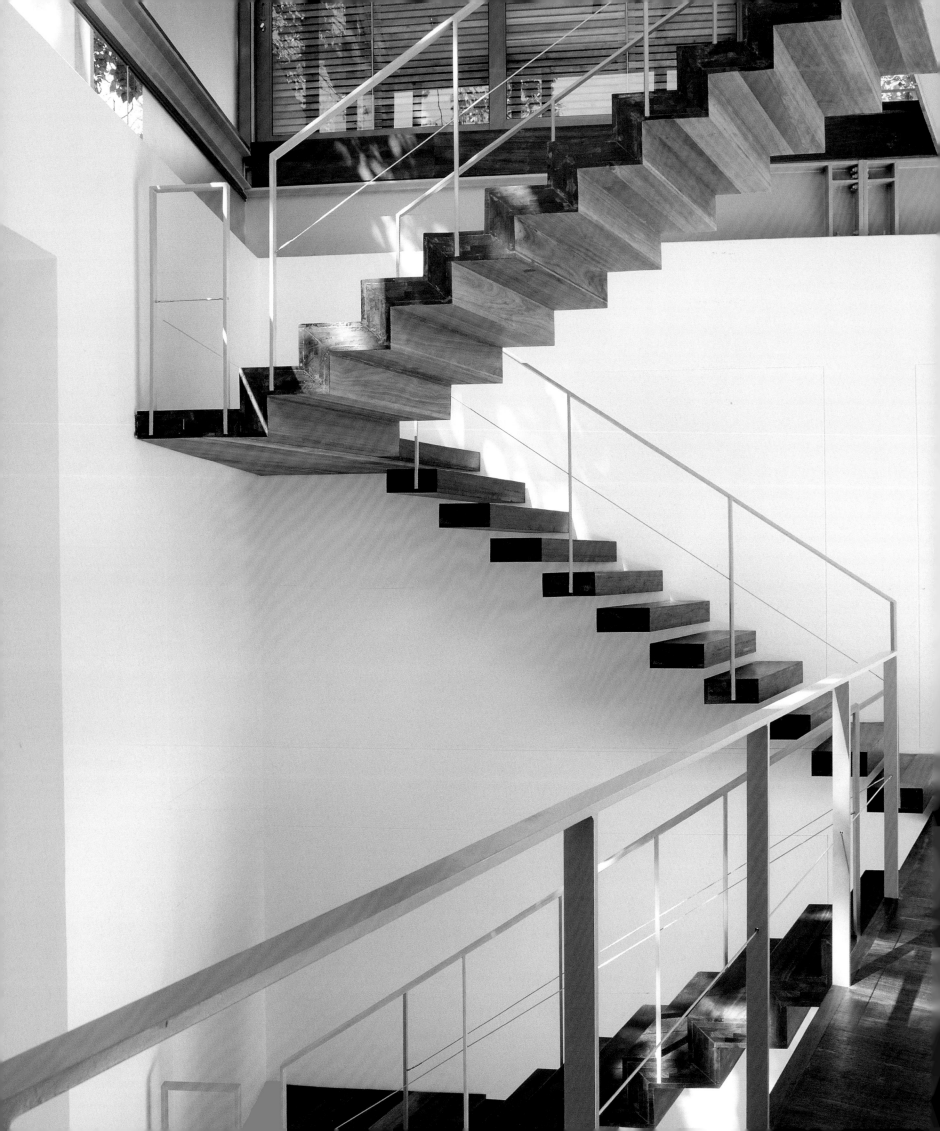

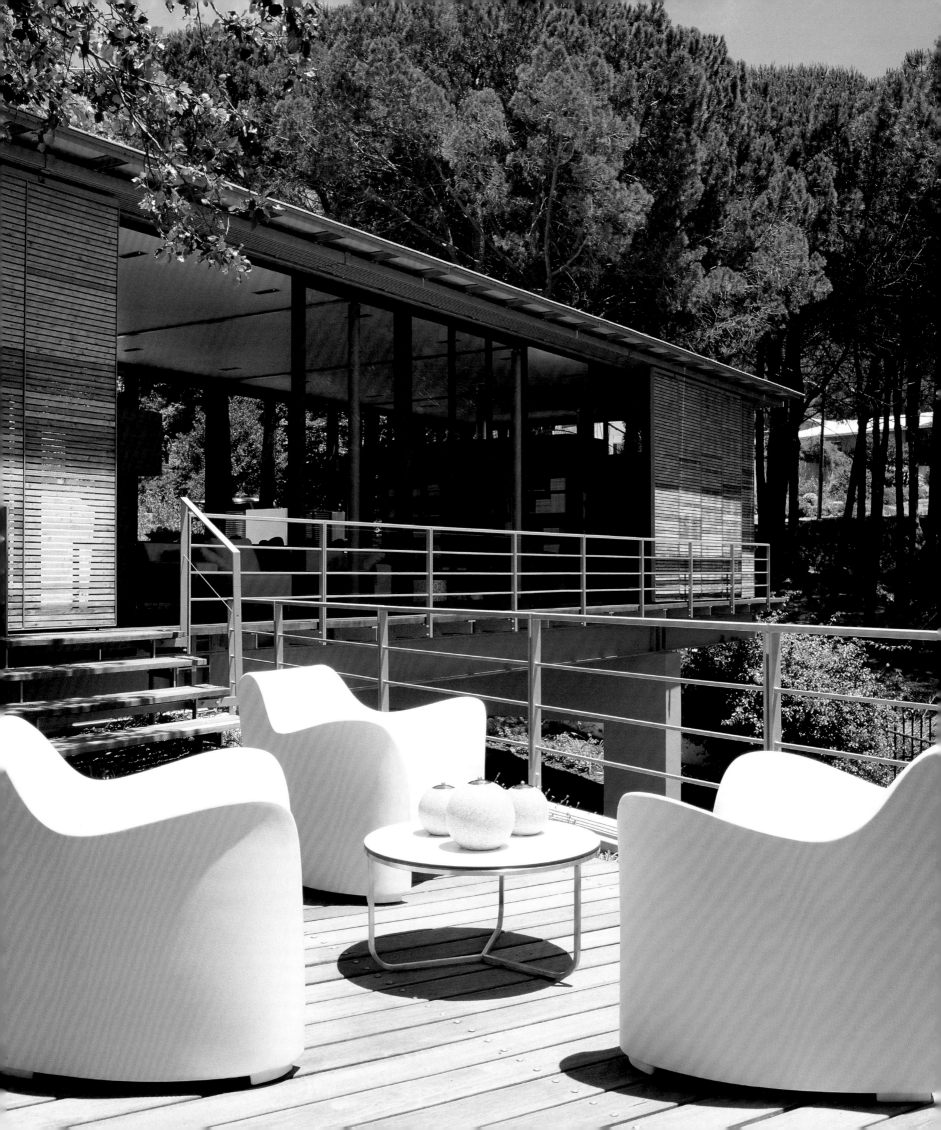

The Grand Café & Rooms
Plettenberg Bay

Above: The coast along the Garden Route, particularly between Knysna and the Tsitsikamma mountains is breathtaking. Craggy gorges, lakes, rivers, forests, cliffs and miles and miles of sometimes inaccessible beaches make it a major holiday destination for South Africans, many of whom choose to have their holiday homes here.

Opposite: Although the owner doesn't actually live here, she might as well. After all this 'hotel' is run like the private wing of a house that's open to the public. Come for breakfast and she'll make you tea. You've never met her? Doesn't matter, stay for lunch. Stay for dinner too; she might be cooking and, if she is, make sure you have a front-row seat. The décor of this room is only the backdrop but it's a foretaste of things to come. Make sure you've booked your room upstairs too, and map out your route to bed before you sit down to dinner.

Gail Behr's The Grand Café & Rooms is a smack to the senses and not at all the kind of hotel you might expect to find by the sea. Part Tunisian kasbah, part township khaya, The Grand is turned out in a hip chocolate palette. There's a very sophisticated brand of boho-chic going on here and it does acknowledges its marine location but only in that nobody cares if you wander in from the beach in a sarong with sandy feet, leaving damp patches on the furniture. Bring the dogs. Book for lunch (Gail could well be cooking; if she is, make sure you're there for a creative and delicious meal), and stay the night. That's how it works here. And the only rule that's really adhered to by the management is that somehow guests through their presence should augment the surroundings (beauty, charm, intelligence, novelty, eccentricity) not detract from it (boring conversation, dullness). It goes without saying that you never know who you might meet here – beautiful heiresses, crooks, polo players, famous models, decorators and billionaires among them. There are fantastic views from The Grand's hillside eyrie way above the mouth of the great Keurbooms River to the lagoon, and then north further on up the wild, wild Paradise Coast facing the Indian Ocean. There are whales, dolphins and surfers to complete the view way below at Lookout Beach which you can observe from under an umbrella on the Café's partially covered terrace where the *beau monde* congregates whenever it's in town and simply needs to nurse its hangover. To one side a swimming pool for resident guests completes the picture. Order the best steak frites ever and a jug of red wine, or two, lounge in the sun for a while under the gaze of a row of strident, kneeling poolside harpies made of cement, then retire to your bedroom – where it's the bath not the bed that has pride of place overlooking the vista. The chocolate palette continues up here with highlights of red plush and furniture painted a shiny black. Everywhere there are elements of surprise. The Grand Café & Rooms takes languid 'no-style' style to new heights and is a triumph of living casually – on the edge.

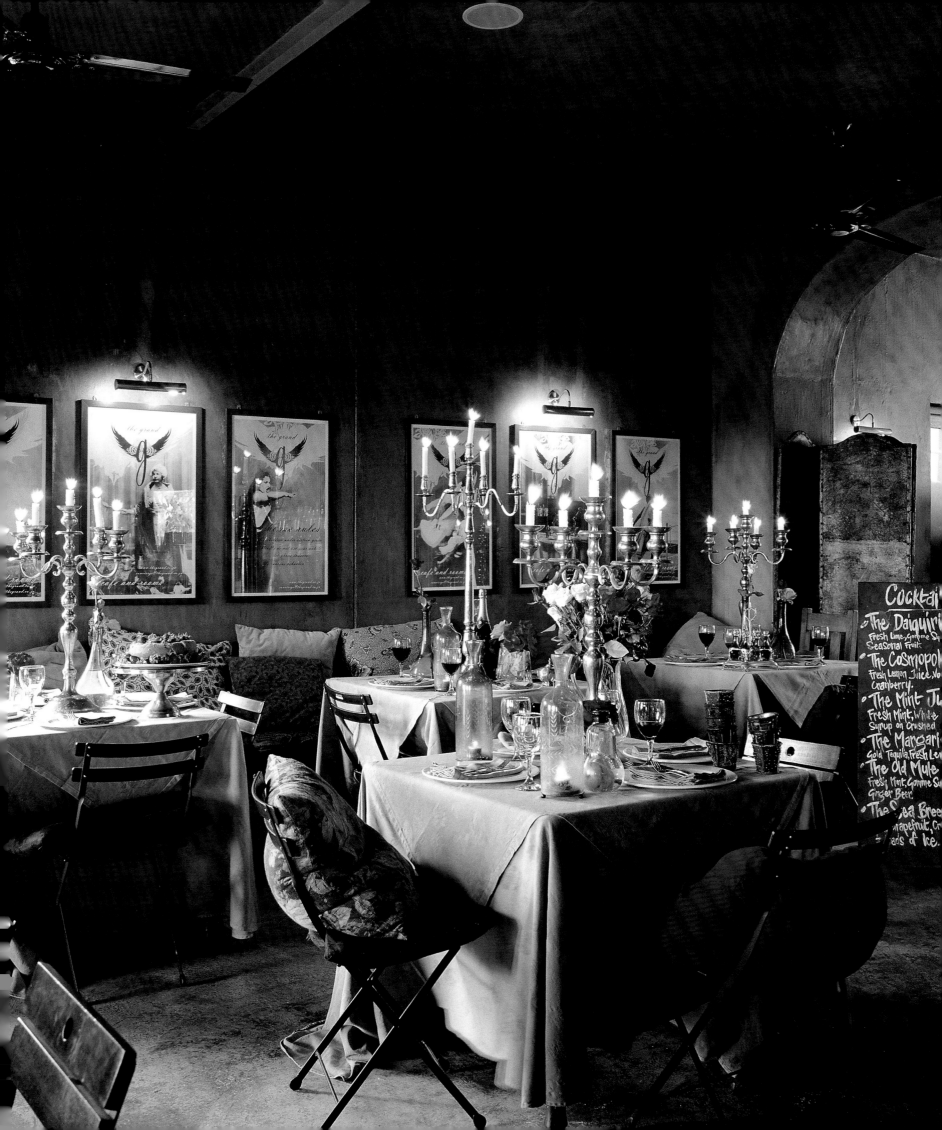

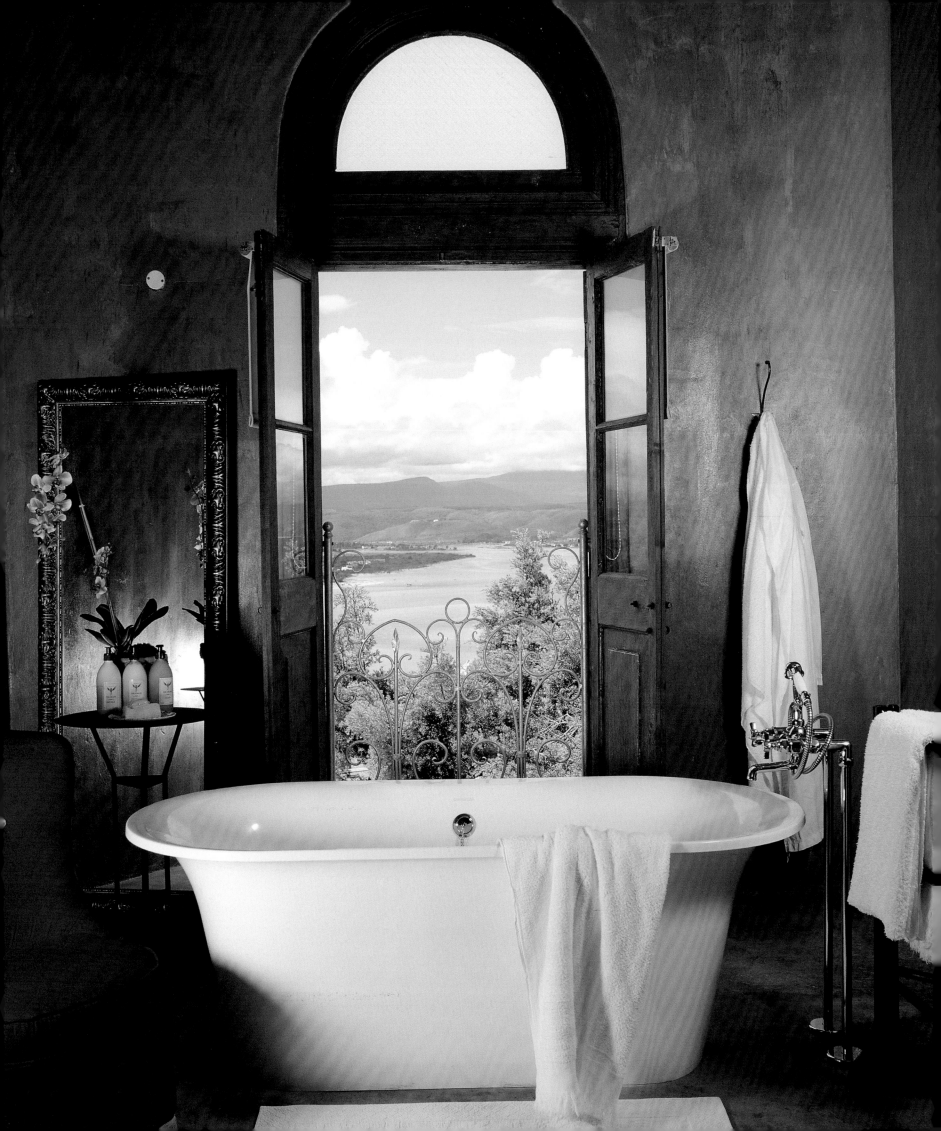

Page 18: You'd be mad not to book this bathroom. In fact it's a bathroom with a bed area attached to it. Have a drink up here, in the bath. Make a movie here: 'Bath with a View'. This is real luxury. And if a breathtaking view is part of the deal, even better.

Page 19: This is the bed that goes with the bath. Beside the bed, which was designed by the owner and made locally from forged iron, a small, velvet-upholstered stool is provided to help you into bed. Without it you might never get in. It's twice the normal height and it allows even better seaside views while you're lying down. The concrete floor is heated.

Top: The bathrooms at The Grand are among the most important features of the place. This one's built for a party of bathers, or swimmers, who've just met in the bar downstairs and need somewhere else to move on to. Or that's the thinking anyway.

Bottom: At the entrance, a flash of louche. A poule de luxe reclines by the front door. Will life imitate art? Or will it in fact be the other way around? You never know at The Grand.

Opposite: A courtyard opening off one of the principal guest rooms is set for a private lunch. The Grand dishes up a kind of luxury that's less about pampering than it is about providing guests with special experiences. How many hotel rooms have a private courtyard dining room, serving food cooked by the patron and brought over to you by a friendly local heiress who is skivvying for her?

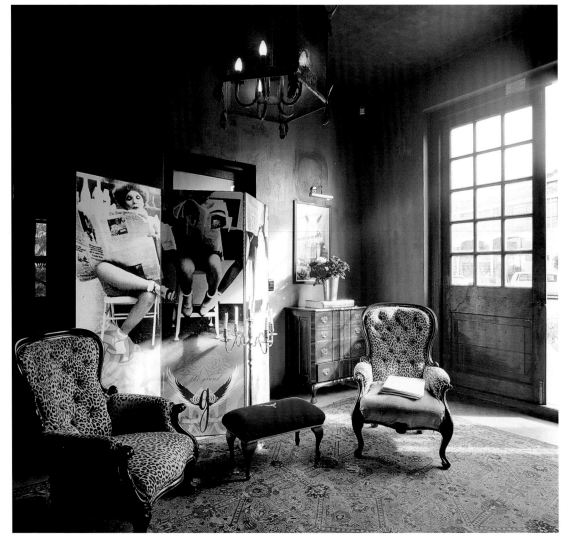

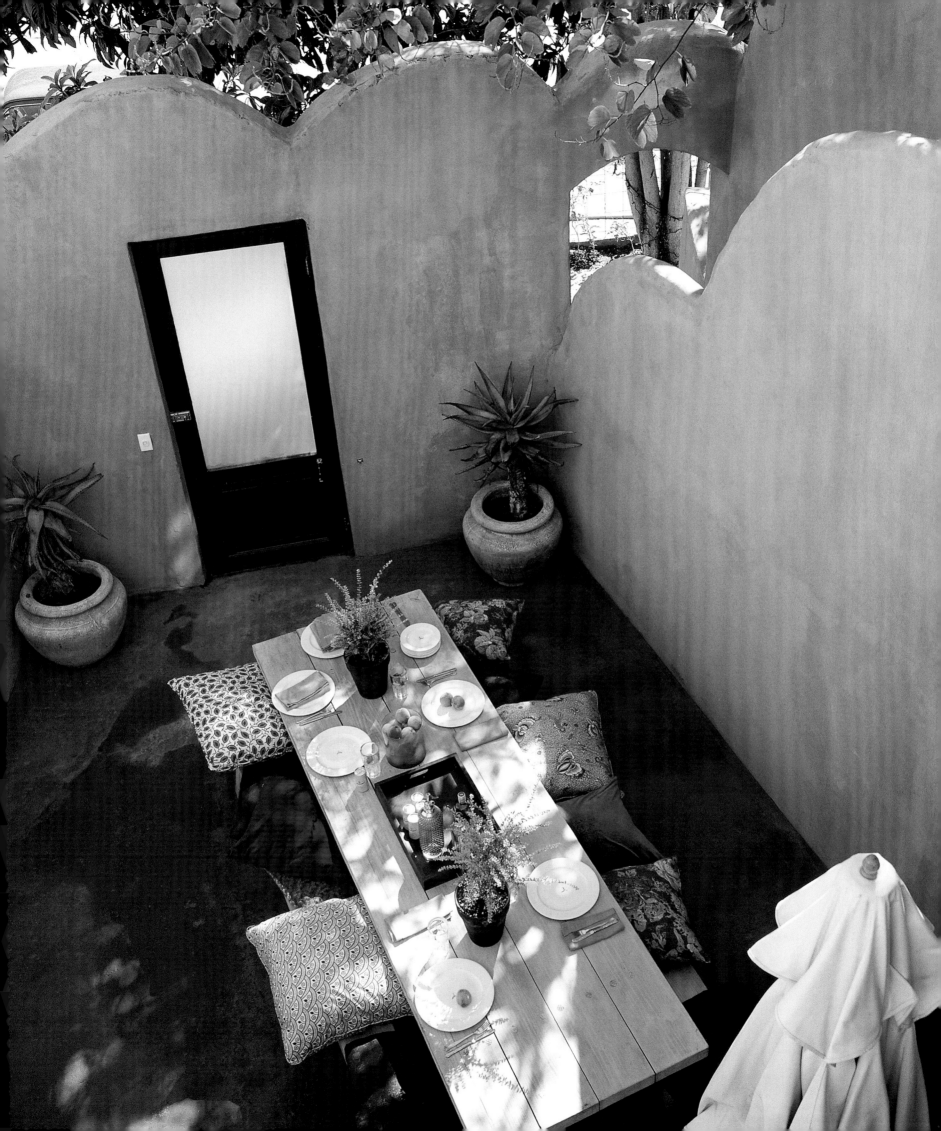

House Rabe
Stellenbosch

Above left: In front of the 1950s Coetzee works stand Murano glass vases.

Right: Piér and Jo-Marie Rabe.

Opposite: Tall 18th-century armoire topped with antique boxes and flanked by Modernist chairs in limited edition.

How do you bring together antiques and the best of Modernist without compromising either? 'We'd just got back from London and I kept seeing a vivid Rothko painting in my mind's eye – it had been on show at the Tate Modern – and suddenly it came to me. I wanted a kitchen that was like a Rothko,' says Jo-Marie Rabe. The courage to bring together the disparate with flair is evident throughout the house. Antiques dealers are all too often thwarted collectors, an obsessive and tendentious breed, whose homes are cluttered with objects they can't bear to part with. Not so Piér and Jo-Marie Rabe of Piér Rabe Antiques. Their Stellenbosch home is a study in the art of living with, rather than just displaying, antiques. Choice 18th-century Cape and modern European pieces, art and silver are in conversation with their spaces. 'No bland white noise. We wanted rooms that would wake people up, a restful minimalism with very alive focal points.' This is a house carefully thought through from the aesthetics to daily comfort. 'The house has two distinct personalities. By day the interiors are calm and restrained,' points out Jo-Marie. 'At night the house is sexy with a glow and drama you wouldn't believe.' Much of this metamorphosis has been achieved with sophisticated lighting. They collect pieces as a couple. 'Piér says he buys and I make sense of it,' elucidates Jo-Marie. They travel widely – antiques shows, exhibitions, fashion museums, from Vienna to London to Amsterdam, and are saturated with design and art. The choices may be iconoclastic but are intended as such. Collecting is a discipline – no rash impulses or indiscriminate stockpiling. 'We are what you might call purists,' says Jo-Marie. 'We collect Cape 18th- and early 19th-century furniture, especially rare and previously "unidentified" pieces, Italian glass from Murano (Seguso, Barovier and Toso, Venini and Dino Martens), early and mid-20th-century furniture by European designers like Eileen Gray, Charlotte Perriand, and Osvaldo Borsani and paintings by artists who lived and worked in South Africa – Christo Coetzee, Herman van Nazareth, Eric Laubscher.' This considered, pared-down look may appear a defining moment for a house such as this, but defined doesn't mean decided; canvases are propped rather than hung and Jo-Marie speaks of the 'provisional' quality of interiors – 'right for now'. The conversation has not yet concluded. The couple's seemingly resolved lifestyle lends itself to revision and after-thoughts along with the possibility of more irresistible buys.

Above: The sleek modern kitchen with Murano glass collection.

Opposite: The living area shows off some of the Rabes' chair collection.
The chandelier is 1950s Scandinavian stainless steel. Rorke's Drift ceramic
stands on the 1800s satinwood-and-stinkwood linen press on the right.
The propped art is by Herman van Nazareth. The cubist chair is a steel-
and-plywood Bauhaus in the original white. There are Christo Coetzee
artworks (1950s vignettes and futuristic Coetzee works).

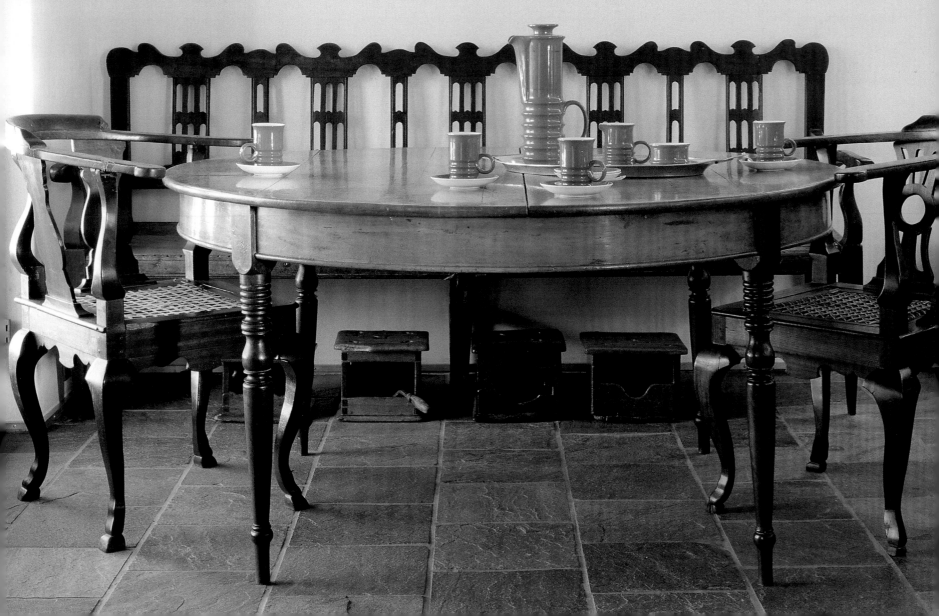

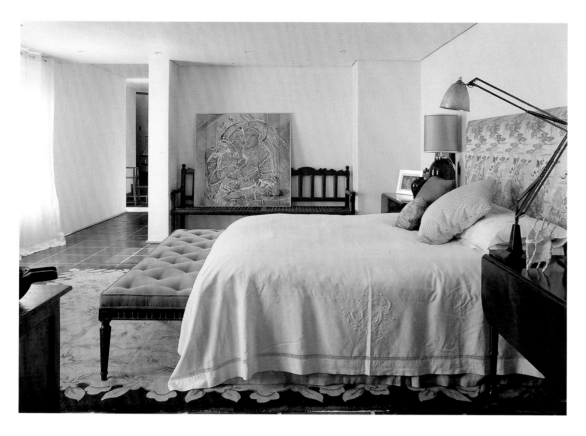

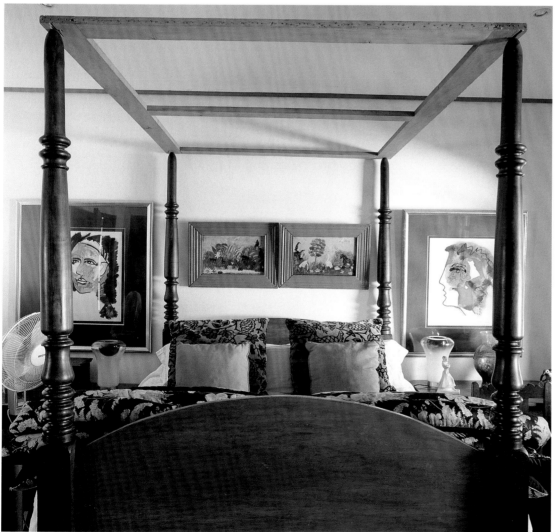

Opposite: Foyer area: on the wall Christo Coetzee's Butterfly with Glass Wings, *with its infinity symbol and protruding nails, looks down on an 1850s eight-seater yellowwood-and-stinkwood dining table found in Ladysmith, a late 18th-century stinkwood* riempiesbank *and Cape Queen Anne corner chairs. On the dining table is 1970s Carltonware.*

Above: In the main bedroom is Coetzee's The Pregnant Bride. *The carpet is 1920s French, the ottoman is a 1900s gallery bench and there is a Tulbagh* riempiesbank *at the back.*

Below: In a guest bedroom, is a mid-19th-century four-poster. Artworks are by Coetzee and possibly Mgudlandlu.

Illovo Penthouse
Johannesburg

Above: Geometrics feature strongly in the entrance foyer of the apartment, with the eclectic crooks of the walking sticks a whimsical contrast to the symmetry.

Opposite: Custom-designed railings curve up above the living area, leading to the bedrooms. The pillar is clad in pearlised wallpaper from Ralph Lauren with seating in cream and off-white custom-made for the space. In the background is the sleek and compact modern kitchen area.

Think 'penthouse' and you imagine a light, airy space, height and unparalleled views. You could be at sea. Add something of the streamlined sexiness of a custom-designed Italian yacht, a celebrity favourite for Mediterranean cruises. Then imagine a sea cruise aboard the *Normandie* in the 1930s; all that Art Deco razzle-dazzle. What in fact you're looking at is a contemporary 'Art Deco' interior with a New World edge, an Illovo penthouse big on style and wow-factor. Decorators Sharon and Shereen Fihrer of Johannesburg's Head Interiors worked in collaboration with the owner Ingrid Wingrove to come up with something that was smart and sassy, sexy and glamorous. 'We remodelled the existing interiors,' explains Wingrove. 'The area here is surprisingly tight – streamlined but narrow – and we were going for triple volume. The effect we wanted to convey was of being on board a liner, sipping Manhattans – decadent, but utterly 21st century. Glamour mattered absolutely: pearlised paints have been used throughout for a shot-silk look and we've used what I call "New World" fabrics which shimmer with a subdued glitter particularly at night. This lustre we offset with grey felt or velvet.' The parquet flooring is Tasmanian oak set in narrow strips to resemble decking. There were no interior doors, only large sliding panels in wenge wood. Nothing could interrupt a great open living area. For a space hollowed out this fully, the furniture had to be custom-designed to get the proportions correct. 'Think sleek,' urges Wingrove. 'Streamlined, gleaming and lit in unexpected places. One of my sources of inspiration was that fabulous bespoke line of Italian yachts from Azimut.' She prefers to call the balconies 'extensions' and remarks on the flow of pale decking that connects indoor and outer spaces. The metaphor of life aboard a yacht or cruise liner is sustained deftly but continuously: the ozone is never more than a deep breath away – and this on the Highveld. All the railings here were designed to ensure the sweep and generous curvature of on-board railing. There are gleaming 'porthole' mirrors above the luxuriously heavy vanity of mahogany and polyurethane in the bathroom. Above, on the terrace, the decked benches upholstered in pristine white leather, and propped up by a mast clad in aluminium, there soar great taut sail sheets rather than the more predictable awnings or umbrellas. Nautical has never taken on such playful conviction as aboard this Highveld penthouse.

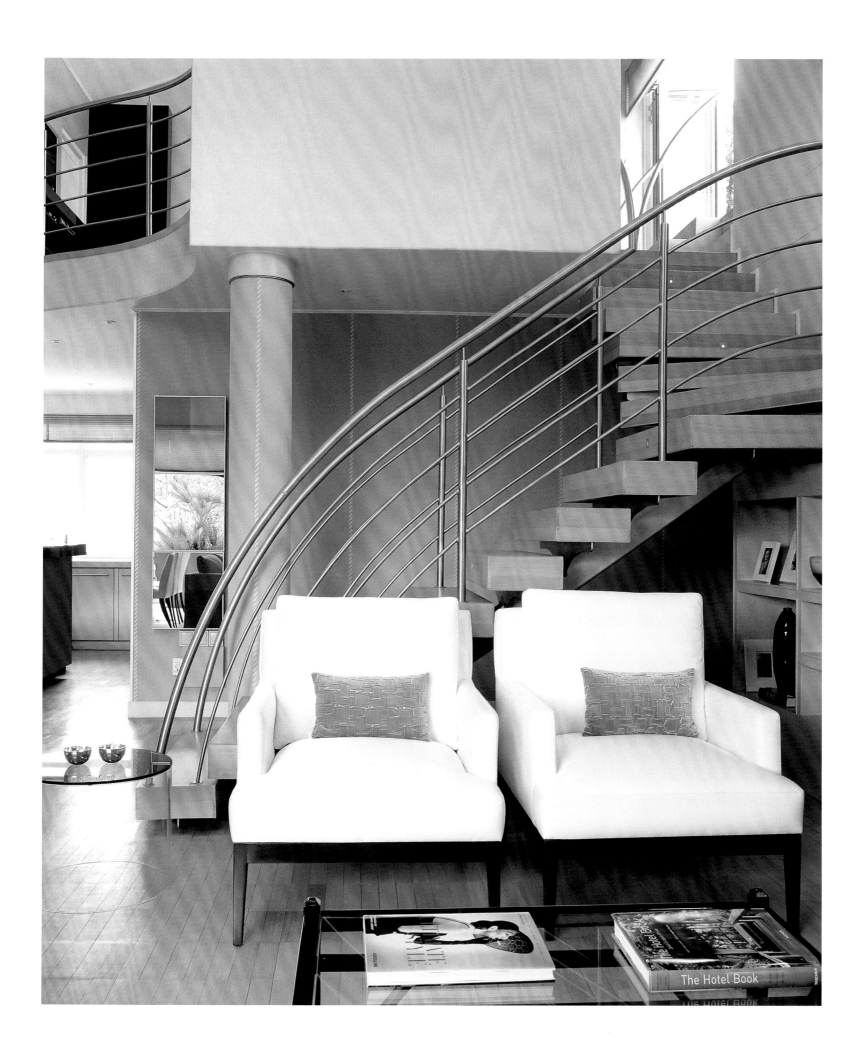

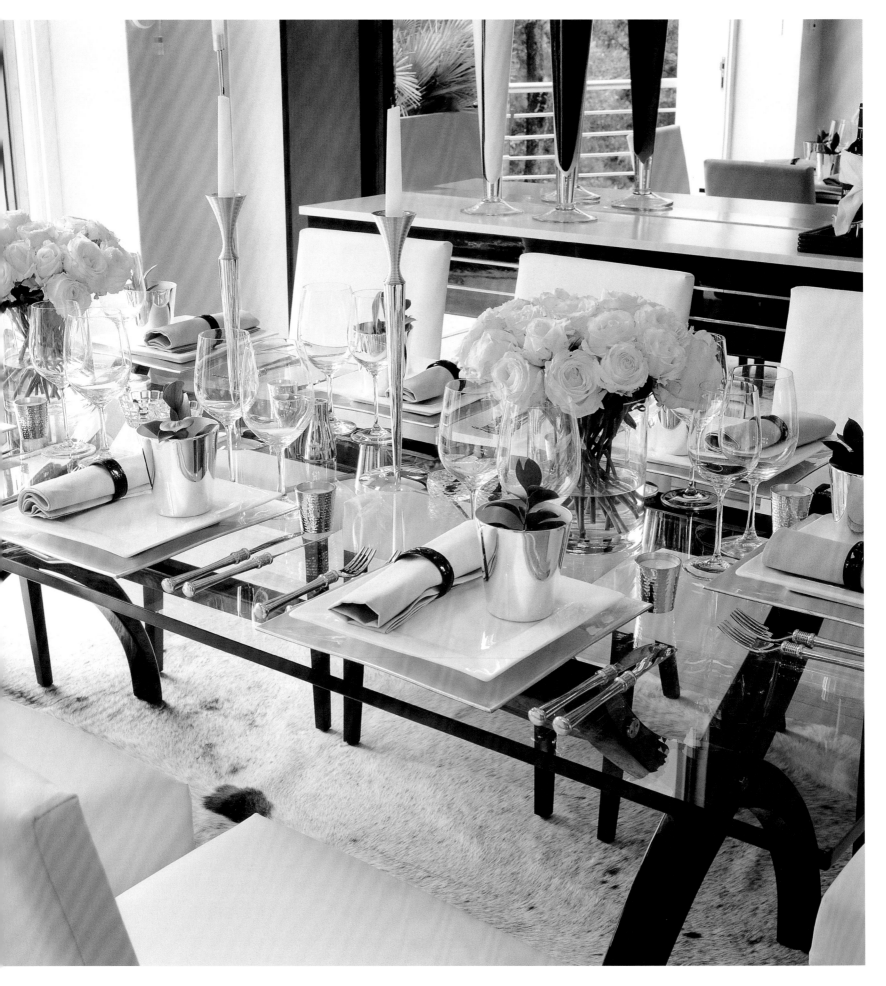

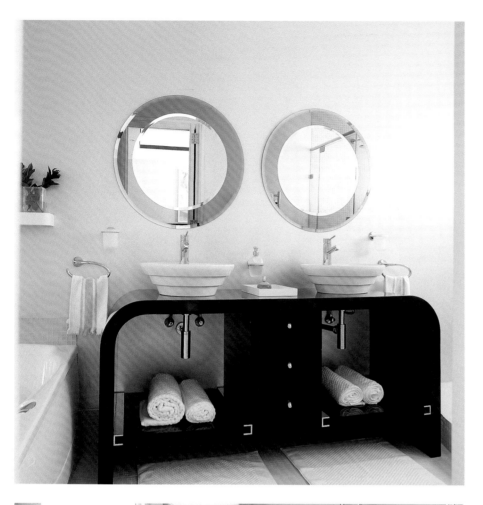

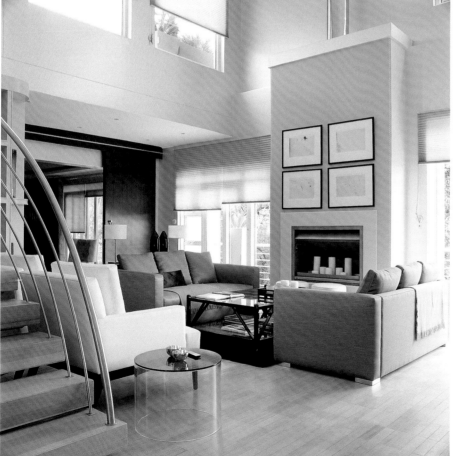

Opposite: Dining table with overscaled balloon glasses and accessories from Head Interiors.

Above: Nautical bathroom with 'porthole' mirrors above a heavy dark polyurethane and mahogany vanity picks up on the streamlined design.

Below: Triple-volume 'scooped-out' interior with barrel-vault ceiling and flooring in honey-tinted Tasmanian oak. All furniture was custom-designed by Head Interiors.

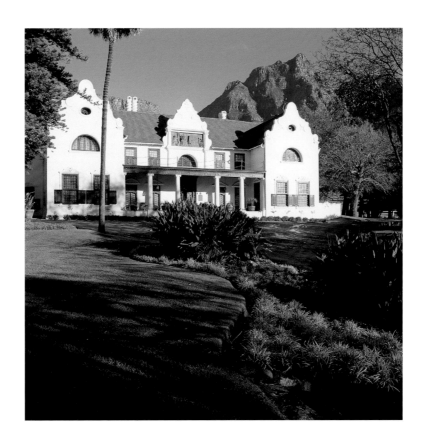

Groote Schuur
Rondebosch

Above: Dramatic location of Groote Schuur with Devil's Peak behind.

Opposite: The wooden corner posts on one of the staircases are carved in the form of the enigmatic soapstone eagles that were found at the Zimbabwe Ruins.

Page 34: The porticoed veranda with chequerboard tiling and chairs designed by Herbert Baker.

Page 35: The bathroom adjoining Rhodes's bedroom – the most masculine bathroom in South Africa. The vast bathtub was carved from a single piece of Paarl mountain granite, for which the floor had to be specially reinforced. Water spurts through the mouth of a brass lion.

Sir Herbert Baker's architectural legacy (seen elsewhere in this book in Noordhoek Manor and currently being rediscovered and newly appreciated in the Cape, Johannesburg and the Free State) is nowhere more magnificent than at Groote Schuur, the official residence of the prime minister of South Africa in the past, although the residence is unoccupied at present. As a young English Arts and Crafts devotee newly arrived in the Cape, Baker was commissioned by colonial entrepreneur Cecil John Rhodes to remodel Groote Schuur, Rhodes's newly bought private residence, formerly a large barn dating from 1657 named De Schuur, in prosaic and literal manner, because it had been the Dutch East India Company's granary. In 1900 Rhodes also sent Baker to Italy, Greece and Egypt to study the ruins and monuments as well as the classical styles of these countries in order to incorporate them into the imposing public buildings he wished to see erected in South Africa. Groote Schuur might well have ended up as yet another pastiche of Palladian-style or Doric temple, but was spared that to take on a singularly vernacular and original characteristic. Baker's intuition led him to design on a much more human and appealing scale on this project. He had received much of his early training during the period when William Morris and the exponents of the Arts and Crafts Movement were advocating the use of natural materials and traditional building methods. Herbert Baker incorporated local stone, thatch and timber and his version of the traditional Cape gable. Baker had already admired the Cape Dutch homesteads he saw all over the Boland and Cape Peninsula. These spacious and comfortable dwellings seemed to him ideal for a hot and windy climate and, in addition, he was sympathetic to the notion of a home-grown vernacular that had taken the best of Dutch architecture two centuries earlier and reworked it for local aspirations. The result was a truly South African vernacular drawing on Cape Dutch homesteads as well as the European reliance on polished teak and tall sash windows. Groote Schuur is one of a kind and exceptional enough to be appreciated beyond all negative associations with the apartheid government. Pay a visit and take in the stateliness and clean lines despite a confection of ornate gables, colonnaded verandas and barley-sugar chimneys.

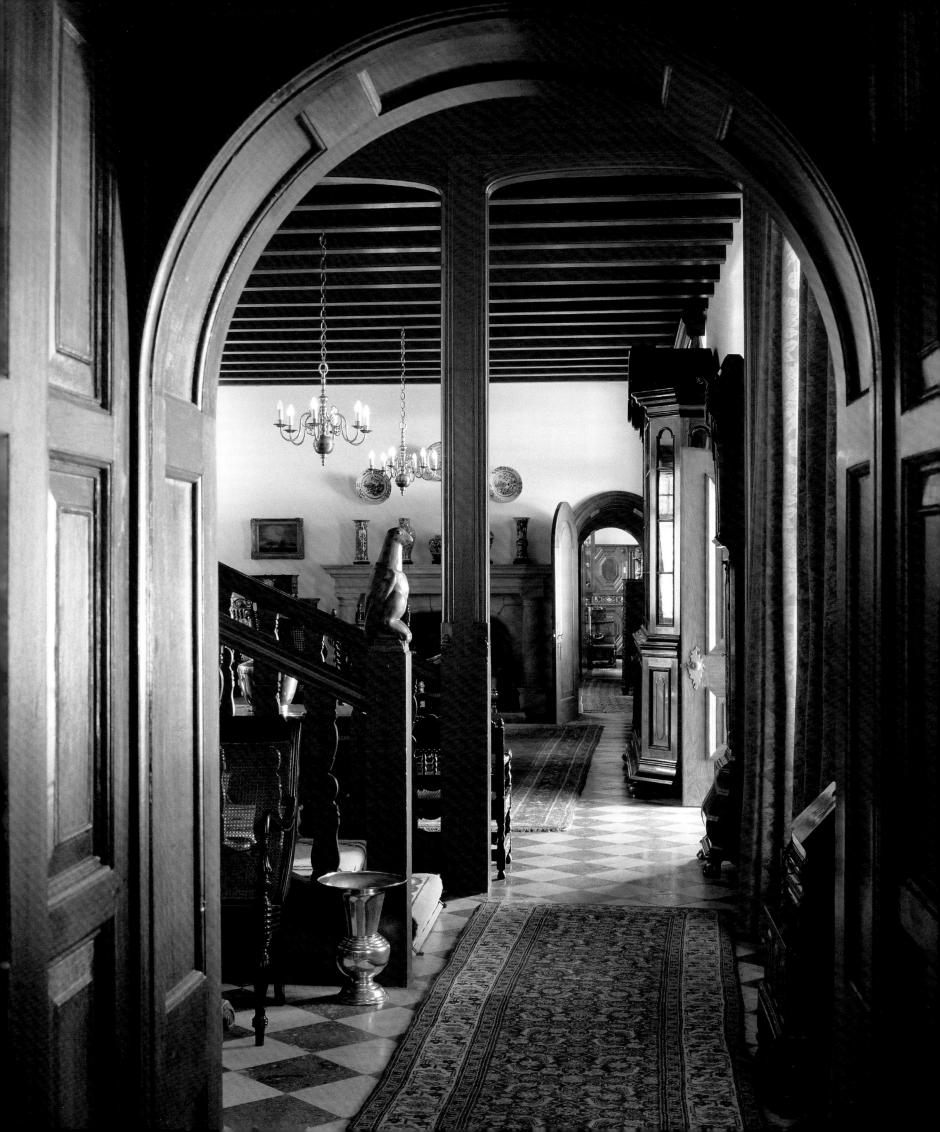

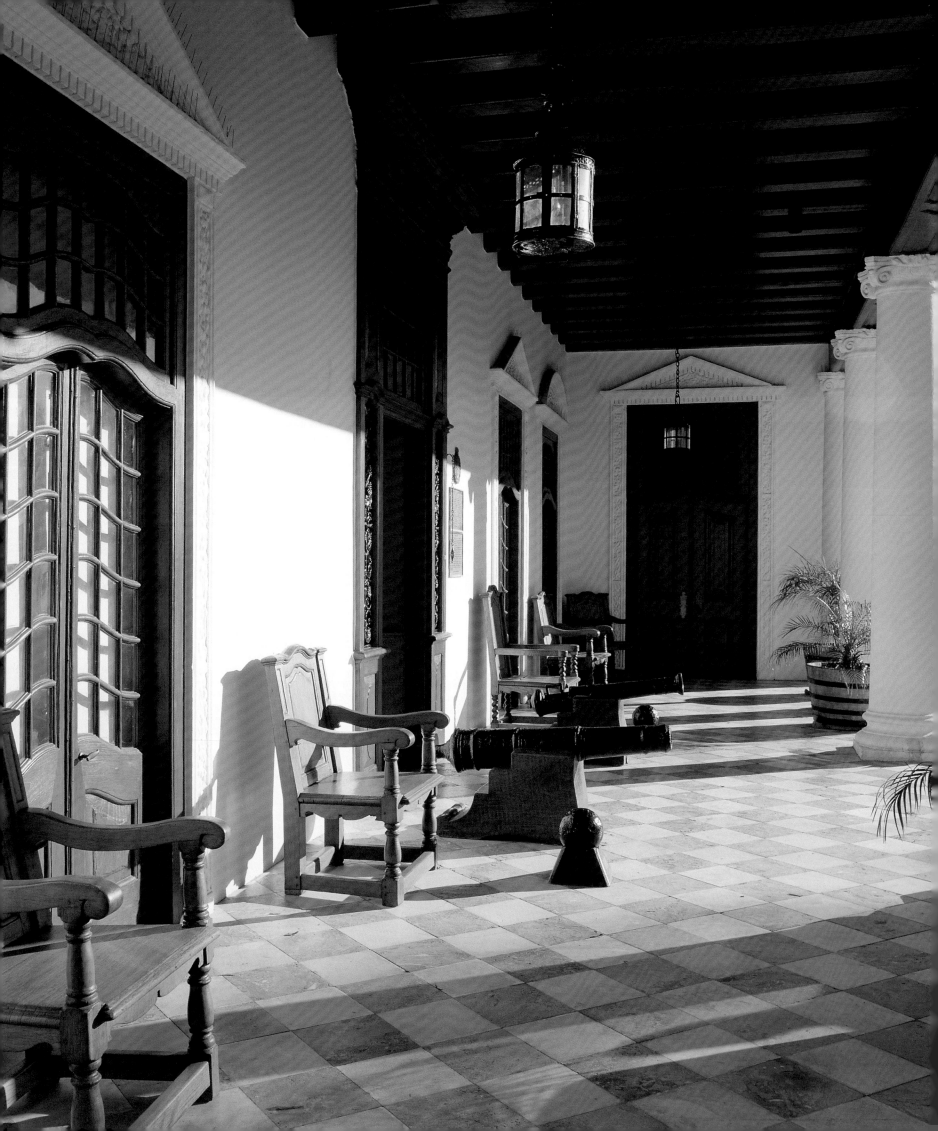

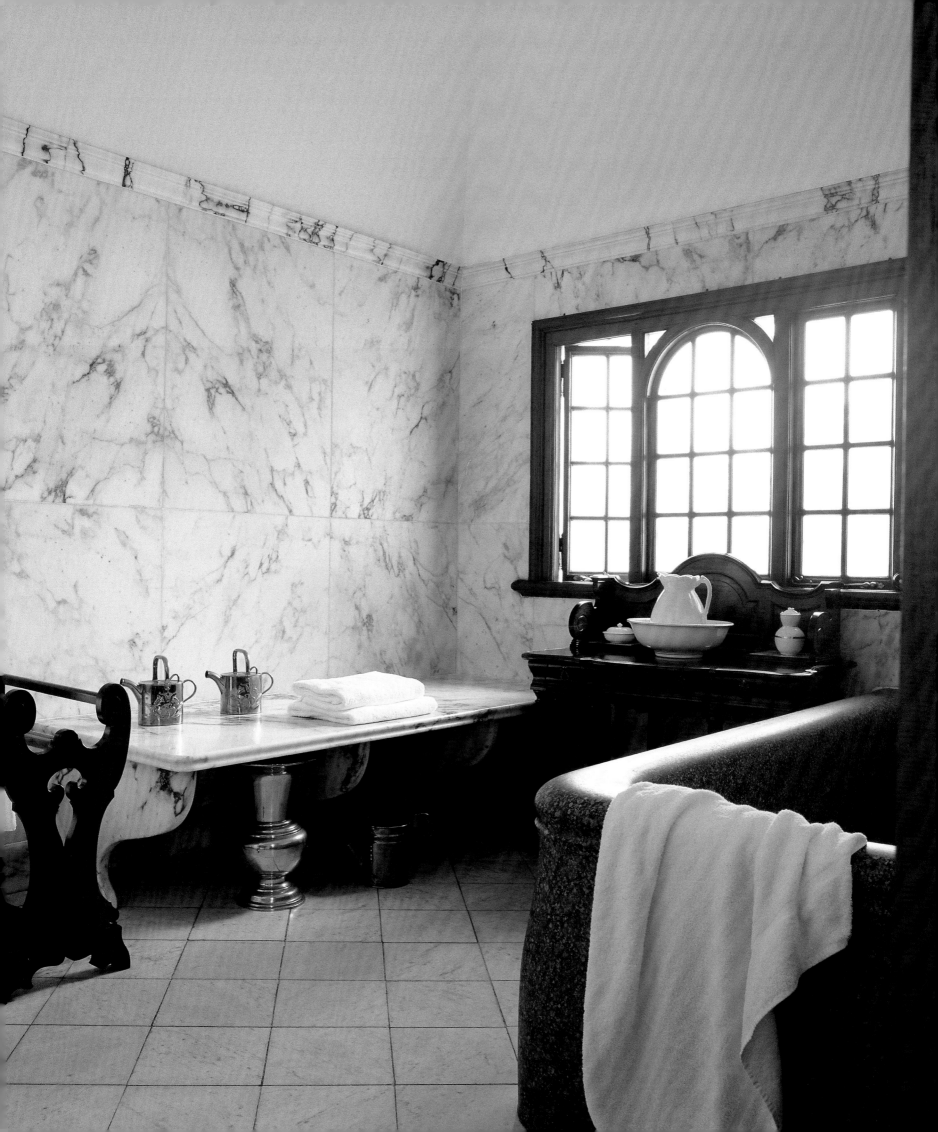

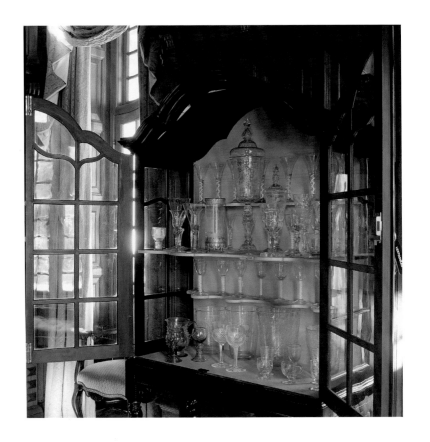

Left: Glass-fronted cabinet with antique glassware collection.

Below: Rhodes' collection of porcelain and furniture has recently undergone restoration.

Opposite: Entrance hall with signature Baker archway.

Page 38: Drawing room in panelling and (later) chintz, brass and chinoiserie. The fireplace has Zimbabwe soapstone surrounds and a copper hood.

Page 39: The monumental kitchen is one of the best preserved rooms in the house.

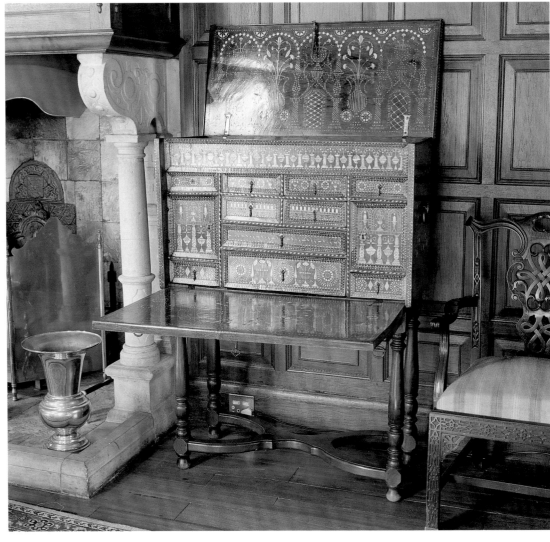

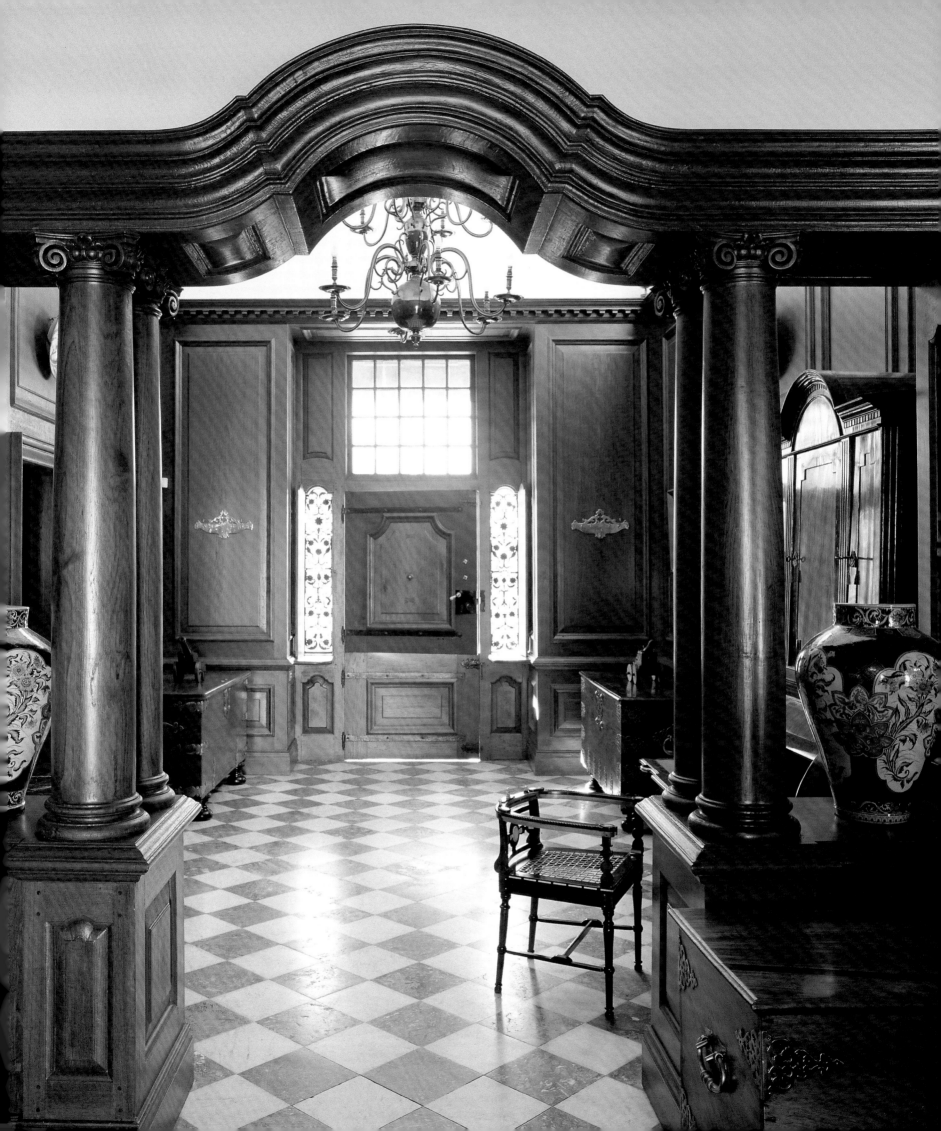

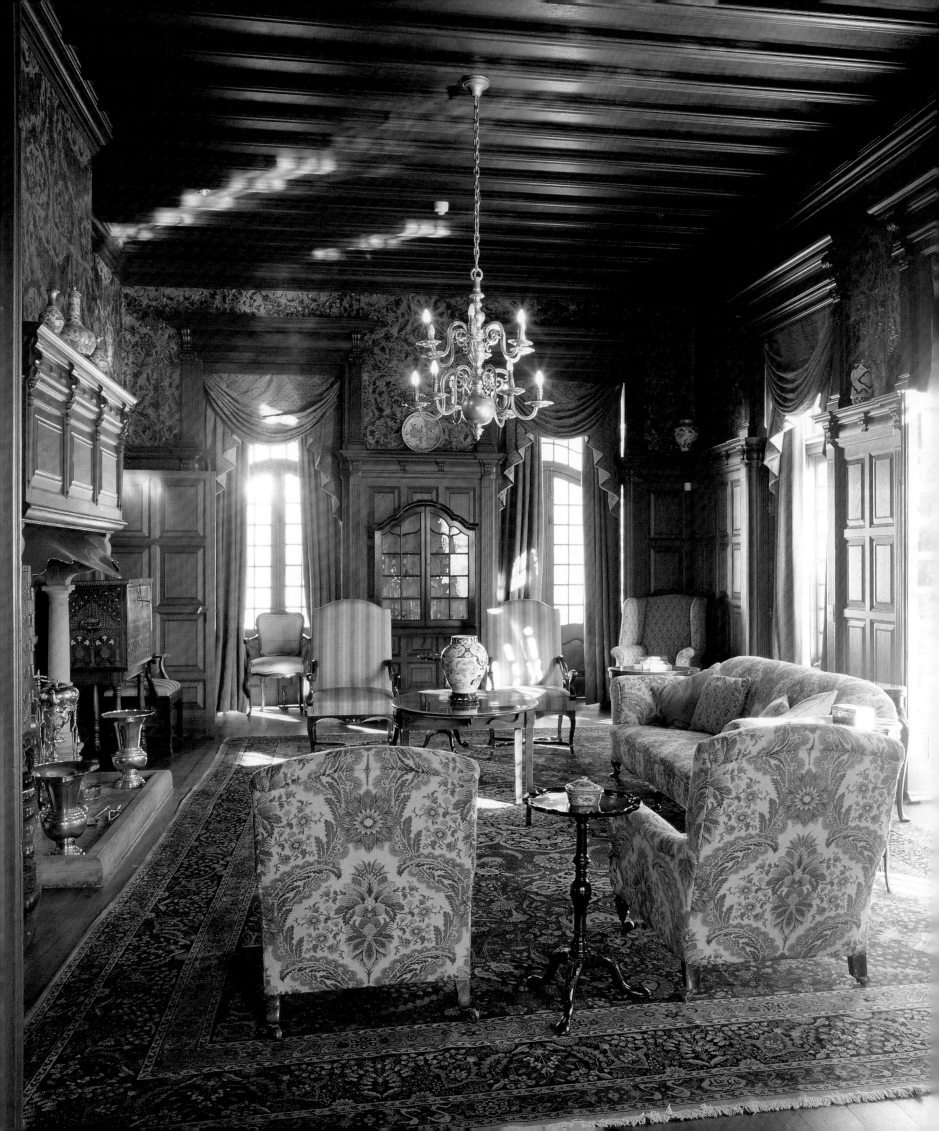

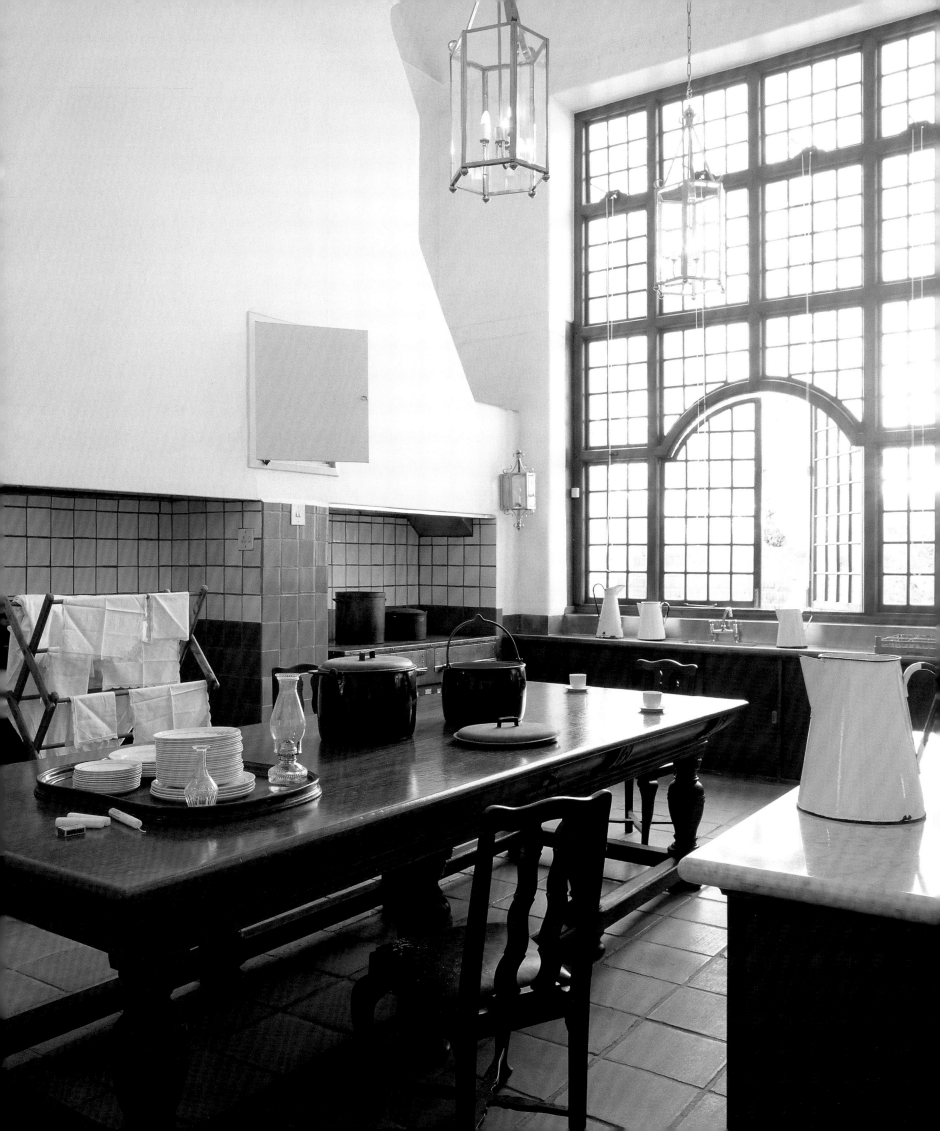

House Constantia
Cape

Above left: The drawing room is decorated in a Chinoiserie style.

Above right: Dining room with silver and blue and white china from Hans Niehaus.

Opposite: Luxury of space: the gazebo is an 'eye-catcher', dwarfed by luxurious trees and shrubs.

Page 42: The guest bathroom is rendered even more magnificent with trompe l'oeil decoration.

Page 43: A masculine feel gives this bathroom the look of a gentleman's club.

'I went to a boarding school in Florence,' says the North Italian owner of this ebullient Cape Town home. 'My dormitory was known as the Chinese room because of the 18th-century panelled walls. When you grow up in Milan or Florence you can't help but absorb a great variety of influences.' The owner and her architect husband were already living in Bishopscourt when they decided to look around for a small piece of land for a vineyard. They heard about a property in Constantia where the house had been built by a banker in the early 1950s when much of this area was still forested and undeveloped. Says the owner, 'We were enchanted but both house and garden needed work. Did we want to undertake such a project? Yes. We decided to spend eight months of the year in the Cape rather than in our homes in Milan and Sardinia'. Not many structural changes were needed; walls were removed to open the place up, doors were enlarged and bay windows created. 'What impresses me about South Africa is the incredible space – everyone should take advantage of that.' They brought their furniture from Italy: 'It helped that we knew the house and could match our pieces for size in various rooms.' Under the carpets they found Rhodesian teak which was sanded and polished and the exterior was painted a light pink: 'I had the Mount Nelson and Noordhoek Manor in mind.' Mouldings were redone, rooms repainted, cupboards were panelled, accent walls papered, finishes resolved. The decorating was done by the owners themselves. 'I have always had a good eye for combining pieces and knowing what works together,' says the owner. The effect is integrated but eclectic. She sourced through Hans Niehaus, Burr & Muir as well as Sotheby's. This is lively, well-informed, conscious decorating at its best, drawing on a rich and wide range of influences: 'I am fond of many periods and have no qualms about mixing together Venetian or French styles, damasks with toiles or contemporary with antiques.' Her husband comes from Venice, herself from Milan and Florence – they have travelled widely and in the guest cottage are rooms themed as 'African' and 'Oriental'. The owner sought out interesting local furnishings: 'These sofas and chairs I found at Block & Chisel, along with the coffee table. I've never seen anything like that again there. It was a stroke of luck.' Of course it was nothing of the sort. The owner's remarkable eye would discern quality anywhere, picking out gold from dross in the most unlikely places.

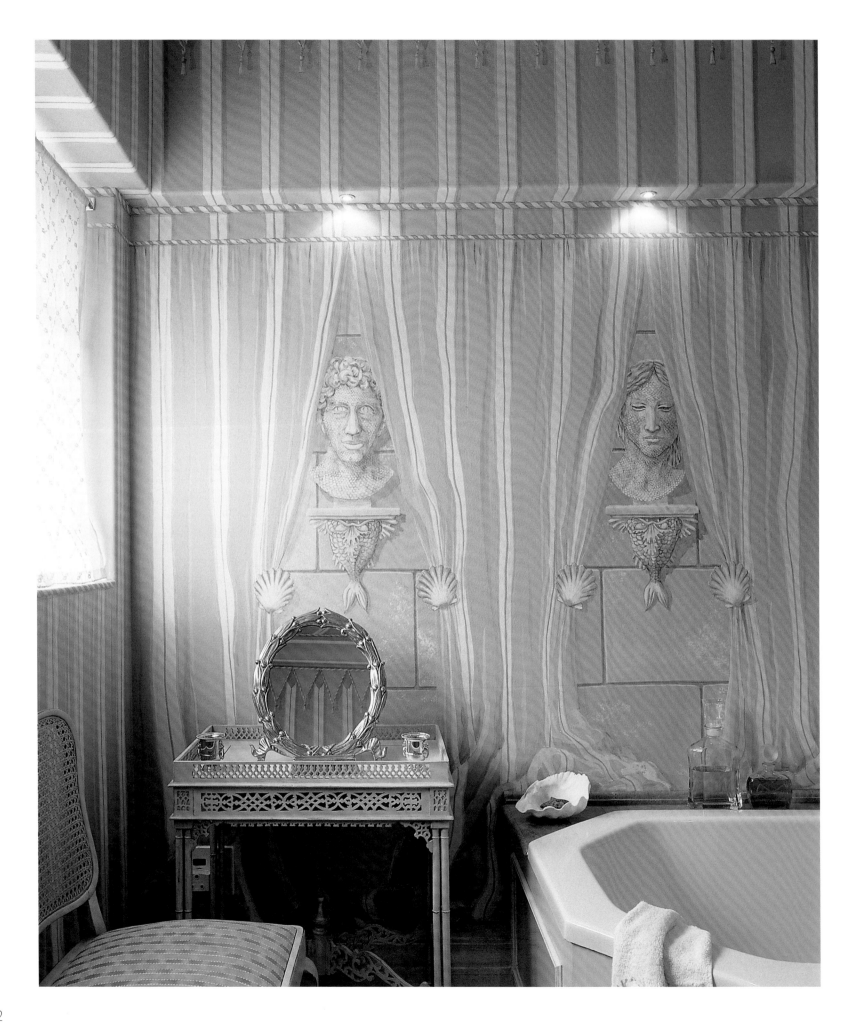

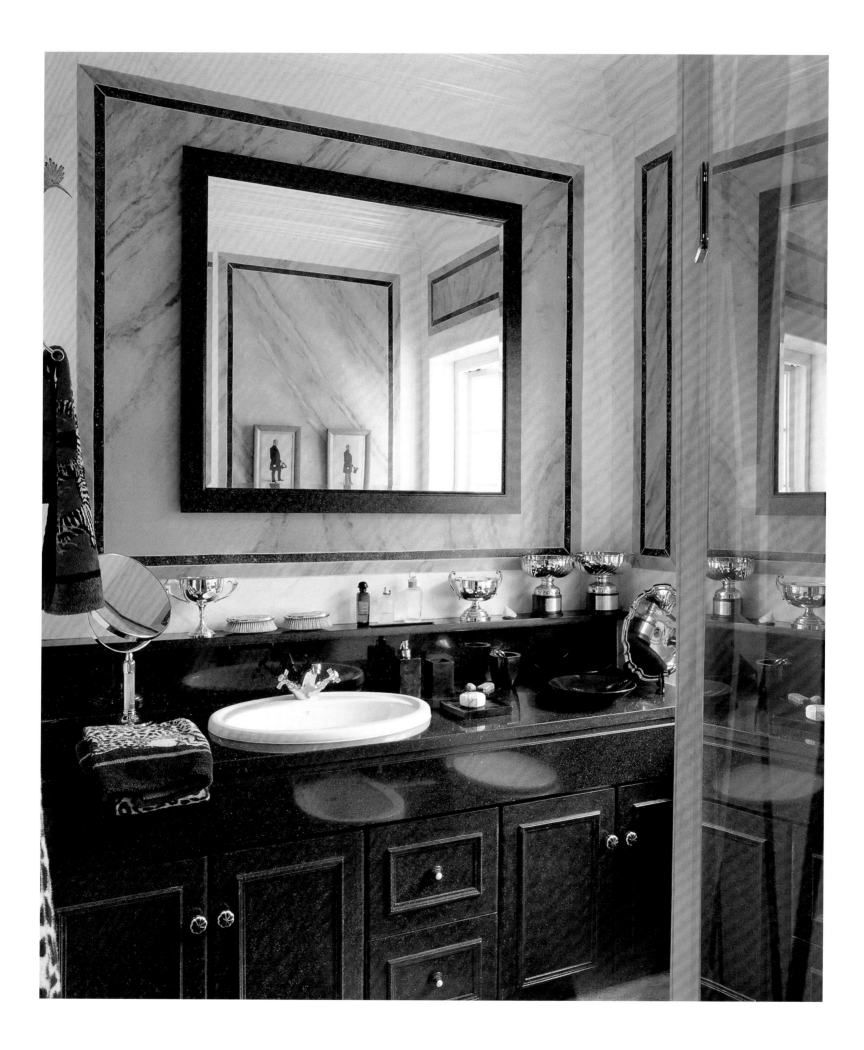

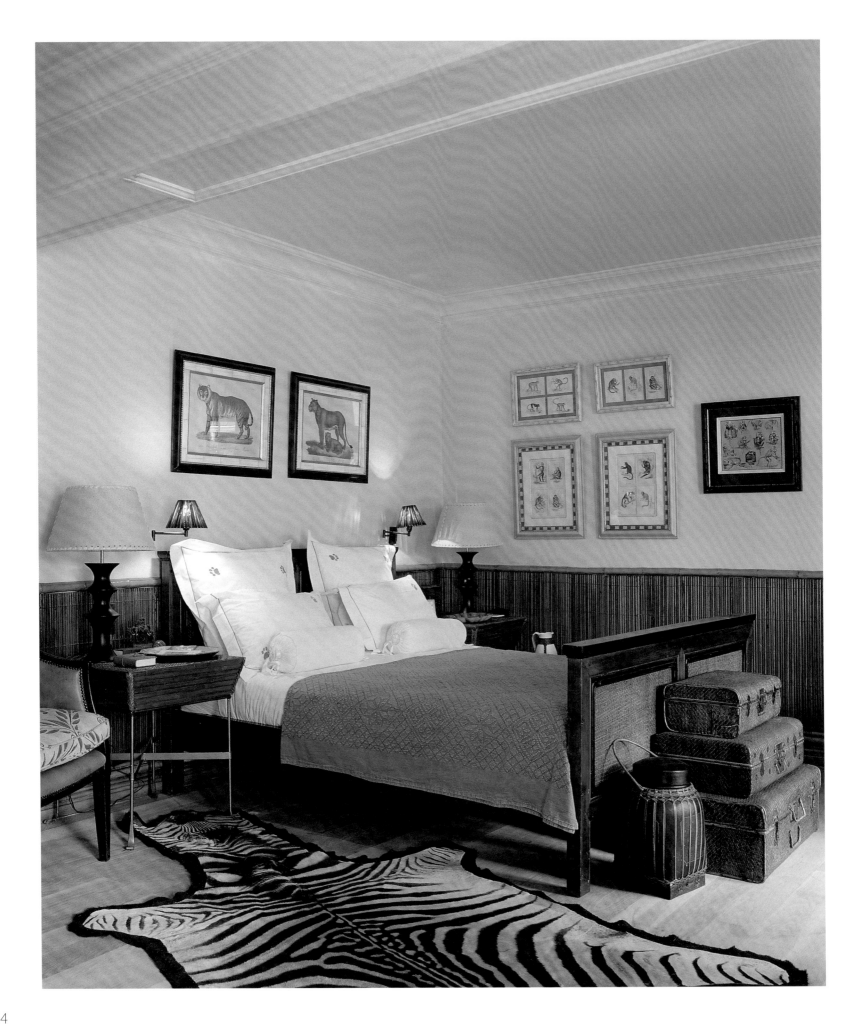

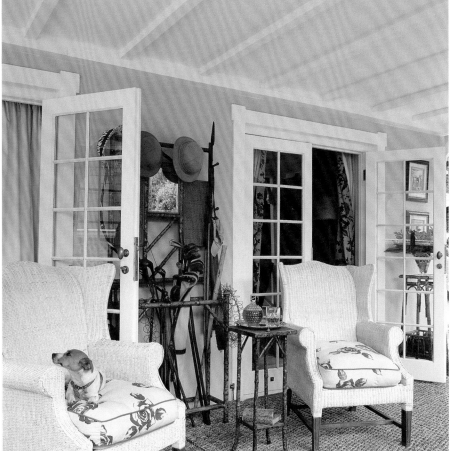

Opposite: Shades of colonial Africa at the guest cottage bedroom.

Above and below: On the stoep a collection of Cape country furniture and artefacts.

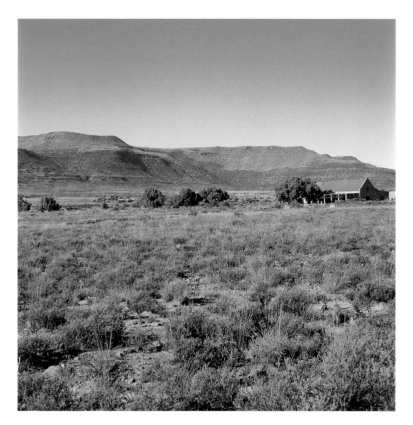

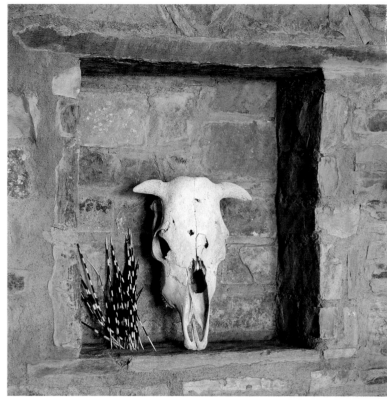

Steenhuis
Middelburg

Above left: The house marooned in pristine Karoo veld.

Above right: Georgia O'Keeffe-style bleached skull and porcupine quills.

Opposite: At one end of the sitting room a table is dotted with finds from the veld. The chairs are from Reinet Antiques in Graaff-Reinet. The old door propped against the wall comes from an outhouse.

Pages 48-49: The approach to Steenhuis: miles and miles of emptiness.

Steenhuis, in the Great Karoo, an hour or so from Graaff-Reinet, and very close (if not under) the Sneeuberg, belongs to Charlotte Daneel who, with her partner Derk Blaisse, has fulfilled a yearning to return to the places she knew and loved as a child. Old links with the Great Karoo around Graaff-Reinet begin with her father's family's connection to the preaching Murrays who made the place famous in the 19th century. Steenhuis, together with an adjacent property, Gordonville, is at the heart of an enormous, remote farm whose lands are being restored after years of desecration by sheep farming. Plains game is being brought back onto it and the old stone farm buildings dotted about are being restored. Life here, in the summer, is led on the stoep, around a stone table focused on the view. Equally, in the scorching heat, you might prefer to lie under the cooling blades of a whirring ceiling fan, or pad about barefoot on the cool stone floors with a glass of lovely iced water from a machine in the kitchen in hand. As they do in the Mediterranean, you close curtains and shutters mid-morning against the heat and open them again in the early evening. Everybody knows that; and it's not too much to ask, you might add, for comfort's sake. It gets very hot here. But wait for winter. It's a cocooning existence made even more comfortable by the (essential) inclusion of underfloor heating, thick, fluffy sheepskin rugs from a supplier in Middelburg and huge fires in a monumental fireplace built to receive them. Even the cement structure of the bed in a guestroom is centrally heated. How great is that? Who wants to be cold in the winter? No farmer hereabouts ever lived like this. This is lifestyle in the Great Karoo as opposed to a way of life on a remote farm at the heart of a great tract of emptiness, the weather the only regulator you might consider keeping an eye on. Inside, Steenhuis is big on texture and scale and, in a sense, evokes the massive boldness of its surroundings. There are big shapes, robust textures and simple finishes. Its furnishings have a basic elemental quality that indicate the owner's absolute affinity with the gravelly natural surroundings. Wood, glass, stone, pewter, ceramic, leather and wicker are the materials that give this house its character and tone. Anybody looking for appropriateness of context in a domestic South African interior should learn from this. It's a look that's absolutely now in this country and if you want more of it you'd better visit La Grange Gallerie, the owner's shop in Franschhoek.

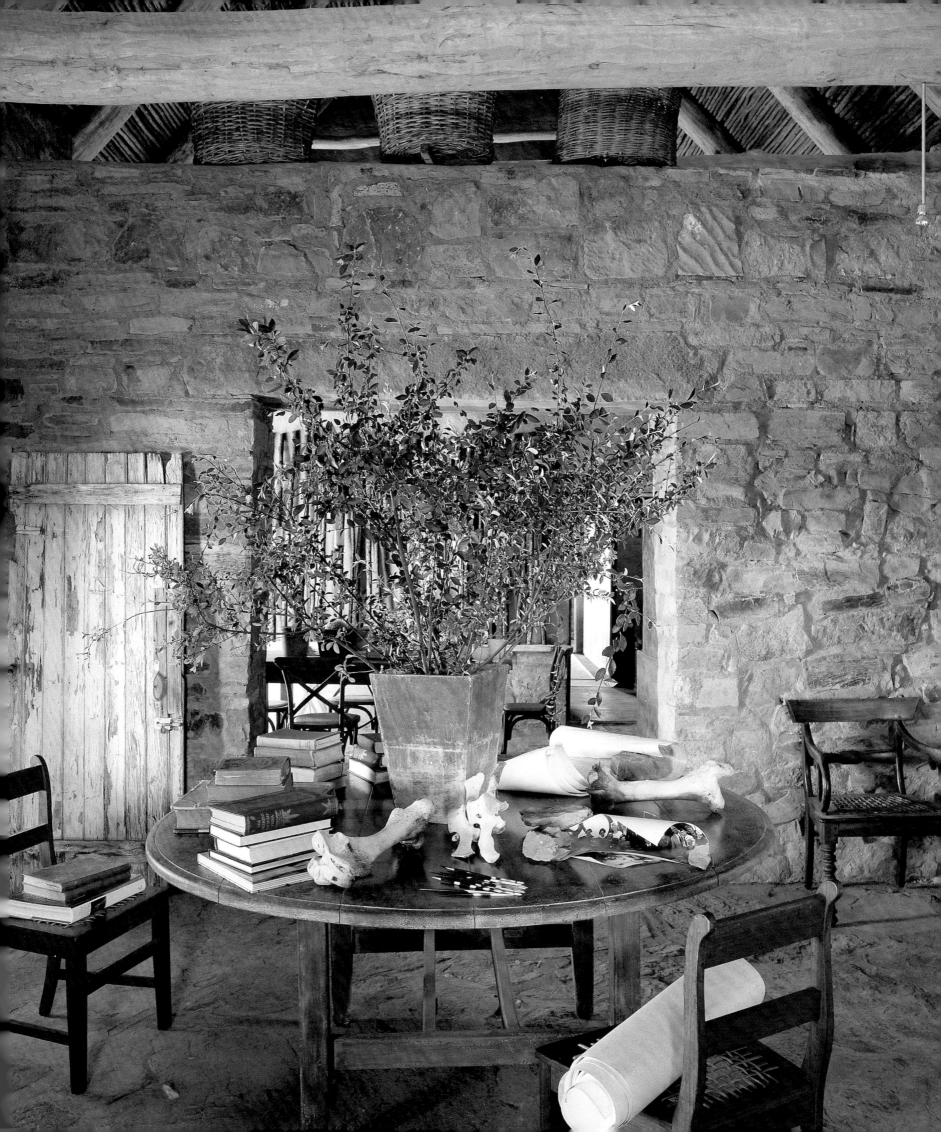

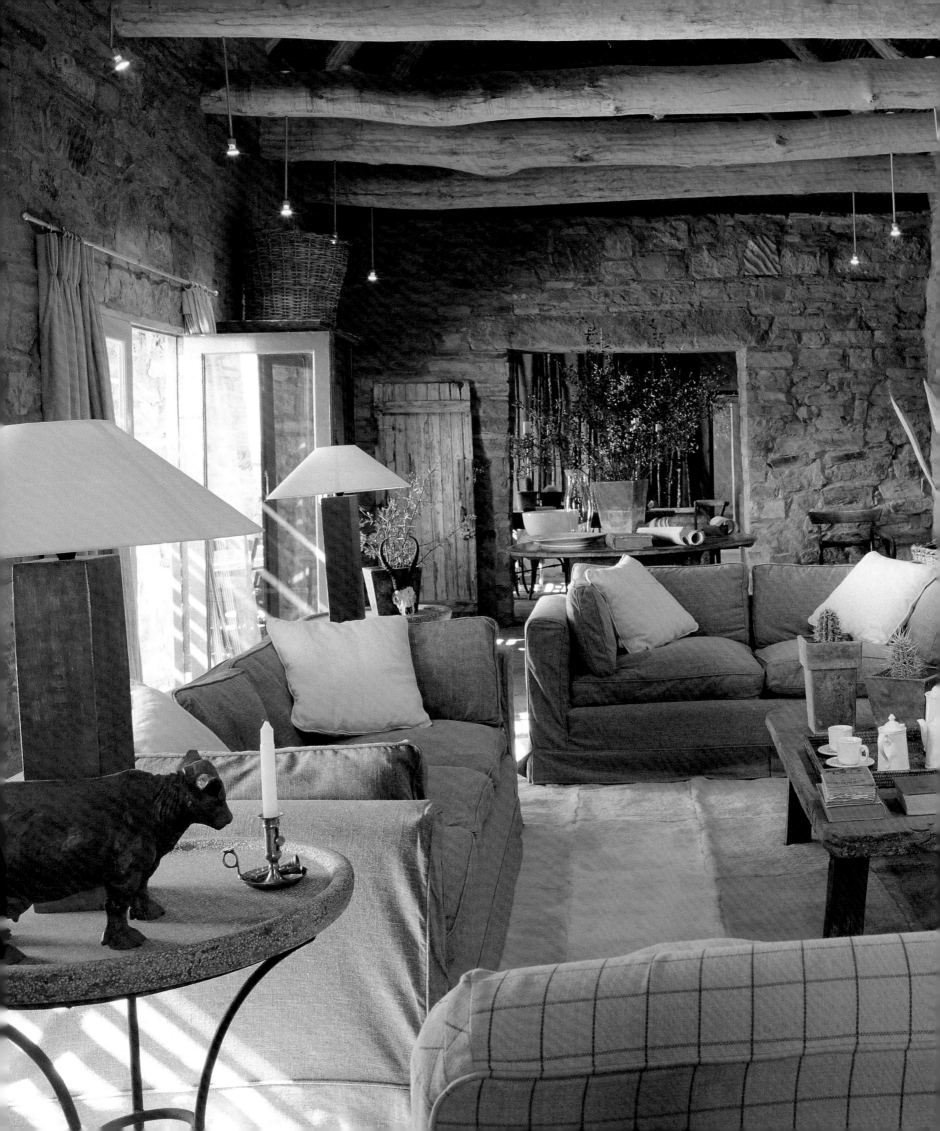

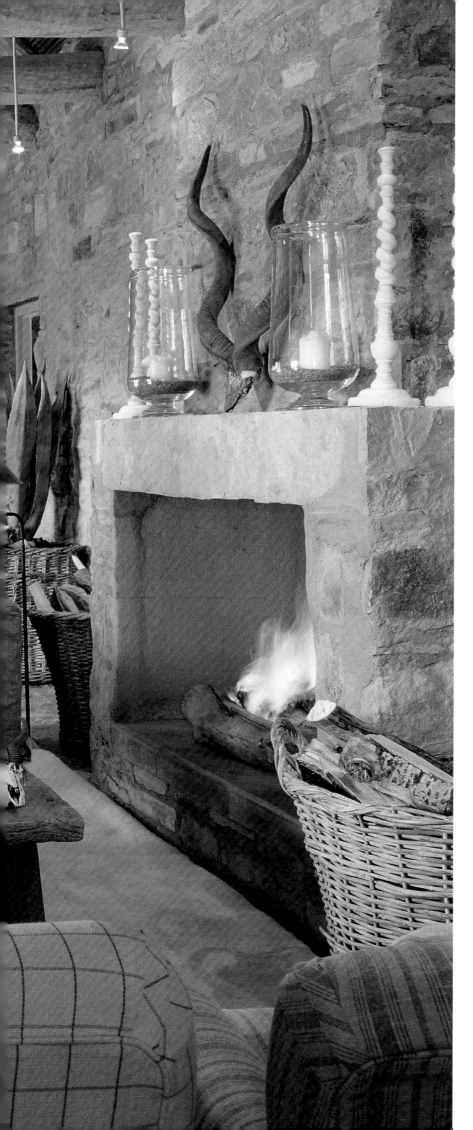

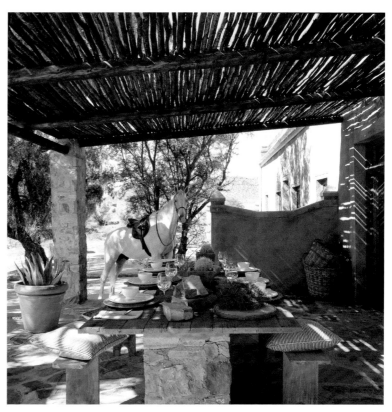

*Left: Sitting room: Building materials were collected
on the farm – stone to supplement the original
stone walls and floors and poplar trees for beams.
Several three-metre stone posts found lying around
were used as lintels above the opening between
the kitchen and living area, and the fireplace. The
sheepskin rug was dyed and made up by Engela
Kruger in Middelburg. Old sheep shearing baskets
are for firewood and agaves from the farm. All the
colours bring the veld indoors.*

*Above and next page: The terrace has an endless view
over the Karoo veld and the Renosterberg. Sleepers
cut in half were used to make up the table top for a
base built of stone.*

*Page 53: In the dining room old fencing posts are
propped against the back wall.*

*Page 54: The foreman's horse pokes its head into
the principal bedroom in which the bed (page 55) is
positioned to take in the view. .*

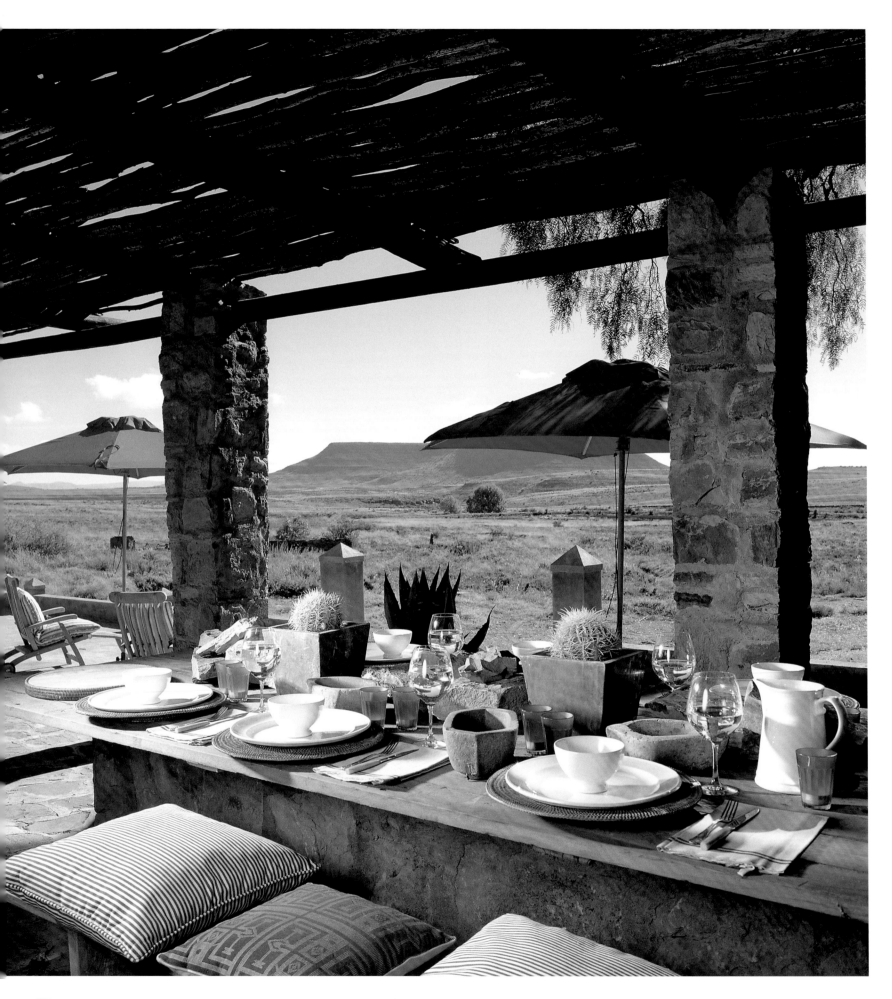

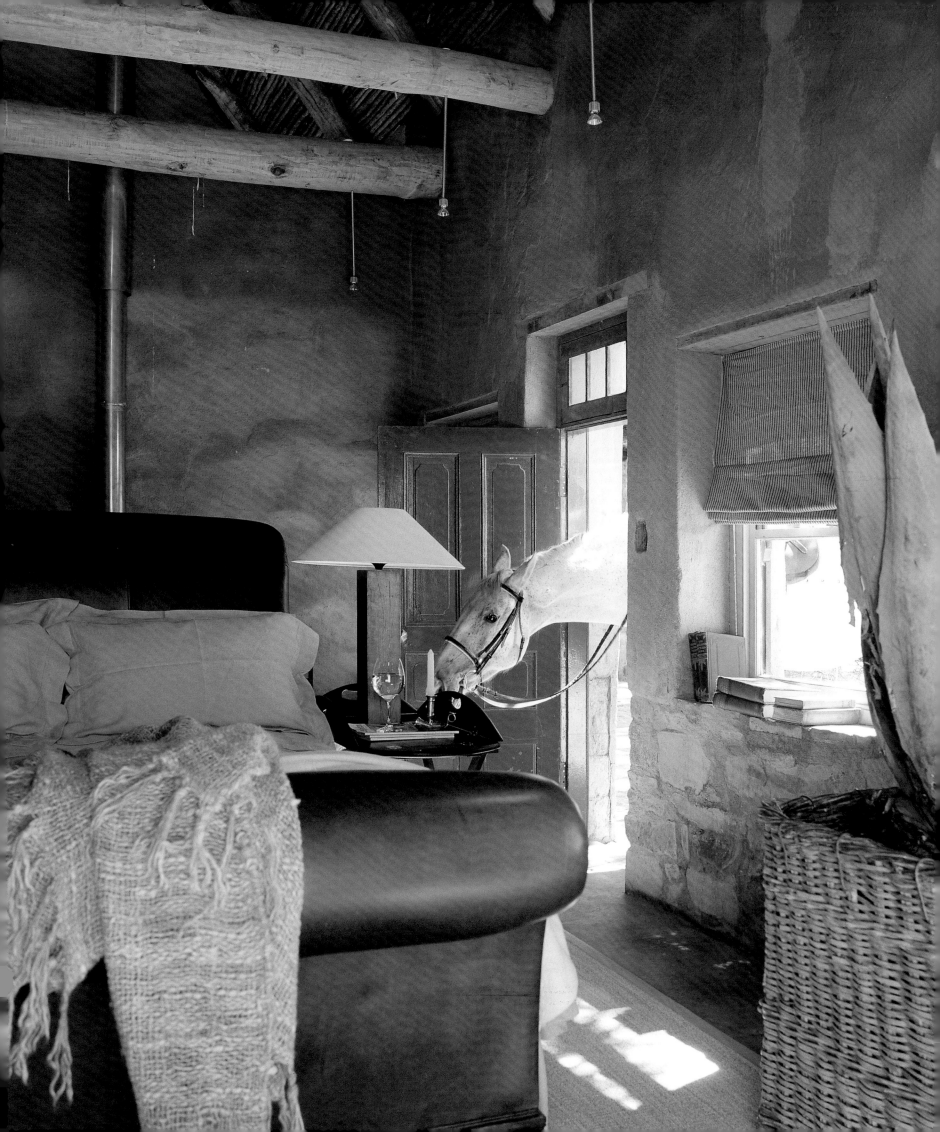

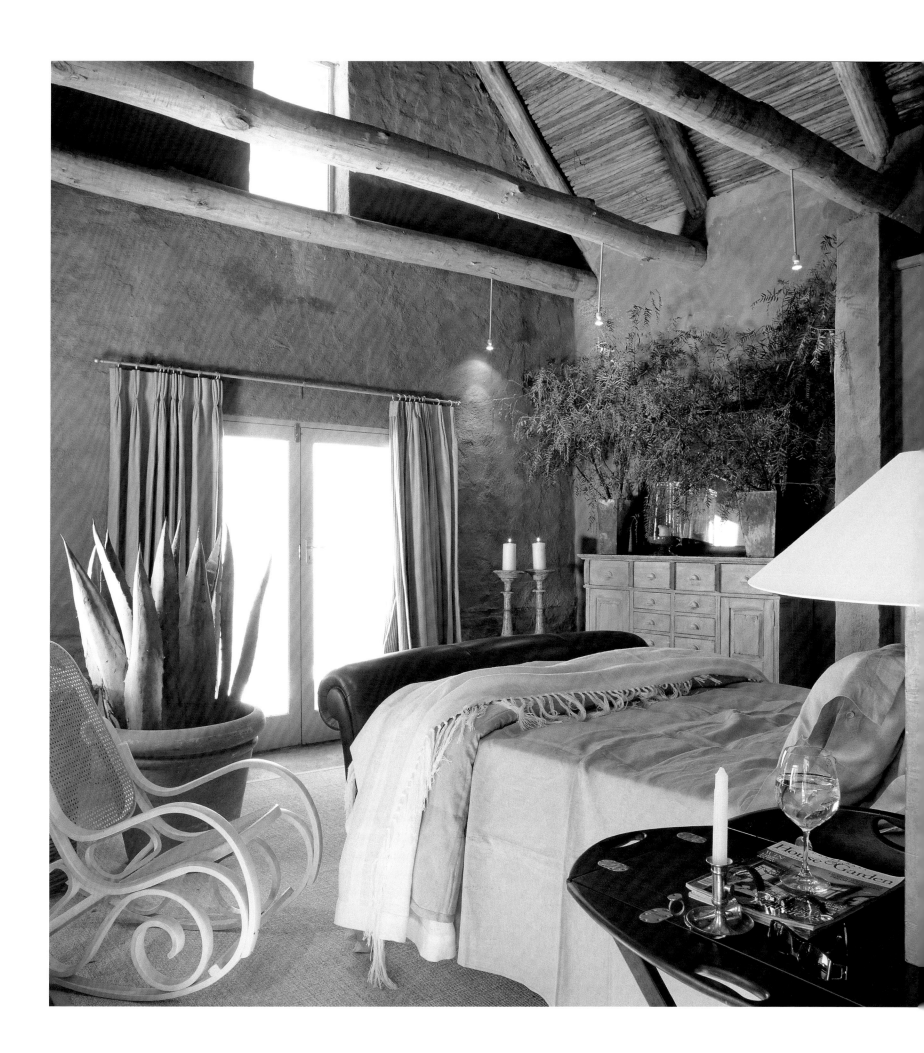

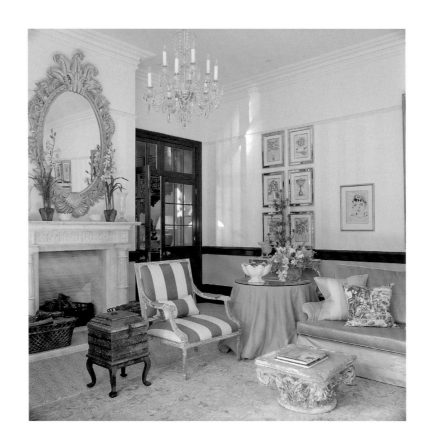

House Mostert
Cape Town

Above: This corner of the drawing room highlights the eclectic mix of finishings and décor.

Opposite: The family room has the best sun and exudes warmth with rich tones, bleached oak, gabled cabinets, an Aubusson-covered ottoman, a rusty tin chandelier and a wrap-around hand-painted tree-of-life mural by Louise Hennings cross-hatched to convey the feel of a faded tapestry cartouche

Page 58: The traditional hallway has aged ochre walls and chequerboard floors in charcoal, pale grey and tan marble.

Page 59: The entrance façade: sunny Cape Town or windswept English moor?

Facing the formidable, vertiginous Fernwood buttress on the eastern flank of Table Mountain, this ivy-covered, grey stone mansion looks like a country manor, and seems to have been plucked from the rolling shires of England and set down in a leafy Cape Town suburb. 'The owners had a surprisingly strong vision of a house that would be a family seat for generations,' explains designer Boyd Ferguson who has seen this house through a decade of design, from the first sketches to its current maturity. Ten years of building and layering allowed the owners as well as the greenery to grow into it, creating a lived-in look key to English landed pastoral charm. 'Their patience in taking time over things was very unusual,' Ferguson continues. 'The sandstone fireplace in the study, for example, took one year to carve. The client pushed us, in a country where this standard of excellence is uncommon, to look for the best carvers, painters, builders and masons. At that stage I hand-drew all the architectural detailing – it truly was bespoke.' The house's construction was overseen by Ferguson in collaboration with architects Bruce Stafford and Stephen Mayers. Historic references guided choice of materials and details, from the grey stone façade to slate roof tiles and the colonnaded entrance portico flanked by a pair of bay windows. The floor plan is symmetrical, with a large, double-height hall and wrap-around gallery at its centre. A most striking feature is the sheer spatial indulgence. Even the kitchen is vast, with its many back-up utility areas – the pantries, larders and sculleries. Diana Vives comments: 'You imagine entire ballets of uniformed domesticity happening below stairs', yet in concession to a contemporary lifestyle, the family of four prefers eating in the adjoining breakfast room rather than at the formal sixteen-seater dining table. 'All the intricate detailing is left to decoration, lighting and surface treatment,' explains Ferguson. 'A mix of English and French furniture, with the glint of brass introducing a Flemish accent, creates a worldly ensemble.' This look may seem unexpected from Boyd Ferguson, widely associated with the contemporary southern African look of Singita Lebombo and it's sister camp, Tsweni. 'It's more period-perfect than most things I do,' he concedes. 'I've become experimental over time but my training was classical. There's no right or wrong for good design – it's about the client's life stage, the intended use for the space, the desire for permanence or transience, and the site's guidelines.'

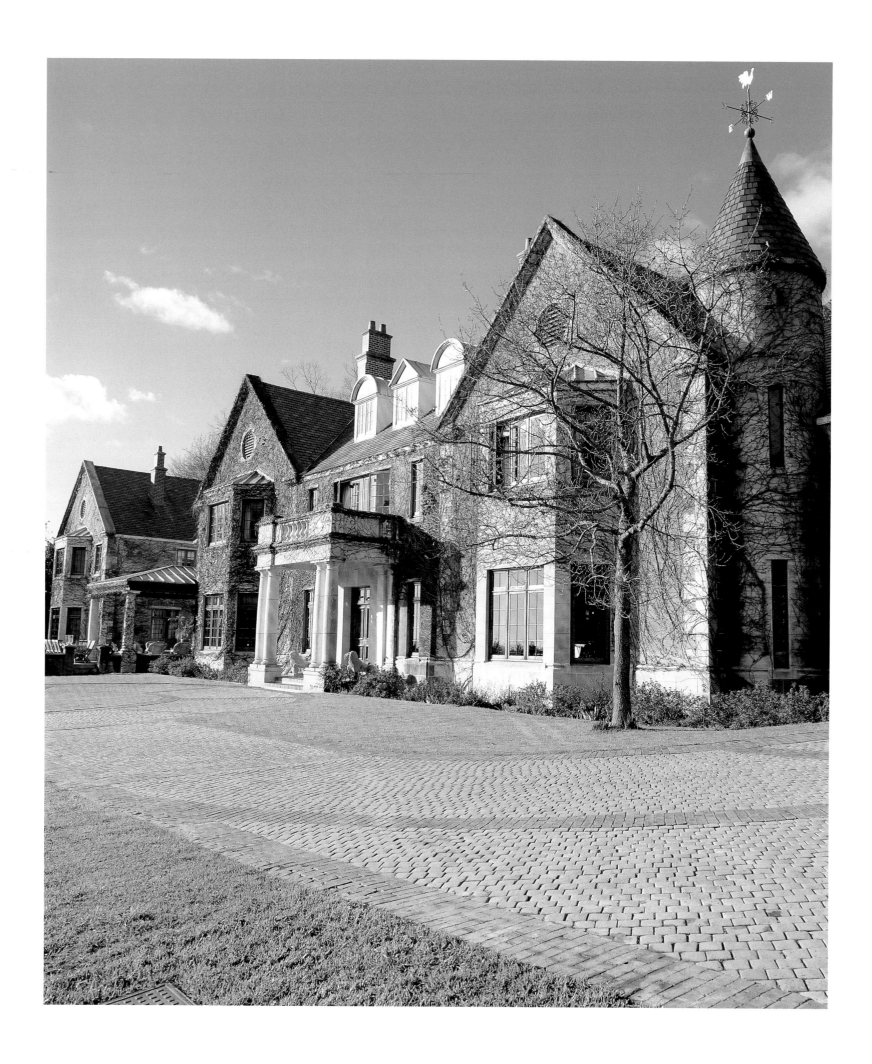

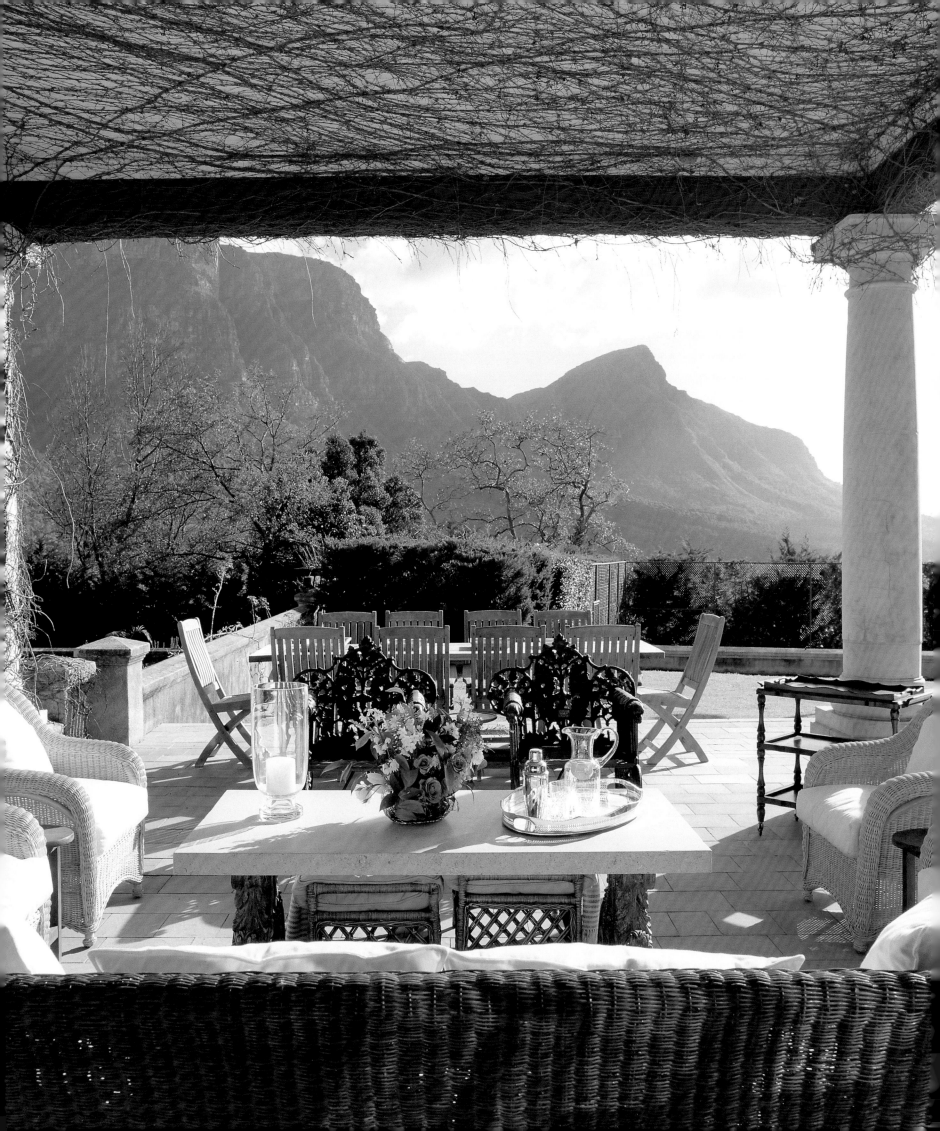

Opposite: One of the finest views of the peaks flanking Table Mountain.

Above: The breakfast room.

Below: The luxury of the dressing room which masquerades as a salon.

Stellenberg
Cape Peninsula

The estate of Stellenberg in the Cape is a remarkable architectural remnant. It lies in secluded splendour under ancient oaks and is surrounded by a celebrated garden designed by the owner's wife with, in part, the help of David Hicks who was responsible for the walled garden. The estate dates back to Simon van der Stel and in the early 18th century it was bought by a former slave woman Christina van Canarie. Another 18th-century owner was Cape governor Rhenius under whose ownership Thibault may have worked on the patrician proportions of the façade and the segmentally pedimented gable. Five great avenues of oaks once converged on the front entrance at the height of its 18th-century splendour. During this period of relative calm at the Cape, further embellishments were made, and Anton Anreith may have been involved, in particular in creating the bas-relief that fills the gable pediment. In the 19th century Stellenberg was spared the ravages of Victorian fashion and the only additions were attractive Gothic vents, a barley-stick chimney and venetians. Similarly, during the 20th century, it escaped the awkward or insensitive renovations that wrecked many Cape Dutch homesteads. Stellenberg remains elegant and its beauty, proportions and finishes are unparalleled among homes of a similar vintage. The front façade retains its segmental-topped gable and pediment filled in low relief. The impressive and slightly austere *voorkamer* is paved with oxblood Batavian tiles; between this entrance and the *gandereij* there is a glazed Cape Dutch *porte de viste*, a carved four-leaf teak screen unique to this period. The interiors, a skilful combination of historical Cape Dutch and French country furniture together with fresh, up-to-date fabrics, successfully meet the challenge of living with history. The owners wanted to 'let in the Cape sunshine' and decided that the décor of the interiors should reflect the layered and varied influences of the Cape – Dutch, French and English who had each played a role in shaping the Cape culturally – and so they brought in historical architect and interior designer Graham Viney to help. The look evolved over a number of years (as did the gardens) with antiques being collected to supplement those already there, notably the 1750s cabinet which once belonged to Governor Swellengrebel and is exactly contemporaneous to the era in which Stellenberg was built.

Above: The front terrace garden in summer.

Opposite: Looking towards the Welsh dresser through the porte de viste.

Pages 64-65: The front gabled façade of Stellenberg.

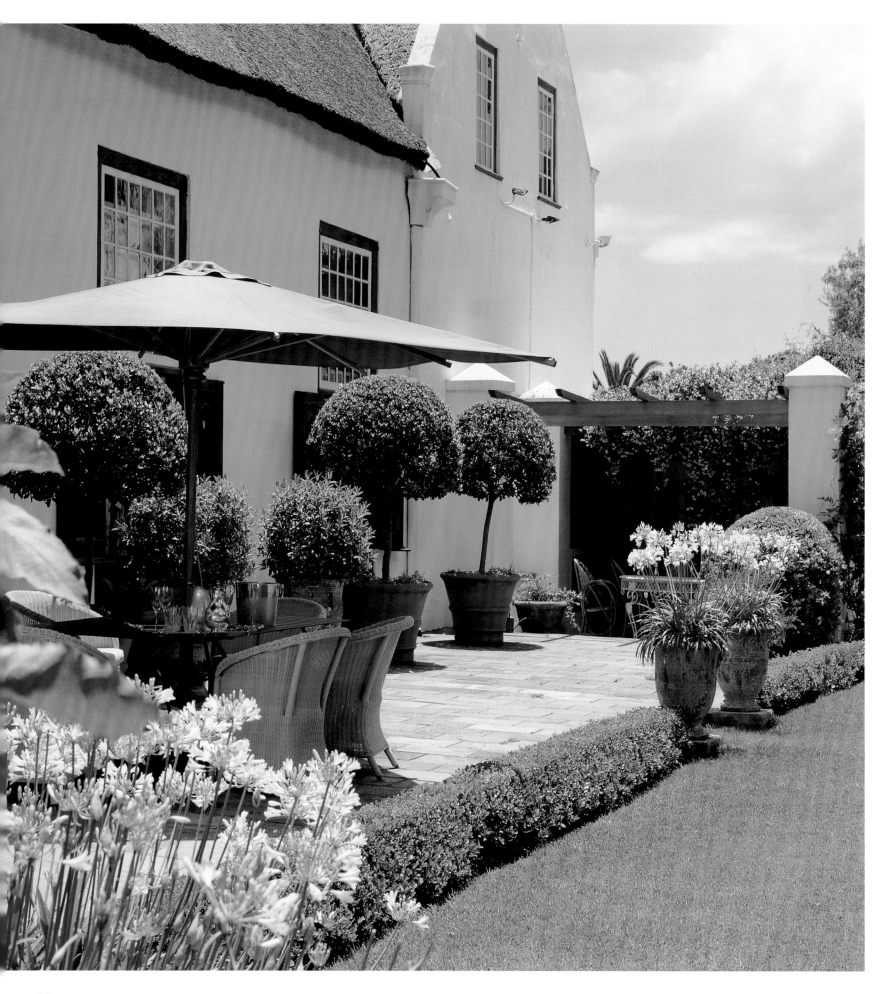

Page 66: Front terrace garden in white and green.

Page 67: The breakfast room.

Above right: Amboyna armoire in the entrance hall.

Right: 1750s bureau cabinet, once the property of Governor Swellengrebel.

Opposite: The drawing room with arch modelled on that in Newlands House.

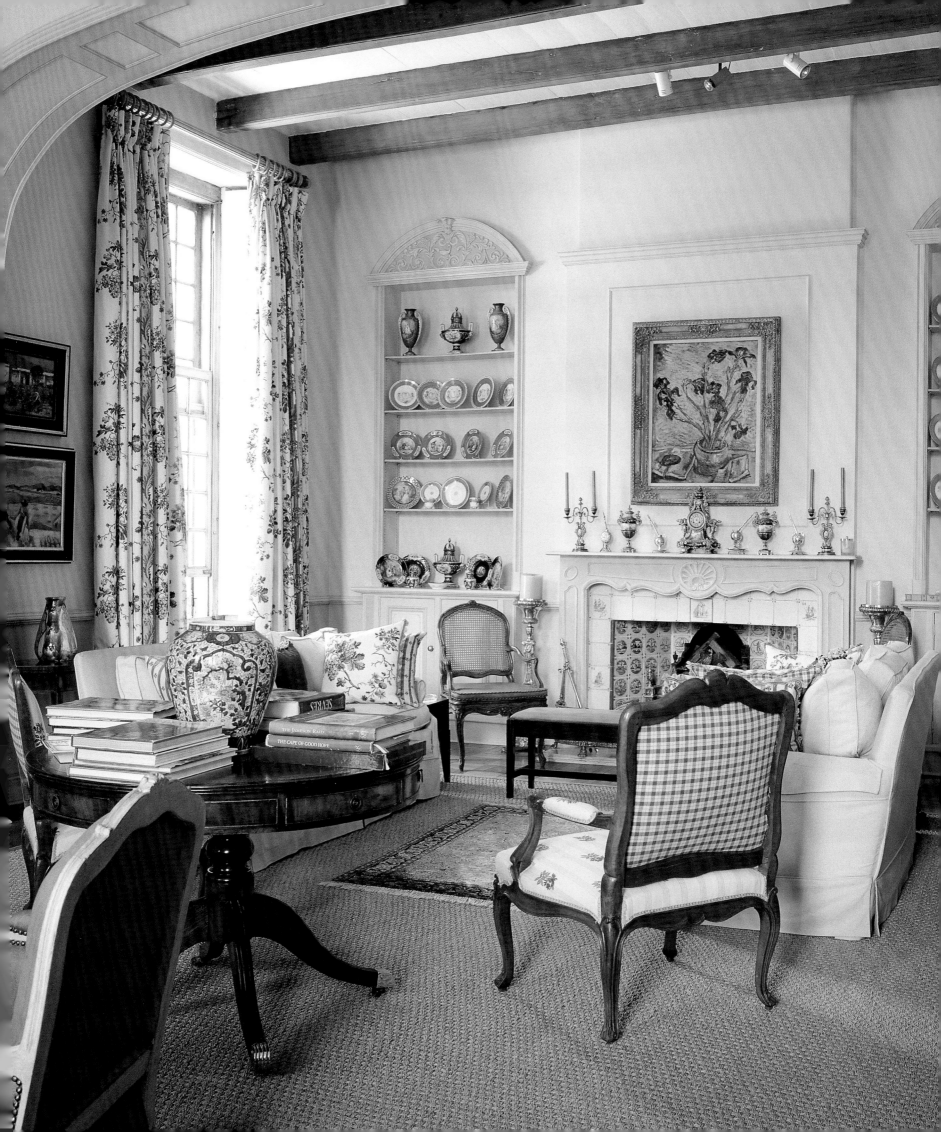

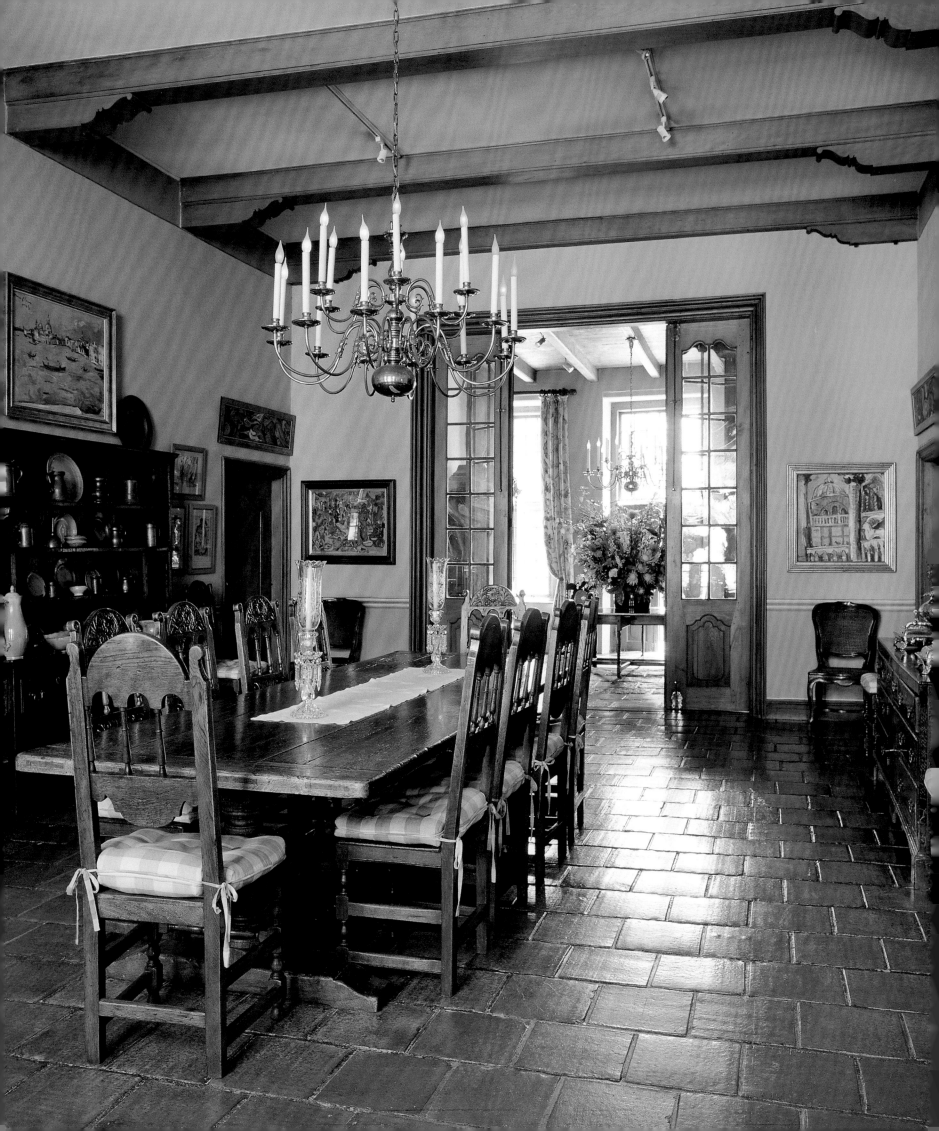

Page 70: Gandereij *French refectory table.*

Page 71: *Courtyard between back wings of U-shaped homestead with Andouze pots.*

Above: *Off the main bedroom, the bathroom houses a French dressing table.*

Below: *Guest bedroom with 19th-century French bed.*

Opposite: *Main bedroom with custom-designed four-poster with fabric from Clarence House.*

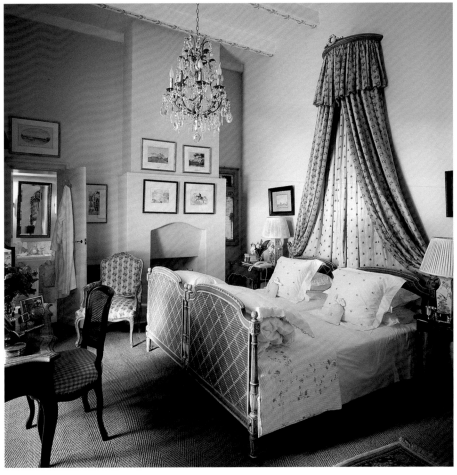

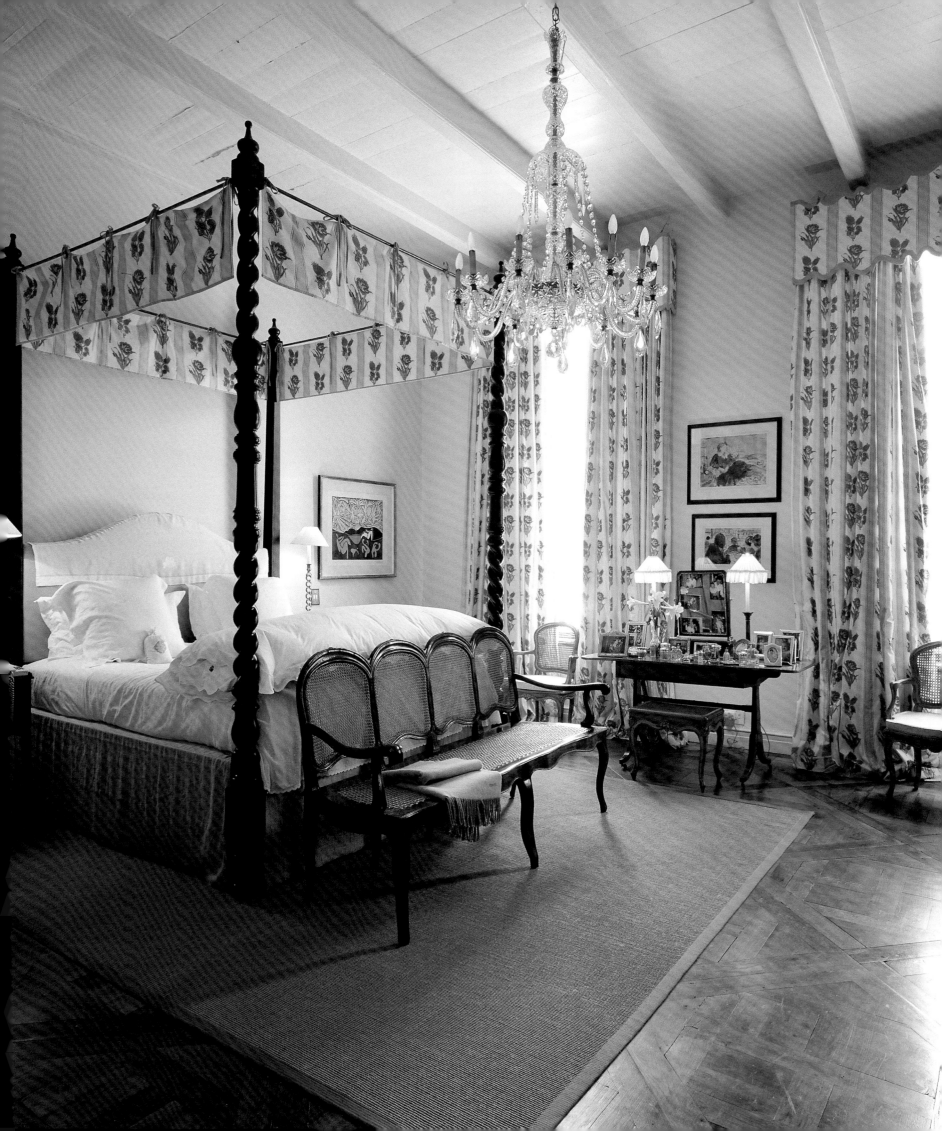

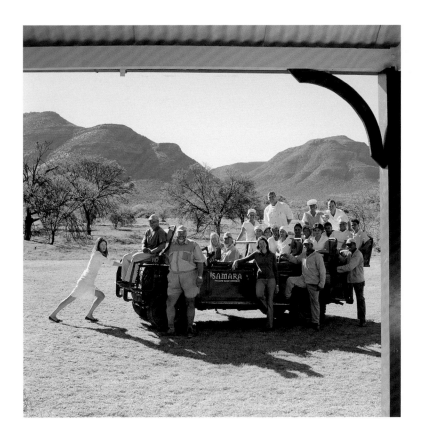
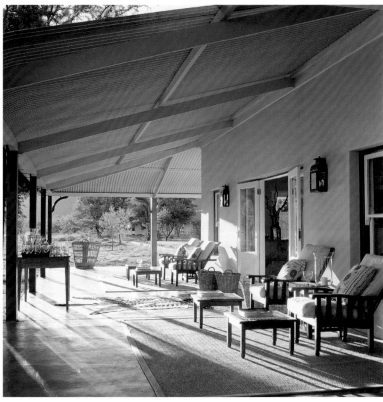

Samara Private Game Lodge and Reserve
Graaff-Reinet

Above left: The staff on a jeep.

Above right: Arrival area on the stoep with old Morris chairs and antique Karoo wool baskets.

Opposite: Living area with riempie coffee table, Nguni hide cushions and zebra skins. On the wall are Zachary Eloff prints of eland and 19th-century lithographs by Cornwallis-Harris.

Pages 76-77: The Plains of Camdeboo.

Samara Private Game Reserve is near Graaff-Reinet, on the edge of the Plains of Camdeboo. It's a place where the Khoisan (or Bushmen) once lived, and it's a landscape once heavily populated with plains game – lion, elephant and cheetah – most of which were wiped out by the early pioneers. The romance of this magnificent setting of savannah and forest, mountain valley and grassy plateaux pulled owners Mark and Sarah Tompkins into its orbit and what was originally 11 farms is now one single reserve of 28 000 hectares from which they've removed all the fences and restocked with the kind of wildlife once seen there in abundance. One of the largest private reserves in the country this valuable heritage is coming alive again – in fact it's one of the few places in the Great Karoo at which paying visitors can really get close to the land, see its fossils and San cave paintings or simply experience its silent vastness. This is an ancient wilderness brought back from the brink of destruction. Samara's lodges welcome guests; you can go on drives to examine the trees and the vegetation, or the animals. There are walks to ancient fossil grounds, and there are picnics on the plateau overlooking the Plains of Camdeboo from which on a clear day you can see all the way to Beaufort West, even Port Elizabeth. The look of Samara's lodges is the comfortable, 21st-century version of the pioneering interior, put together with the help of John Zwiegelaar of John Jacob Interiors. There are three suites in the main lodge surrounding a massive, comfortable sitting room filled with books and layerings of artefacts found in the veld or rescued from local antique shops. Old Karoo furniture blends comfortably with big squashy sofas and animal-skin rugs while out on the stoep – deep and wide in an effort to keep the interior rooms as cool as possible during the day – a relaxed country-house atmosphere ensures a lifestyle of total informality. A little further away three private suites built to resemble typical Karoo cottages surrounded by acacia and aloes are located in the path of roaming game which visitors can watch from their own little stoep or even from their beds. Here too the look is comfortably layered, every detail considered and resonant with place, so that even if you spend all day in your room relaxing in a deep armchair reading that old South African classic, Eve Palmer's *Plains of Camdeboo*, you will begin to see what it was that brought the Tompkins' here in the first place.

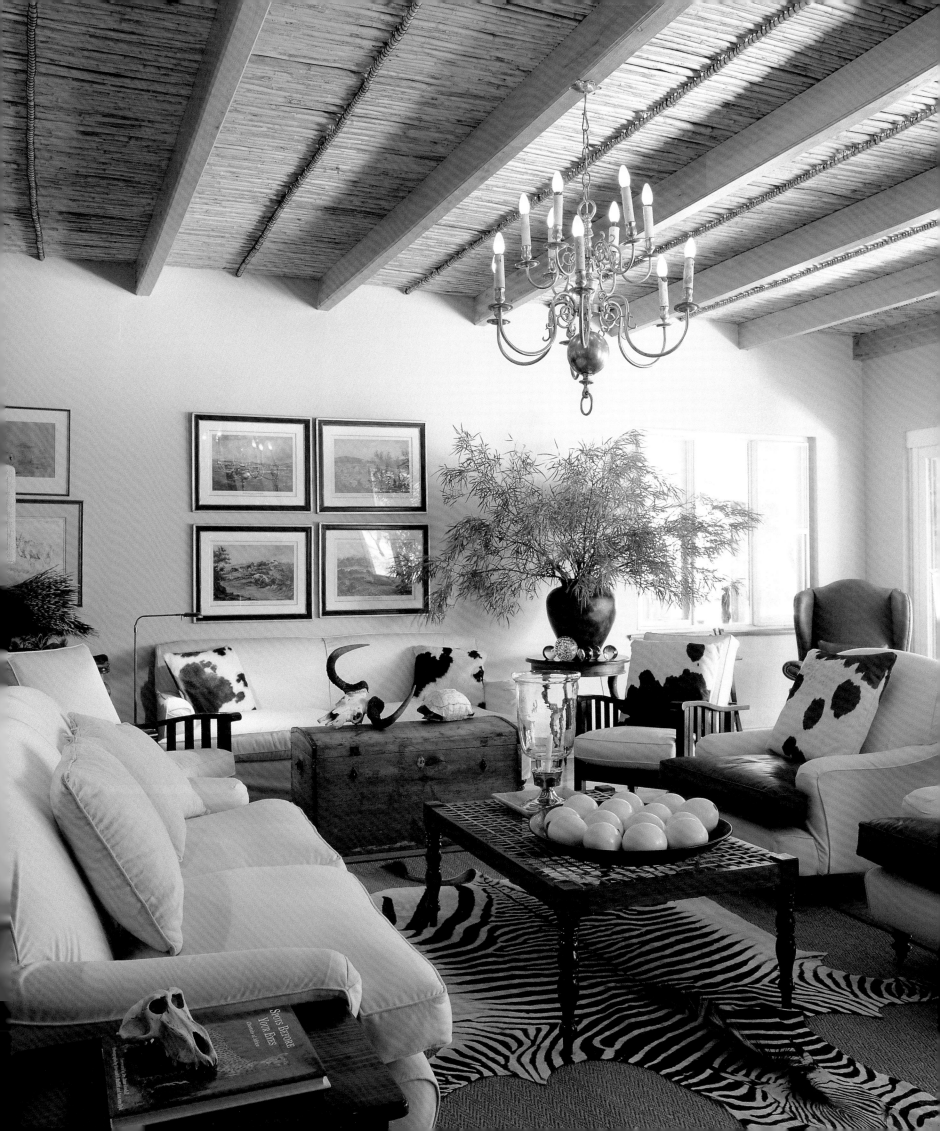

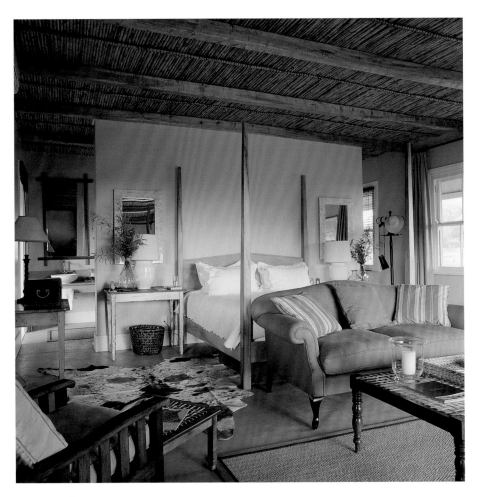

Above: The colours of the Great Karoo are brought into Guest Cottage 3. The yellowwood four-poster was customised in Graaff-Reinet.

Below: Bathroom with traditional Karoo-style stinkwood and yellowwood furniture.

Opposite: Dried aloes from the reserve, a stuffed porcupine and old fruit-pickers baskets dominate the bar. The mirror came from Private Collections.

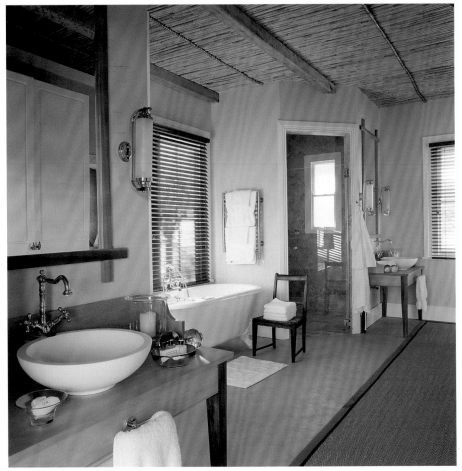

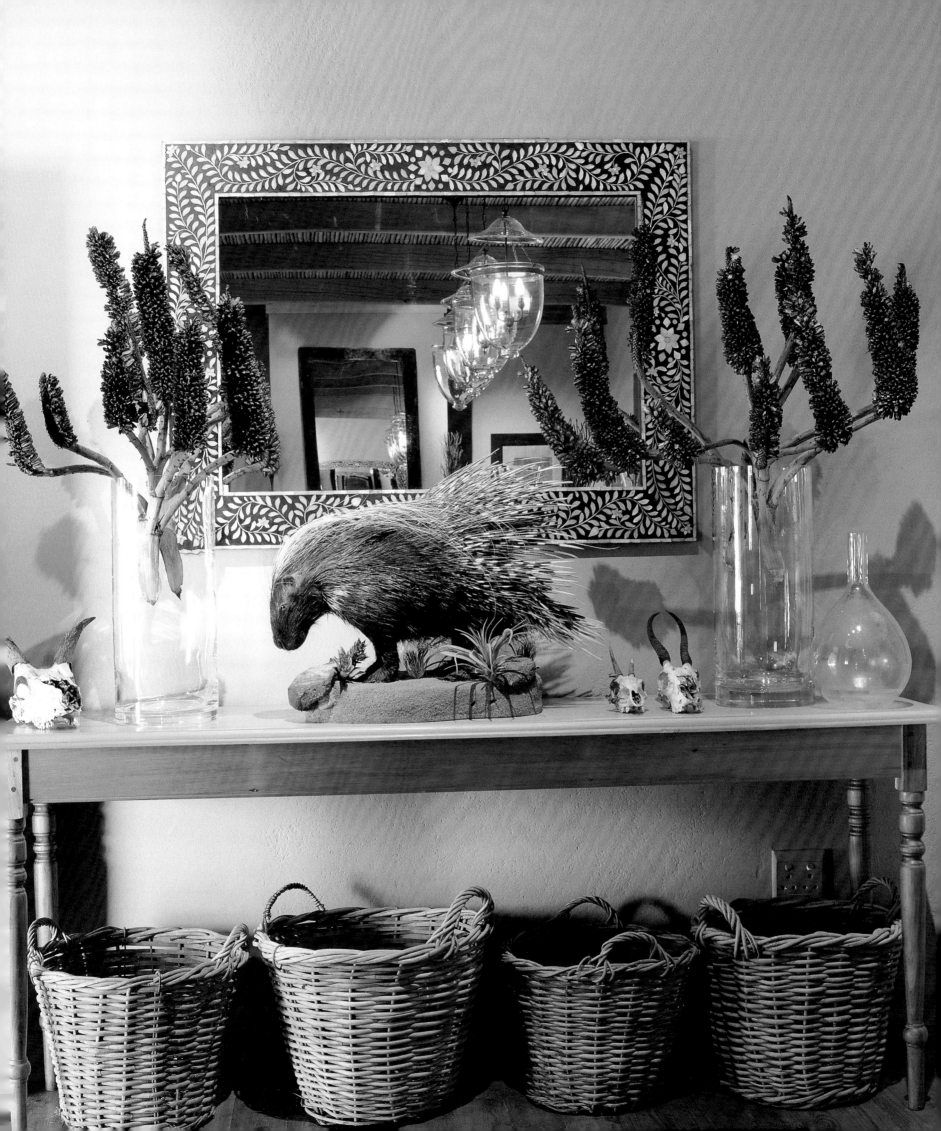

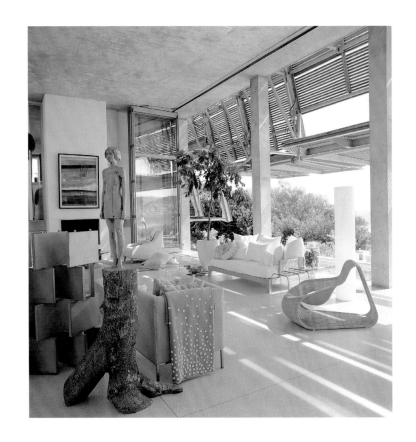

Beach House
Plettenberg Bay

Above: In the living area there is a lovely palette of sand, suede and porcelain.

Opposite: Ocean views from the main terrace.

Pages 82-83: Outside in: the spectacular main living area, occupies the space between the 'living pods' at either end. Facing the ocean, the shutters lift away while glass doors fold out of sight opening the room to the sun and air. The 'Capri' sofa is Cecile & Boyd's and the wooden statue is by Egon Tania from Michael Stevenson Contemporary.

This beach house straddles the length of a sea-facing dune above the eight-kilometre curve of the Robberg Beach at Plettenberg Bay. The work of architects Andrew Makin and Janina Masojada of Design Workshop, and interior designers Boyd and Geordie Ferguson together with interior architect Joy Brassler, it is a brilliant solution to a lifestyle quandary: the owners wanted full-on beachside living on a notoriously windy site, but they also wanted a new way to live as a holidaying family by the sea. Not only did the building have to dodge the weather but it also had to provide a sense of living in the open air. In the end, not only does the building itself become the mechanism for climate control, but the massive main open-plan living space houses everything you need for your daily activities. Architecturally, a single-roof, open-living home on a massive scale is what you have here. The spectacular, light and airy main living area ('a building trying not to look like a building' says Makin) should be read as the 'space' between the living pods which flank it at either end. These, raised and intimate in scale, are the main bedroom suites, one for the parents the other for the children, and there's a kitchen pod housed in its own 'contained' structure. This could well be described as the updated version of South African stoep living taken to a logical conclusion. Design Workshop designed a house clad in a curved slatted shell of floor-to-roof shuttering. Three metres behind the shutters are a series of five-metre-high sliding, folding glazed doors. The shutters lift away from the frame hydraulically, opening or closing in 45 seconds while deploying sophisticated sensors to make sure nothing gets trapped in their downward trajectory. Perversely, one of the best options is shutters down and glass doors open, which takes shade to a whole new level. You're outdoors, but not really. And the very sensuality of beach life has informed the way the house was decorated; there's a lovely palette of sand, suede, porcelain and so on. This house asserts an uncompromising holiday mood and it's light and airy and, above all, appropriate in its setting. You could walk through this house in a wet bathing costume, or picnic at the terrace table off bright melamine with children and dogs running around. There's a free, youthful, wind-in-your-hair casualness about this house, but it's the chic version of it. This team really got it right and this house will in time become a benchmark design for holiday living.

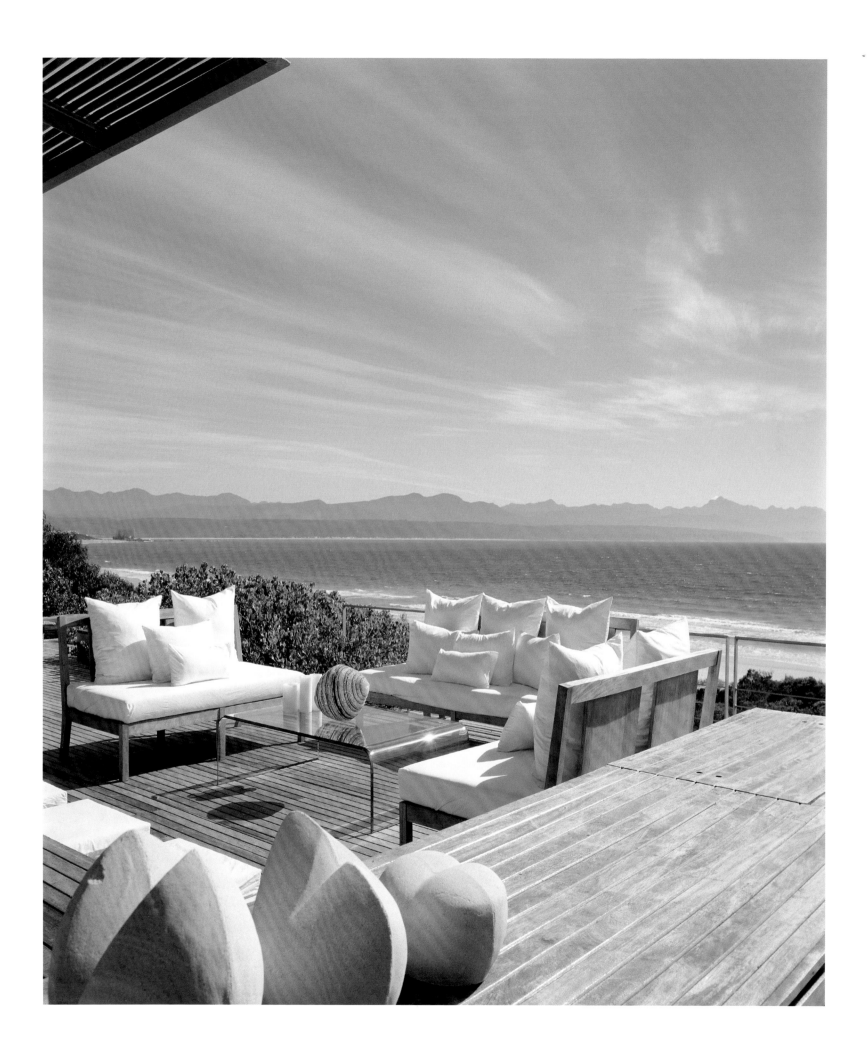

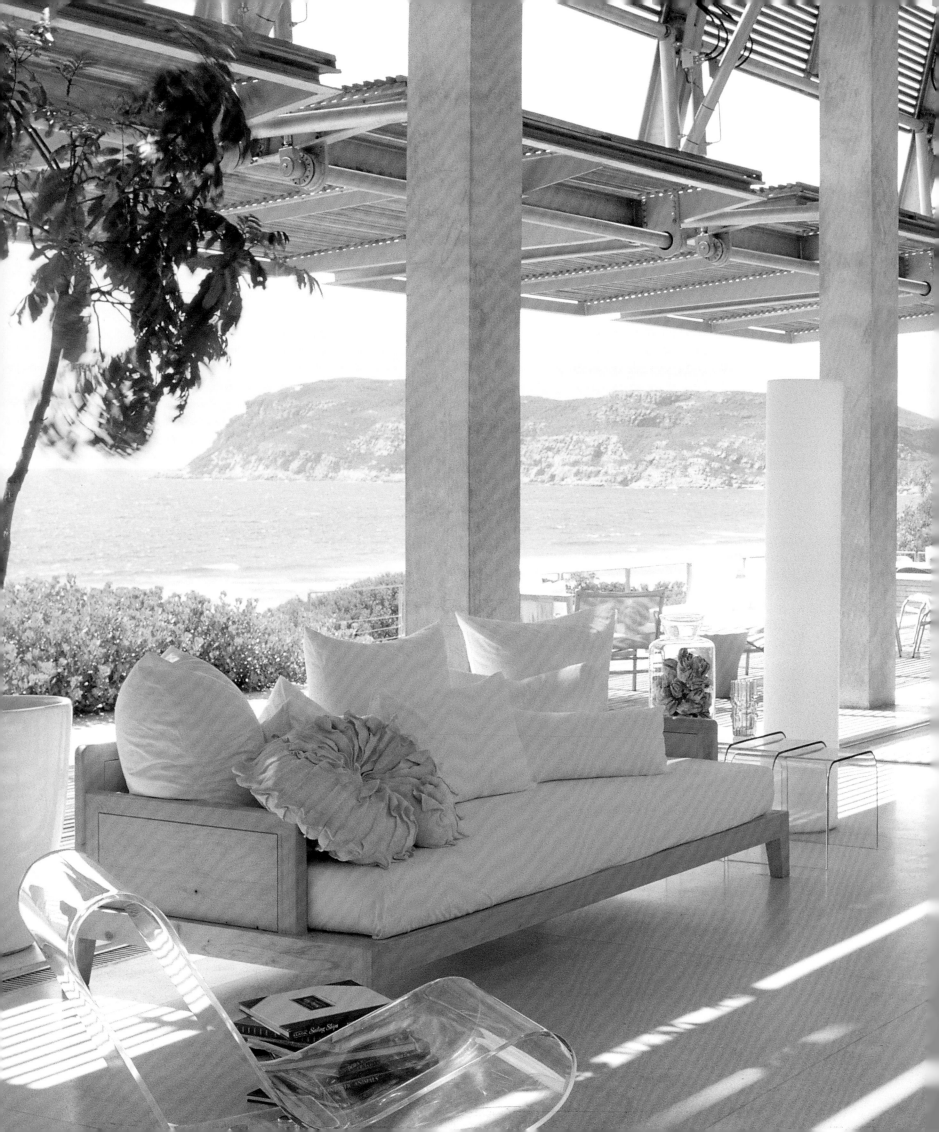

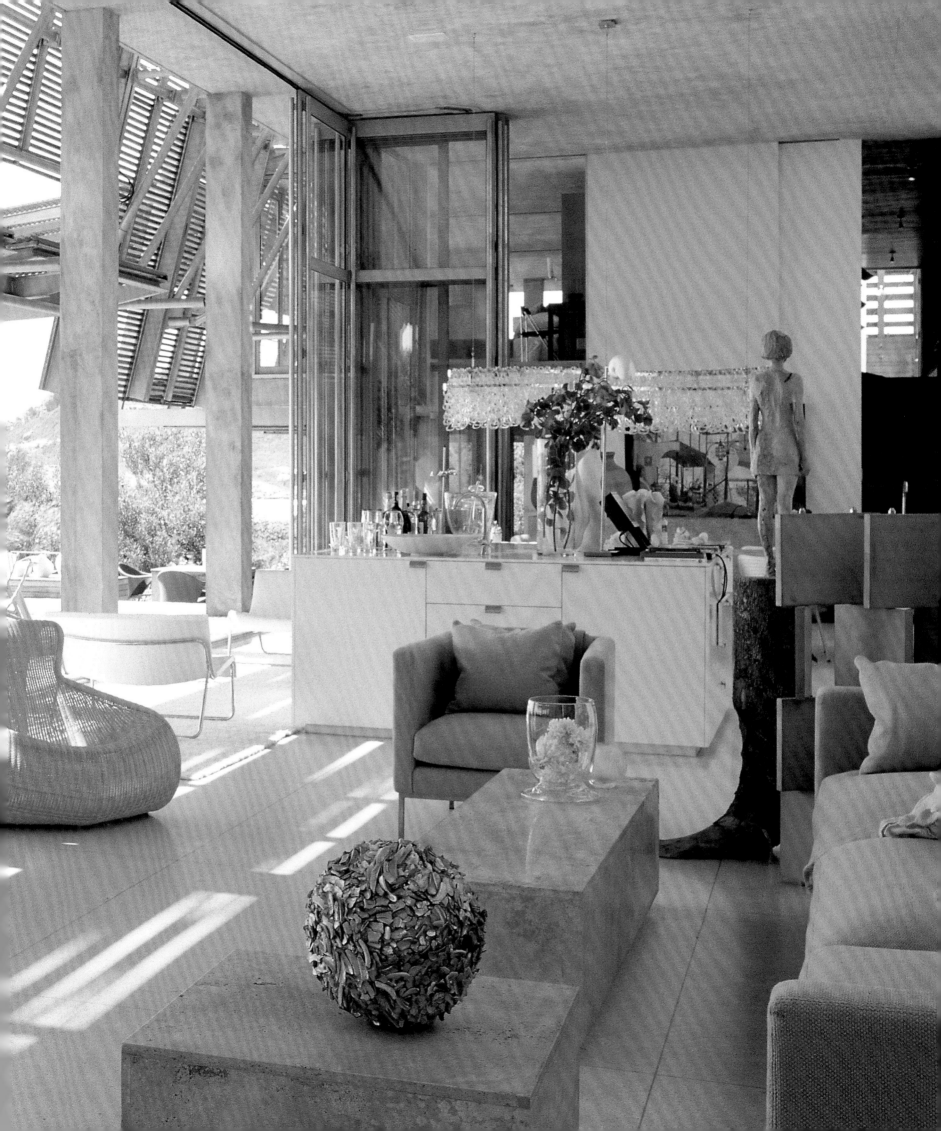

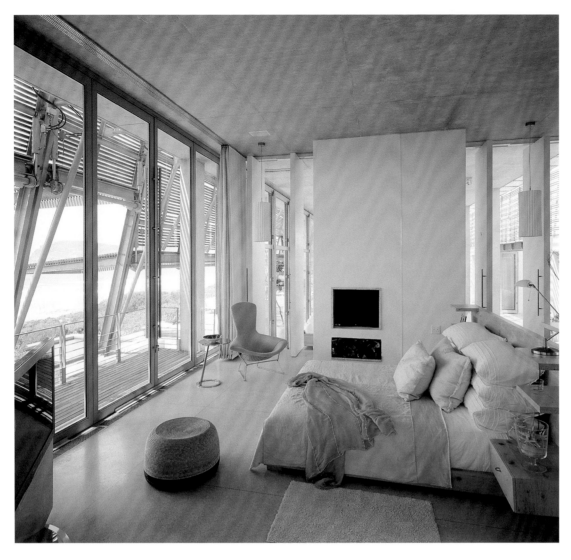

Left: In the main bedroom on either side of the fireplace, two windows look down over the living area.

Below left: The kitchen is housed in its own pavilion, or pod, adjacent to the living area.

Below right: The terraced veranda leading out from the living area.

Opposite: A sleek bathroom is uncompromisingly contemporary.

Pages 86-87: Watching the weather: the shutters dominate the ocean façade.

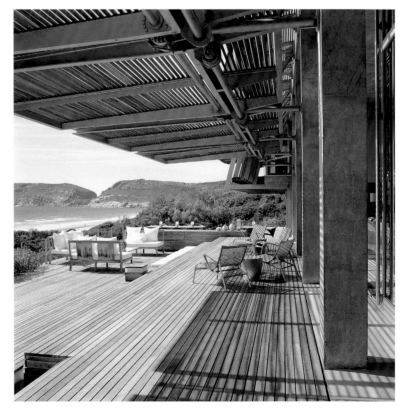

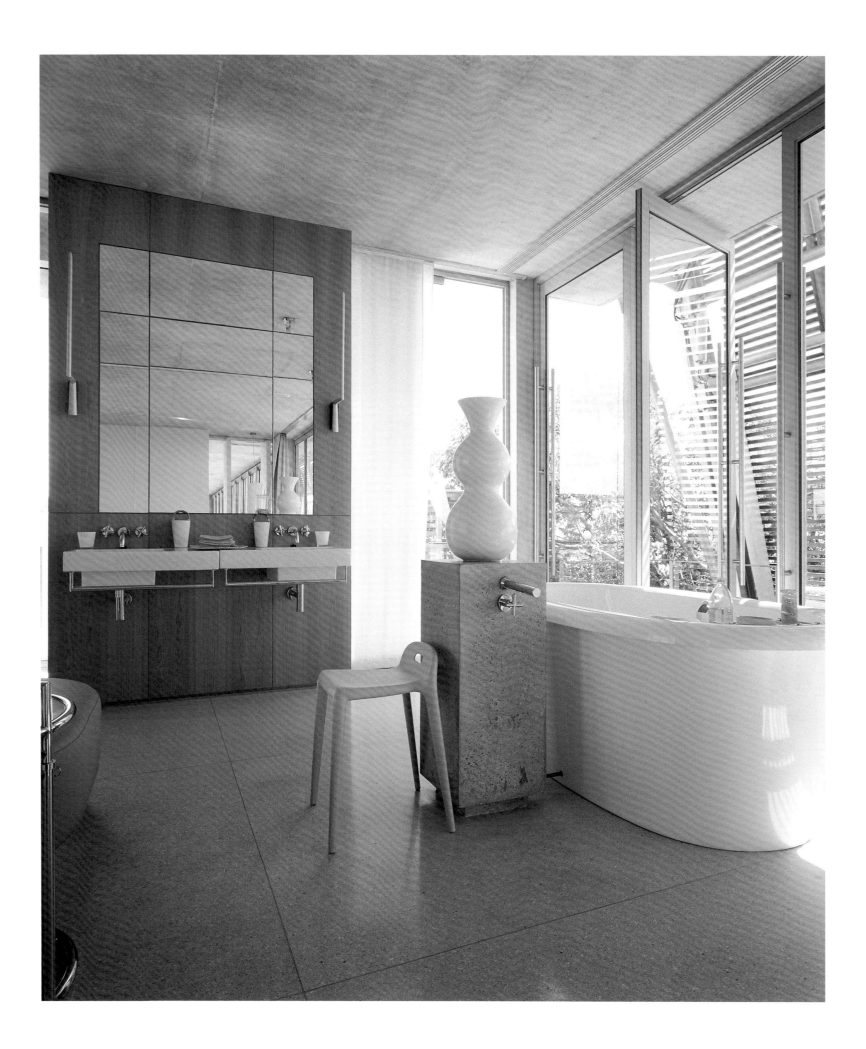

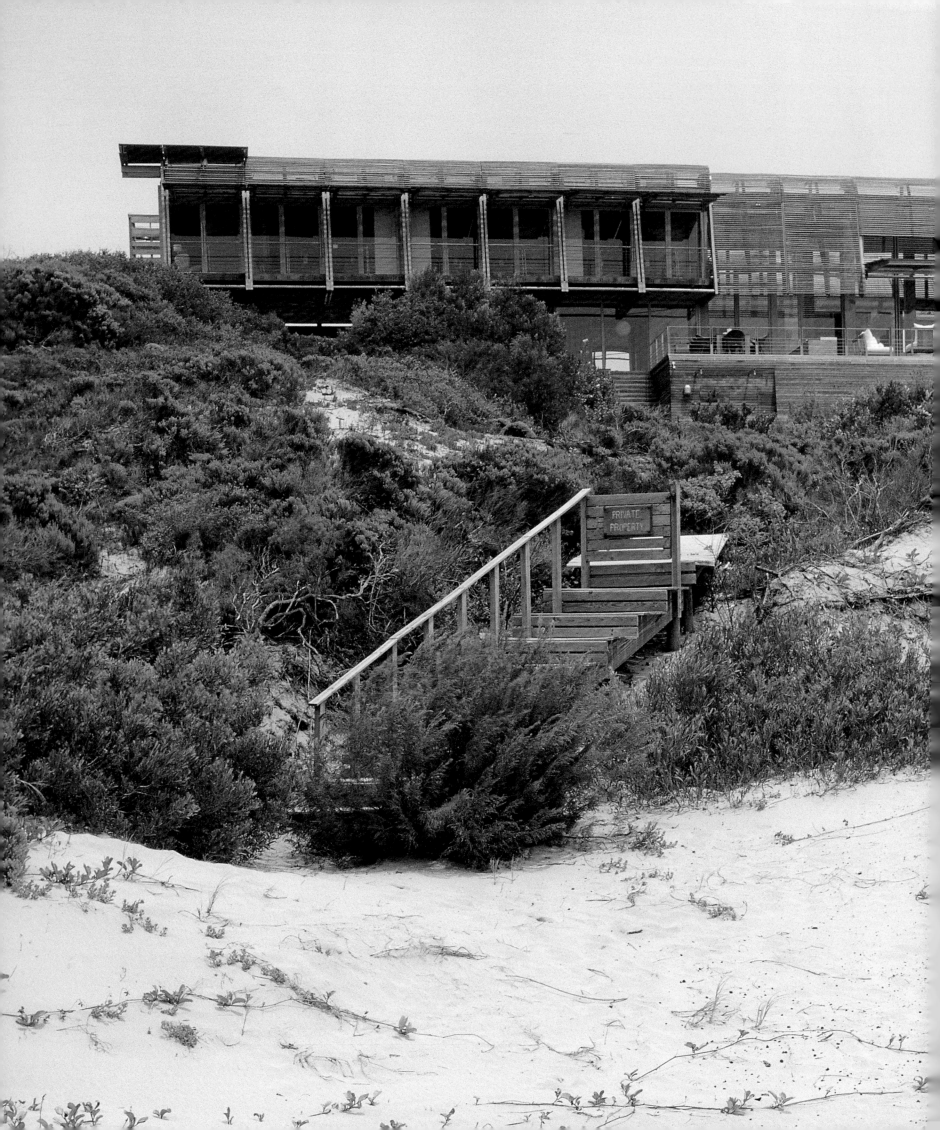

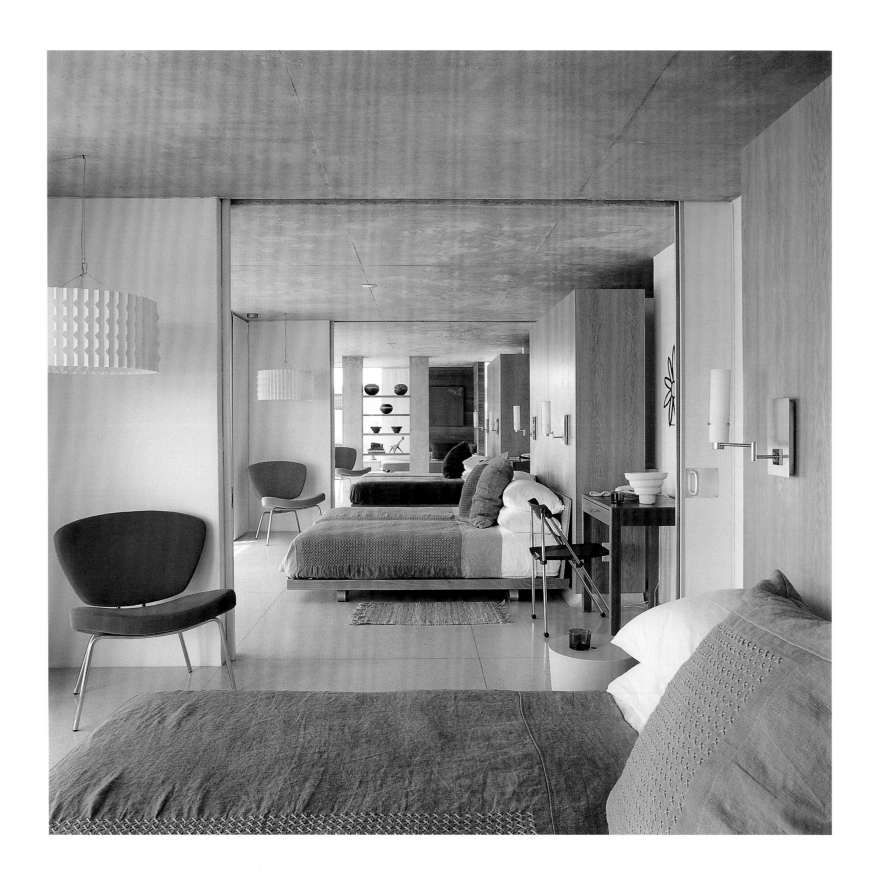

Above: The children's room is one large space with pocket door screens which close to create three distinct rooms.

Opposite: A 'gallery' leads from the entrance, at the far end, into the heart of the building. On the left, the living areas, on the right the kitchen and other domestic spaces.

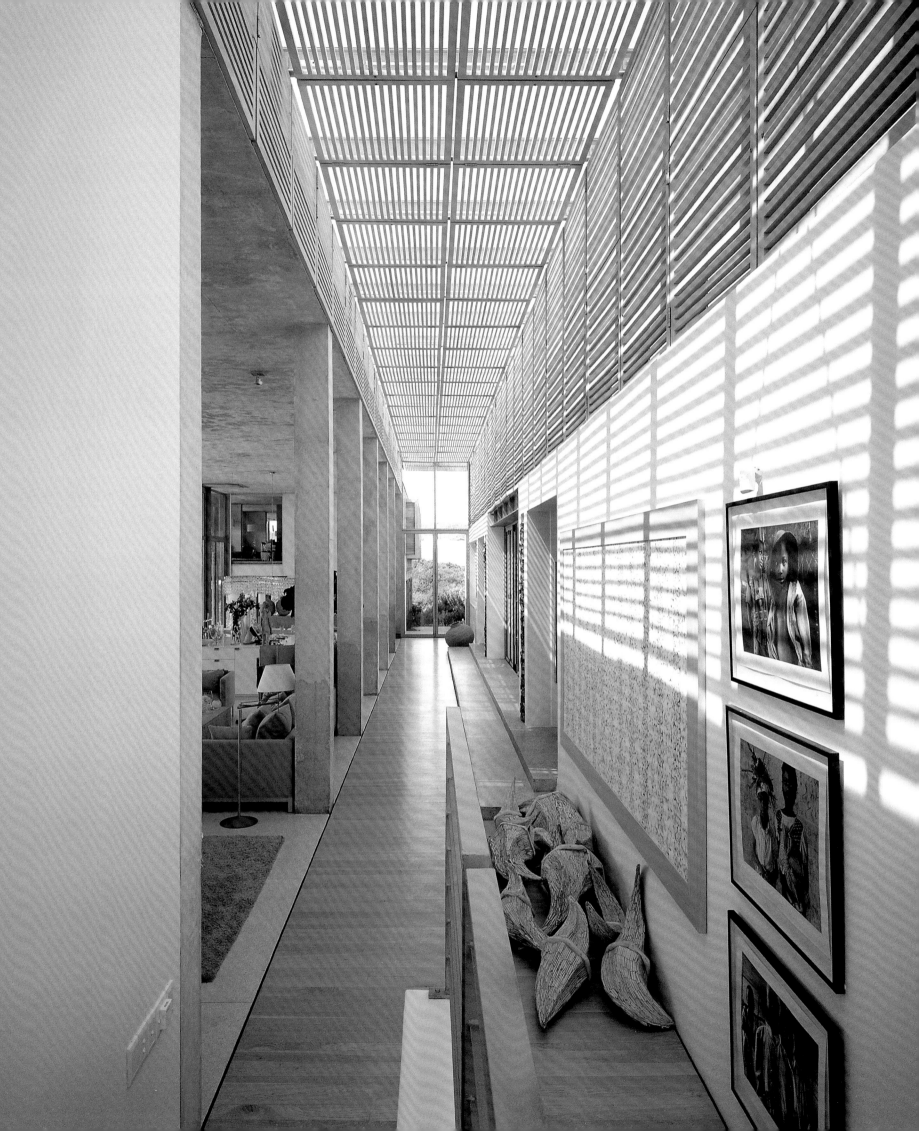

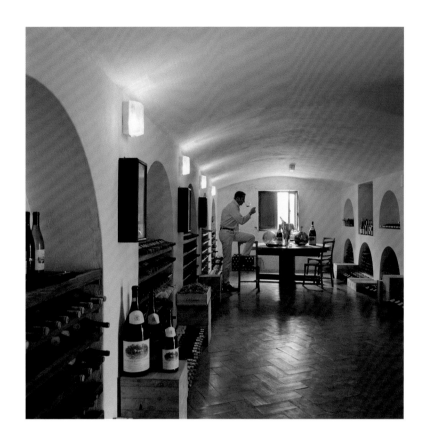

Braemar
Hermanus

*Above: Anthony Hamilton Russell tasting in his
vaulted wine cellar.*

*Opposite: The massive bath was industrial
salvage.*

*Pages 92-93: Loggia with the prime north-
facing view of the Babylonstoren Mountains
over the olive grove and vineyards – and
down the cypress avenue. French oak table
commissioned and made in Hermanus from
large used wine storage barrels. French oak
chairs commissioned and made in Hermanus
from old wine barriques.*

South Africa's big wine success story is that of Anthony Hamilton Russell who, with his wife Olive, has vineyards and a farmhouse in the Hemel 'n Aarde Valley near Hermanus. Its become well-known and not only for the wine. They entertain on a grand scale, and do it royally, winter and summer, spoiling their guests with first-class wines from the farm. Like the couple themselves, their house is larger than life. Its stately silhouette pops up on a hillside way above their farm, visible for miles around. Inside there are great light-filled spaces with curved ceilings, polished wood floors, windows opening onto sweeping views of fynbos, mountains and vineyards. The loggia is its most characteristic feature. It says it all – the irrepressible zest for life and entertaining and long conversations over exceptional wines. Says Olive, 'This is our main summer entertainment area and is a perfect family relaxation space in summer. The view is magnificent – the reason for the orientation and location of the house. It was Anthony's favourite view on the farm. There is a wonderful feeling of being indoors and outdoors simultaneously – something that the Cape Dutch and Cape Georgian stoeps did not achieve as satisfactorily. The loggia is perfectly sheltered from the prevailing summer southeaster off the Walker Bay. The winter wind from the northwest is another story!' The house and the lifestyle are a perfect fit – the sense of place, the personal collections, the way items have been chosen and brought together with style and comfort in mind. It is not a self-conscious home and both Anthony and Olive are very sensitive to a sense of place and the expression of that place in terms of small thought-through collections. Nothing precious, mind you. There's a practical, robust aspect to everything undertaken here. Old wine barriques from the estate have been turned into oak chairs as have Norfolk pines planted by Robert Stanford in the Overberg; a feeling for salvage you might say. The foundation stone of the 1830s hospital serving the leper colony underpins a windowsill. Landscapes by local artists, eclectic but congruent, take pride of place. Everything has been considered and deserves to be there. This is homemaking as an art form.

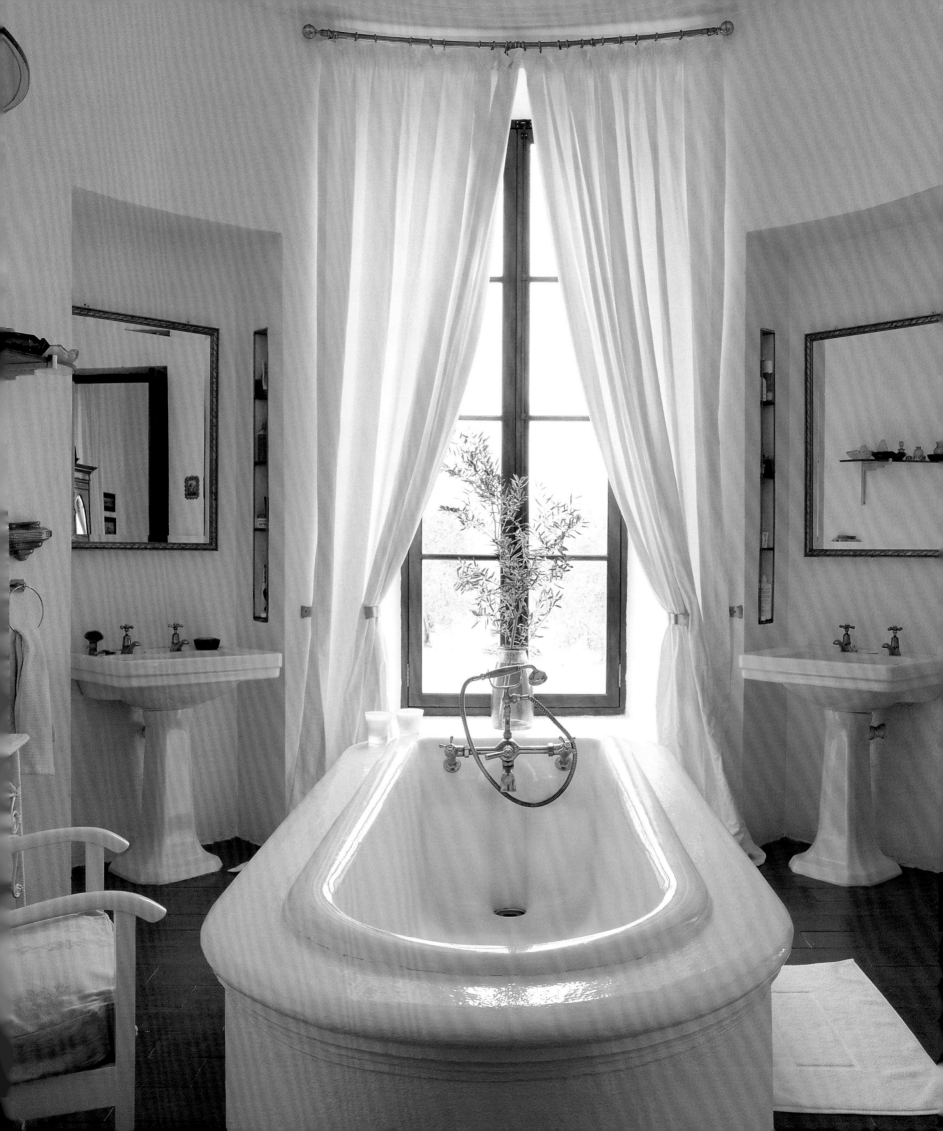

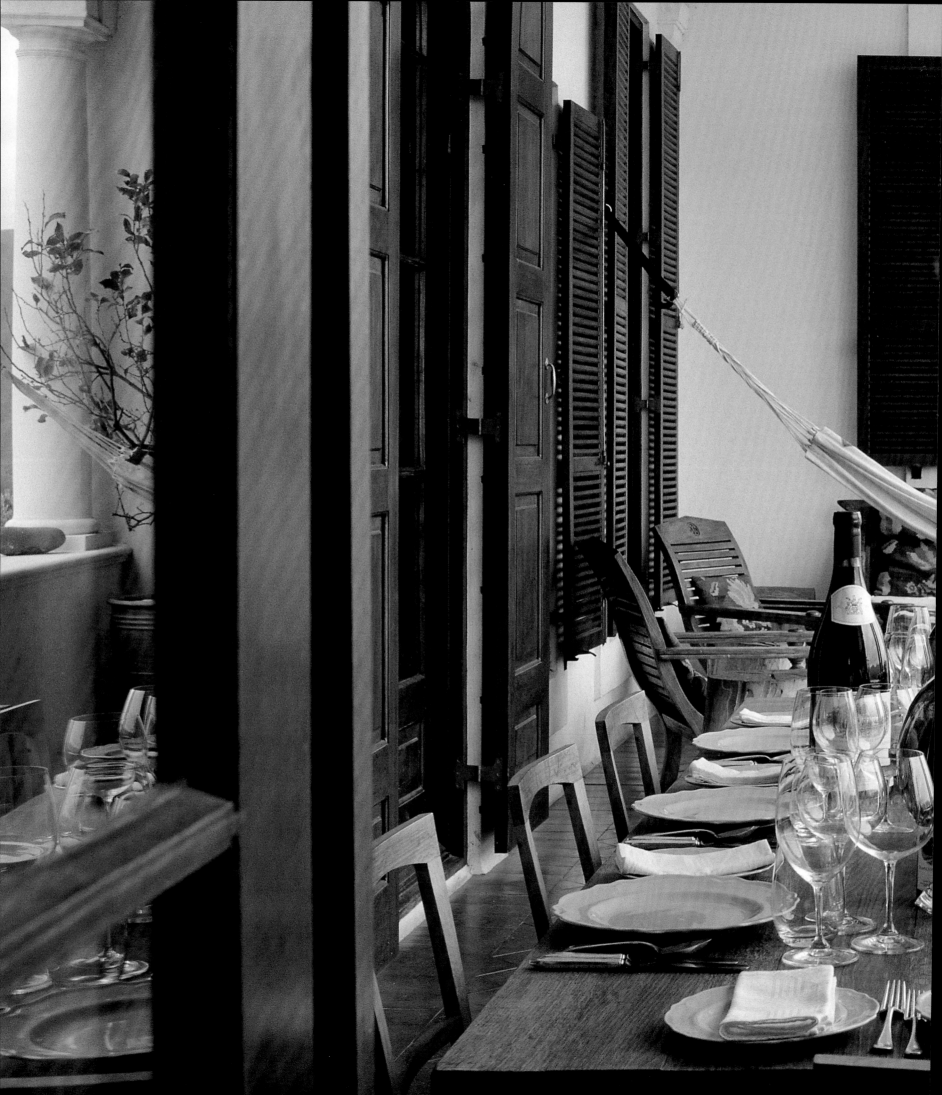

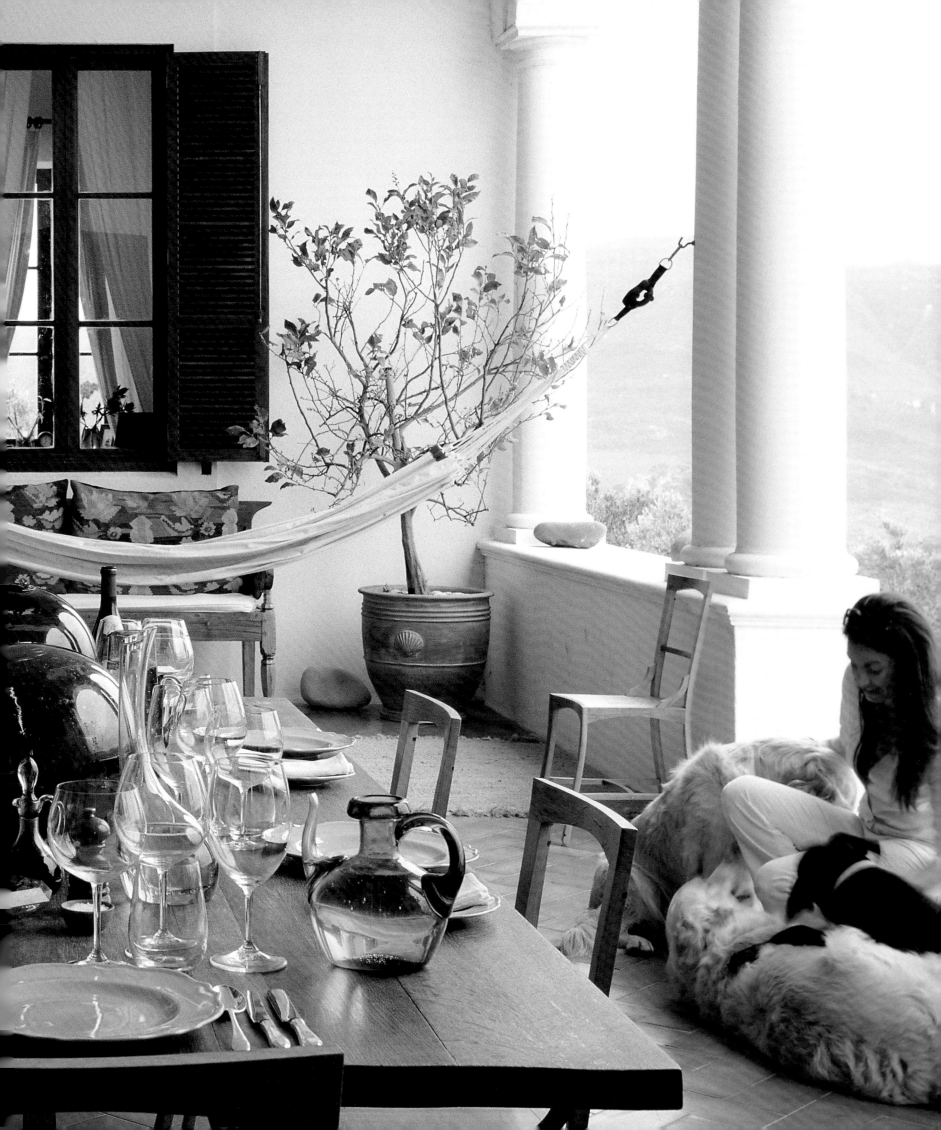

Above: Found objects and carvings are unexpected in this stately building.

Opposite: The proportions of the bedroom have an Italianate aspect. White walls, white soft finishings are cool for summer living. Custom-made sleigh bed purchased in London made of Indian cherrywood. Wingback chairs found in a second-hand shop are fitted with white bull-denim loose covers. The Edwardian dresser came from a local antique shop.

Aberfeldy 9,
Johannesburg

When the owners commissioned Stefan Antoni Olmesdahl Truen Architects to design them a house, they wanted the exact opposite of their neighbours' stylised homes which had borrowed so freely and derivatively from Tuscan, Provençal, Mali, Bali and Cape Cod traditions. Here the brief was strictly to do with a refined contemporary design bearing an intimate relationship to the landscape and a sleek sexiness that suited their style. 'The design,' architect Greg Truen points out, 'was to make the most of all the familiar but elusive possibilities of Highveld living: great weather, lots of sun, dry winters, space, and light.' The site determined the layout and planning of the house which is a very organised yet flowing series of spaces that run along a main spine – 'an interior avenue' – subtly terraced and punctuated with planted courtyards. The living space downstairs includes a sitting area with glass walls that faces the pool in an undivided indoor-outdoor flow, and an open fireplace that acts as a room divider between the interior avenue and the kitchen. The dining room is a few steps above the living area and also opens up to a courtyard and a section of the swimming pool. Upstairs, there are three en-suite bedrooms in secluded privacy. The indoor-outdoor aspect is integral to the experience. Firstly, it's easy to access. 'Every single space opens fully to garden or water or sky; you can always slide a wall or two walls of a room away,' explains Truen. 'Upstairs the wall of sliding, folding doors in the main bedroom recedes so that you have the feeling of being on a deck suspended in the treetops.' Secondly, the house itself seems to float like a series of platforms above the garden, suspended in the urban landscape yet not confined by location or limited by boundaries as are many urban homes. Many of the steel structural columns of the house are buried in the aluminium window frames which gives the house an appreciably lighter and more refined feeling. Again the sensation is one of floating suspended above the footprint. And inside, the lighting is discreet, enveloping rather than confronting, diffuse and filtered, deliberately low impact. The interior design, by Antoni Associates, is unobtrusive too. 'It's an orchestration of almost-not-there tones and bold pieces. A sculptural quality has been achieved across the design, from architectural effects to lifestyle and comfort. The furniture has strong form; it's reflective and modern-minded,' says designer Mark Rielly.

Above: Modern art compliments the building's clean lines.

Opposite: This house embraces the outdoors; 'you can always slide a wall or two walls of a room away,' explains its architect.

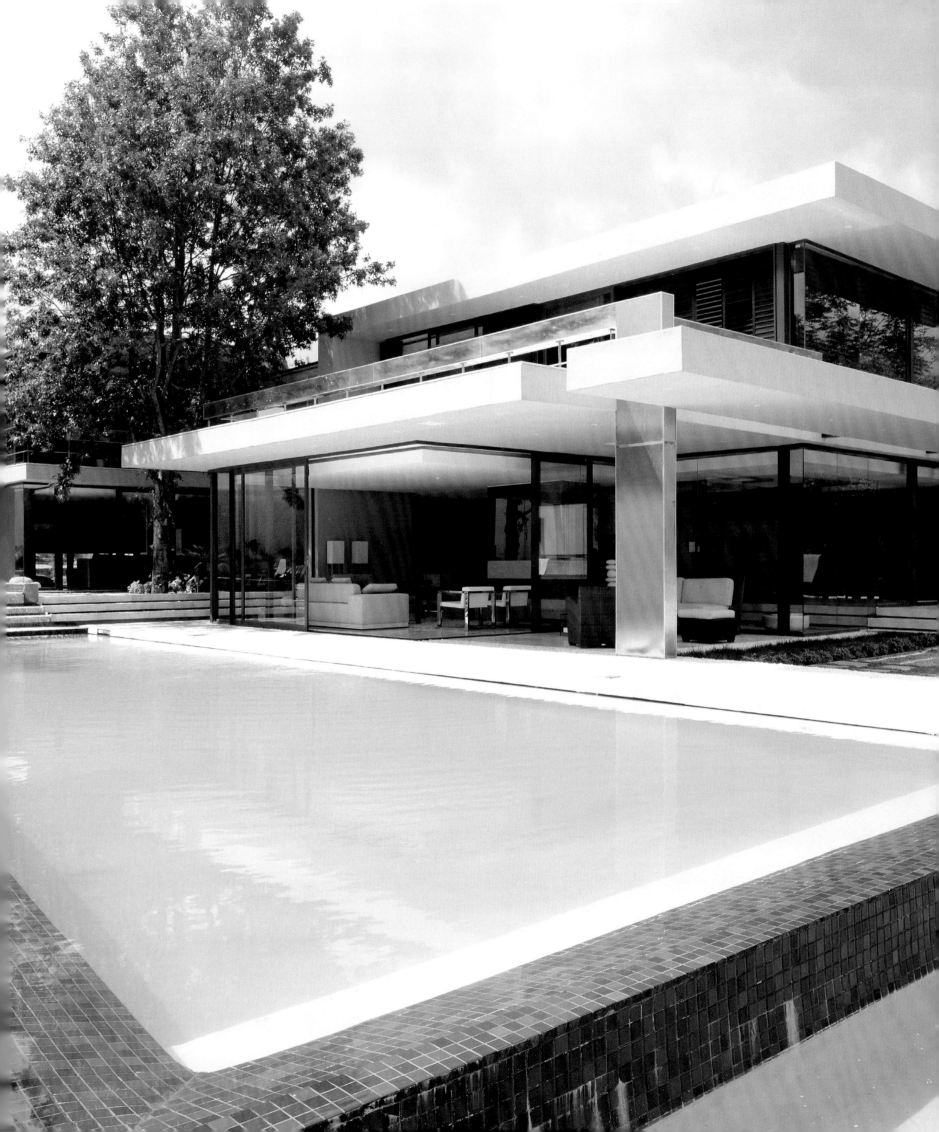

Above: The main bedroom and bathroom. Shutters fold away entirely to give the feeling of being on a private deck in the trees.

Below: The living room with custom-designed chairs by Antoni Associates.

Opposite: An 'interior avenue', subtly terraced, runs along the spine of the house.

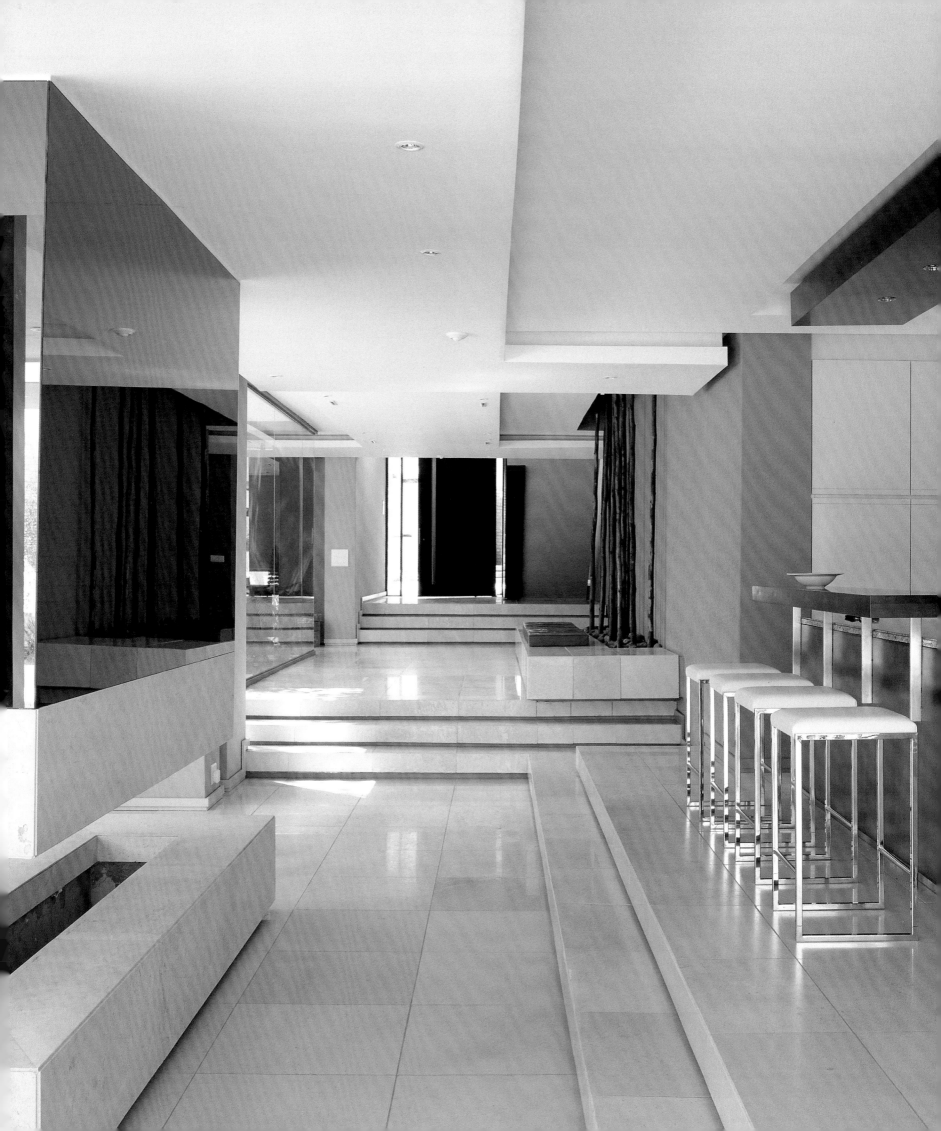

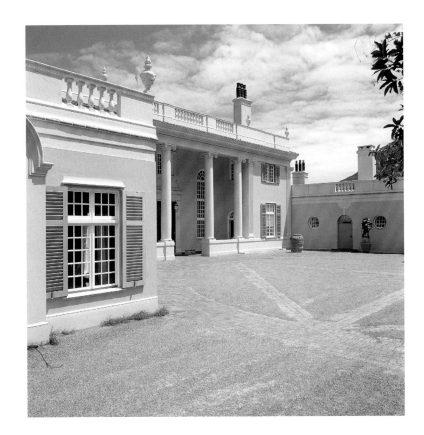

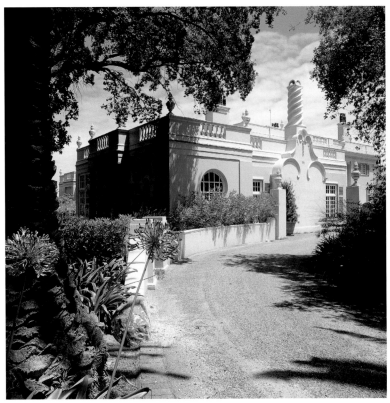

Noordhoek Manor
Noordhoek

Magnificently sited, Noordhoek Manor's façade of urns and pilasters is flanked by two elliptical, colonnaded loggias, each elegantly glazed against the notorious southeaster trade winds which, every summer, blow in over not one but two sunlit oceans. The house was originally built for Sir Drummond Chaplin and designed by Sir Herbert Baker, with its foundation stone inscription composed by Kipling, the British Empire's then poet laureate. Its style belongs to the last great phase of colonial building; Baker designed it from India where he was collaborating with Luytens on the new capital at Delhi. The garden façade is reminiscent of a Cape neoclassical town house suggesting no more than a backward glance at Baker's early practice at the Cape, while its interiors are redolent of New Delhi with their fine inlaid woodwork, handsome chimneypieces of Portland stone, and groined and vaulted ceilings. Plasterwork details on the staircase and the ceilings owe their reference to Baker's own family house in Kent, while designs then in hand for monogrammed escutcheon plates crested with the Zimbabwe phoenix, a baboon or whale, bear testimony to its owner's love of detail. This is a house designed for entertaining. The Chaplins, a childless couple, built it and retired there after governing the English colonies of the Rhodesias, and from the start planned to fill the house with family, friends and distinguished visitors. The monumental terraces, drawing rooms, card rooms, billiard room, tennis courts, croquet lawn and flower gardens were all designed as a background for parties. As historical architect and decorator Graham Viney who worked on the homestead pointed out: 'Informal at Noordhoek, according to Sir Alfred Beit, meant black tie.' And then it all ended. Sir Drummond Chaplin died; his wife became deranged and died incarcerated in one of the wings. Then in the mid-1980s, the estate was acquired by John Aspinall. For three-and-a-half years, the house, its contents and gardens underwent an exacting and painstaking exercise in restoration and preservation together with sensitive and elegant redecorating. The surrounding fynbos mountainside was restored and replanted with local species. Noordhoek re-emerged as one of the country's great houses.

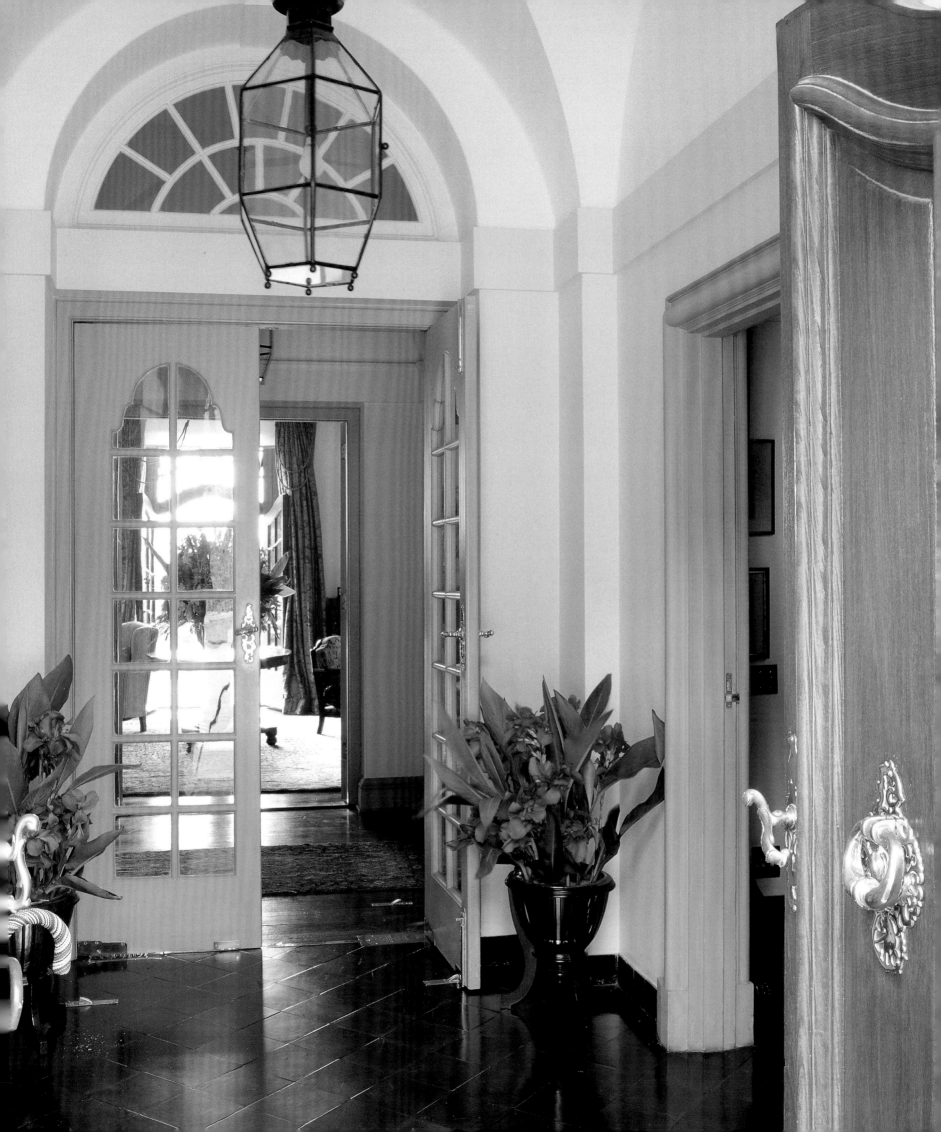

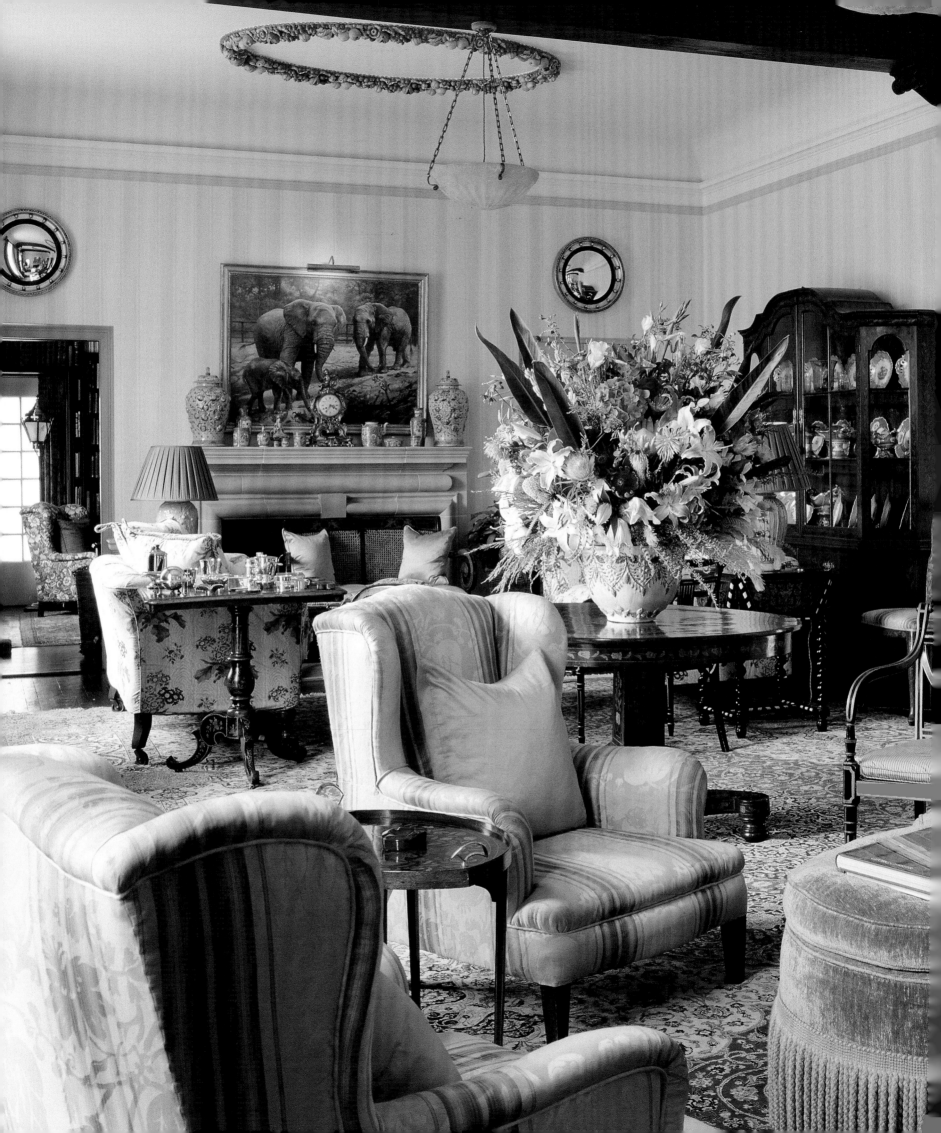

Opposite: The double drawing room showing the massive chimney pieces, marquetry and china that survive from the Chaplins' day. The wildlife study of elephants is by Spencer Roberts; the auricular chintz is by Mrs Monro.

Above: The elaborate escutcheon plate typical of the house entwines the Chaplins' initials.

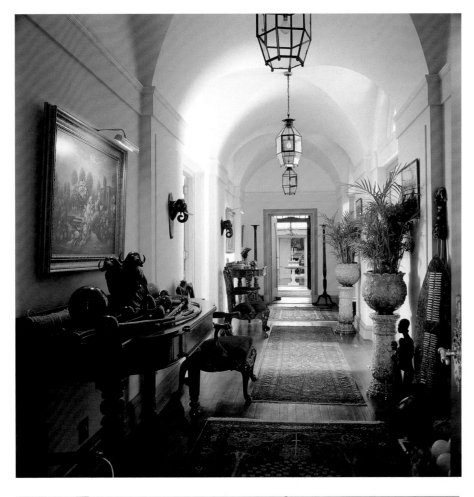

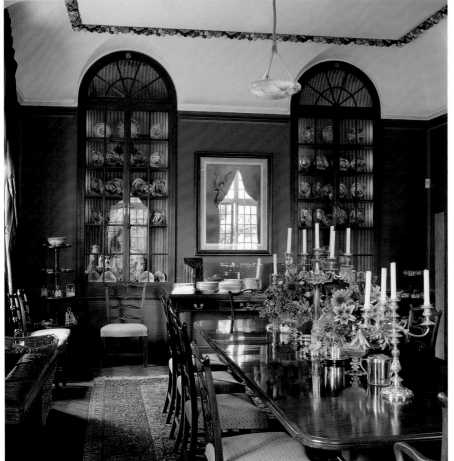

Above: The groined and vaulted hallway is strongly suggestive of Baker's work in Pretoria and New Delhi; the wonderfully carved chairs representing India and Africa were commissioned by the owner's wife as a gift to her husband.

Below: The claret colour of the dining room was chosen by John Aspinall from a scuff in an old rug. The chairs came out of Vergenoeg, the Baker house on Muizenberg beach.

Opposite: An Arabic theme is subtly picked up in the atrium.

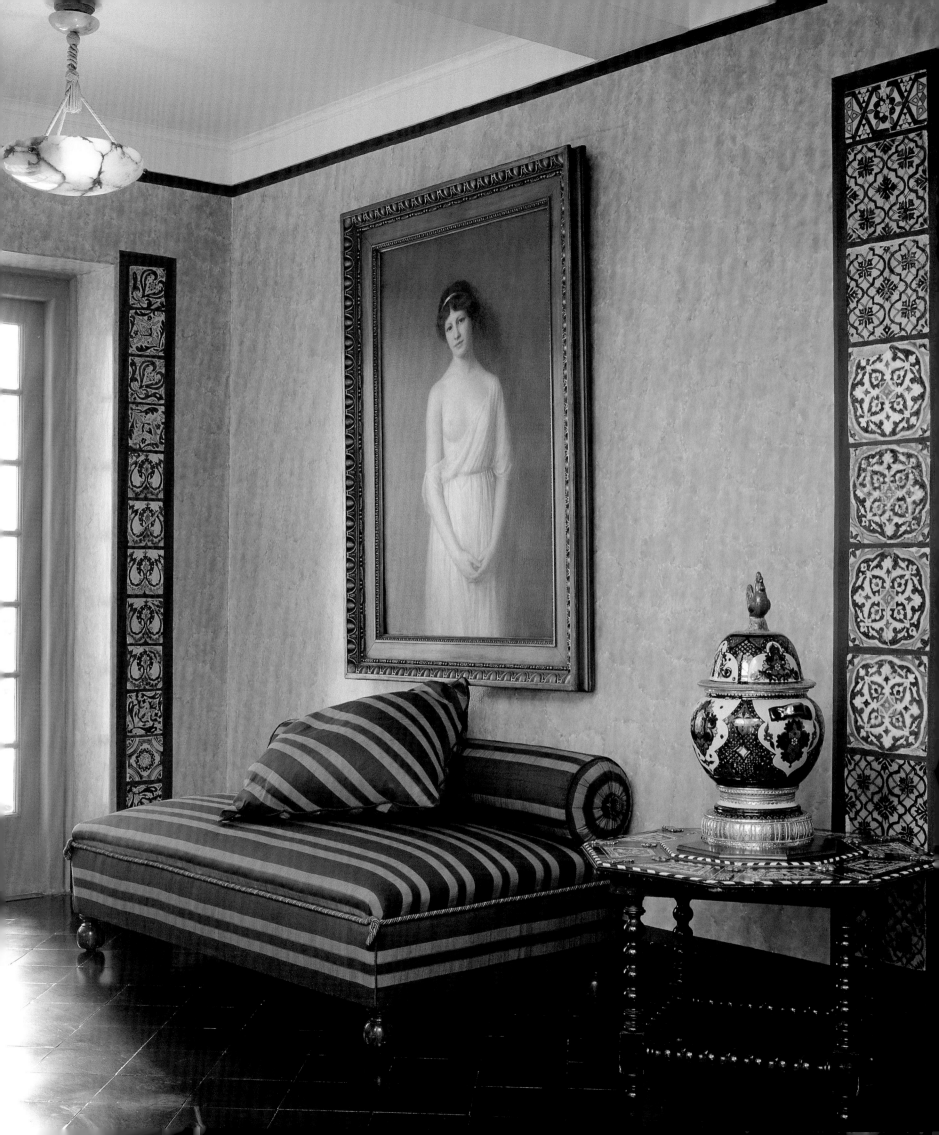

Robberg Beach End
Plettenberg Bay

This is all about the simplicity of screeded floors, cool, gentle colours and large uncluttered spaces – nothing to come between yourself and the beach. 'A similar light, even transparent approach is evident in all my projects,' says decorator Suzy Lubner, owner of this beach house in the dunes on the edge of Plettenberg Bay. 'The homes beside the ocean are casual, easy-to-live-in spaces.' This is not formal living: on the main floor, all the rooms open up into each other, flowing from the kitchen through the sitting room and out through vast sliding doors to the terrace which leads down to the beach. Family and friends can sweep in and out with towels, umbrellas, cold drinks and straw hats as easily as the tides sweeping in and out of the bay. Originally intended as a holiday house, it suited the family so well that they decided to stay on permanently. Talented local architect Paolo Viotti drew up the designs and Lubner then worked alongside the builder to ensure that the finishes and detail were just as she wanted. Situated facing the Robberg peninsula, materials were chosen to help the house blend unobtrusively into its surroundings. Locally sourced wood, coconut beams brought back from Bali, and vernacular latte for an *afdak* all work together to create a natural, organic look that echoes the sand, fynbos, and shifting tones of sky and sea. The decoration is kept to basic neutrals – low-key wall colours and simple linen curtains on thin iron rods – to form a backdrop to an intriguing collection of furniture, art and objects. Lubner and her husband are keen travellers, and she has collected things wherever she goes. There was a container from Indonesia filled with pots, furniture and tiles. 'I love Mexican, Chinese and textured fabrics,' she says. Pieces from Thailand, Africa and Europe are also thrown into the mix, along with shells collected from her own beach trawls. Lubner had the luxury of starting from scratch and each piece was chosen exactly for its spot, collected in the course of the year that the house was being built. The informality of this beach house gives her carte blanche to play with eclectic table groupings and hangings and an unpretentious, eye-catching series of displays. On the pool terrace, for example, an African Sanufa bed with an Ikat cloth from Bali and local raffia cushions sits next to a Thai stool, a paper umbrella and a Balinese gong. 'The big thing is not to clutter,' Lubner says, 'but I love collecting things so it's a bit of a struggle to maintain the restraint.'

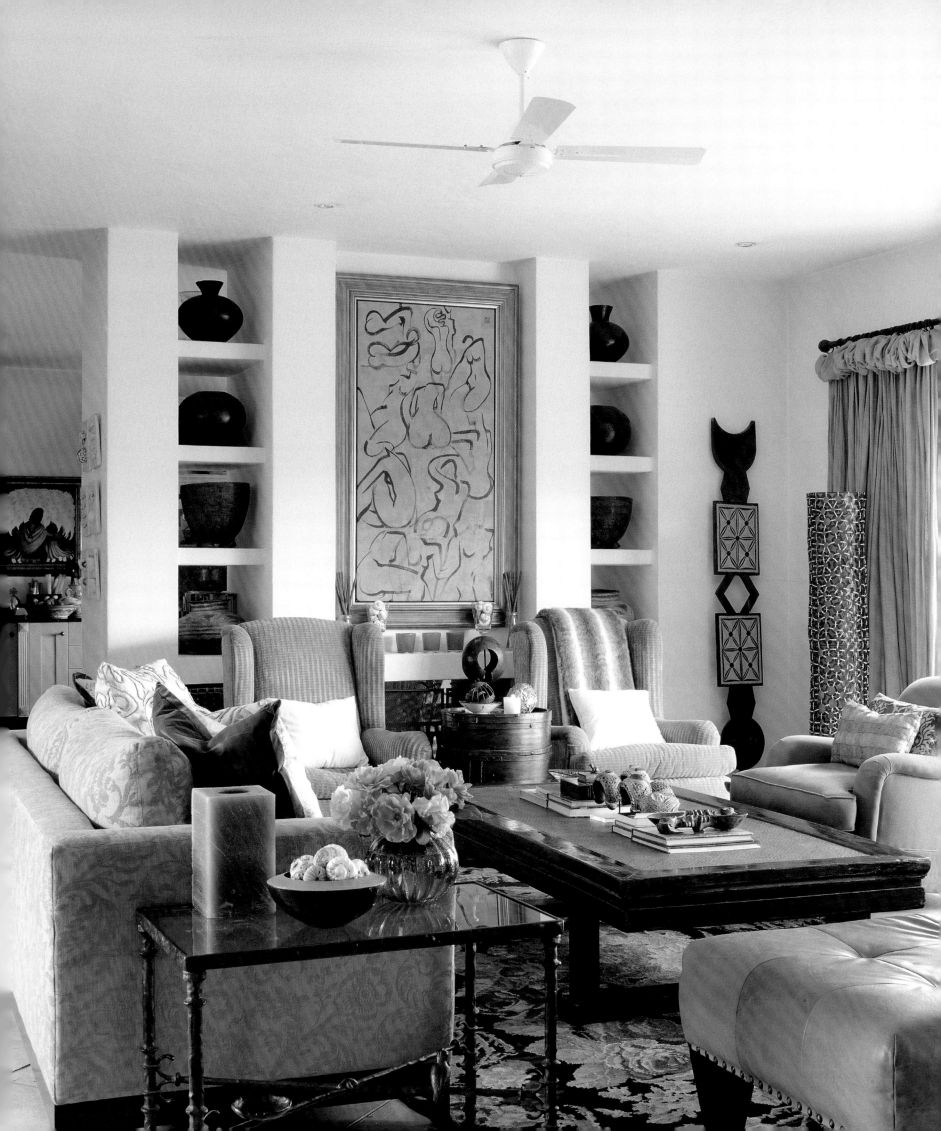

Clockwise from top left: On a landing, a telescope faces the sea; view from the landing looking down the stairs with customised balustrade; in the kitchen, Mexican chairs are placed around a table from G2. The units, made by Euroline, and hood above the stove give a hint of Provence.

Opposite: The front terrace. The sofa is made from latte by local carpenters. African stools from Amatuli are used as side tables.

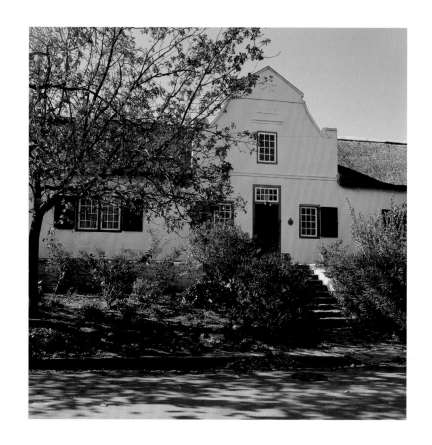

Christo Coetzee
Home
Tulbagh

Painter Christo Coetzee once scandalised the village of Tulbagh by dressing up in his mother's wedding dress and promenading up and down Church Street on quiet Sunday afternoons like a mad transsexual bride. 'That was the *enfant terrible* in him,' comments Jo-Marie Rabe. With her husband Piér, Jo-Marie has bought a number of significant Coetzee artworks and was a close friend for many years. Coetzee enjoyed a meteoric rise on the international art scene in the 1950s, running off to Spain with his art teacher and taking in the influences of Velásquez with princesses, dragons and castles along with the horror of Goya's Spanish civil war. The growth spurt was Paris – he was bought and promoted by Left Bank dealer Stadler as well as *Vogue* photographer Anthony Denny. His abstracts were energised – great swirls of colour – and his topics satirical verging on surreal. For a while it seemed that Coetzee was becoming famous. 'But,' he told his friends, 'fame is overrated.' His greatest personal need was for his roots. He came back to a South Africa that had entered the cultural laager of apartheid and, when he set about courting the Afrikaner establishment, he met with rebuff after rebuff. He bought a Cape Dutch cottage in Tulbagh in the early 1970s. 'What attracted him was the light which is radiant, clear, luminous.' You might consider the rooms in this cottage as installation art. The Rabes recall that Coetzee very rarely changed anything in the placement of objects or paintings: 'In the studio at the back, there was energy and works in progress. He painted over older canvases, walked on canvases like Jackson Pollock, moved everything around. Each tablescape or collection was an *aide-memoire* for him.' Even as his art veered towards the mundane and safe, his lifestyle became wilder and the layering of rooms a testament to his past. 'Here he would have a *jonkmanskas* but with Catholic altar candlesticks on top of it. The heretic and the devotee bound into one another.' He loved the paradoxes of the Catholic baroque and his portraits of Madonna/Magdalen brides reflect his inner world and serve as reminders of who he had been, his relationships, his obsessions. The furniture was equally eclectic and random, an inspiring *mélange.* A young male companion died in a car crash and Coetzee was shattered. He was lonely and bitter. Yet he continued to make art. No matter how difficult and opaque or baffling Christo Coetzee could be, he remained the kind of Faustian artist who paid for his art with his soul.

Above: Façade of Coetzee's Cape Dutch cottage in Tulbagh.

Opposite: Coetzee's self-portrait as bride takes pride of place.

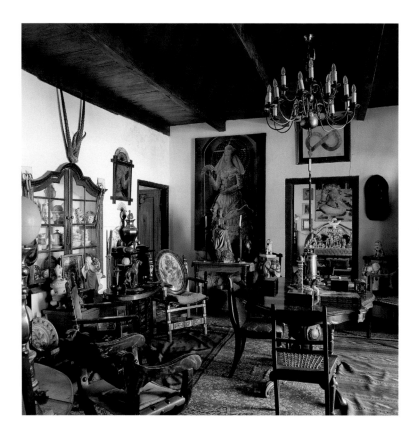

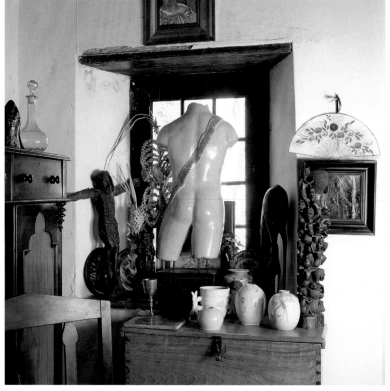

Clockwise from top left: Layered and enigmatic, in Coetzee's bedroom, every surface is crowded with objets of fetishishtic interest; examples from Coetzee's collection of painted glass and brassware; ceramic torso sculpture with motley 'art-swap' collection; the entrance is crammed with eclectic sources of inspiration.

Opposite: Christo Coetzee's studio in a converted waenhuis with strong natural light, and walls and ceiling pristine so that he could work against a blank canvas.

House Lewin
Plettenberg Bay

A beach house in a league of its own with the kind of simplicity that can only originate from sophisticated forethought. 'This definitely wasn't going to be a trophy house,' says owner Lucille Lewin of the iconic beach house on Robberg. 'The brief to architect Seth Stein six years ago was that we did not want to disturb the environment. The peaceful and lovely beach and dunes were fragile and even then there was evidence of jarring and undisciplined building. We wanted visual silence. The house expresses its South Africanness, not in any over-determined or obvious way, but there is a distinct feeling that it is secondary to the landscape and almost part of the fynbos.' London-based architect Seth Stein, who had worked together with Lucille Lewin on various projects, pointed out that sooner or later there was bound to be a 'surge' of building around them as Plettenberg Bay's property boom continued. Stein came up with a brilliant solution. 'There is no communication with the town or the houses around us, no windows facing in that direction. Many beach-house owners have an indiscriminate love of sea views that take in amorphous sweeping surrounds. Seth very cleverly gave us a secret view, framed in latte and maximising the best aspect. We had seclusion and privacy, yet were able to embrace precisely those elements of fynbos, beach and ocean we enjoyed.' The design was sensitive enough to include a 300-year-old milkwood. Seth Stein's design was a complex yet satisfyingly simple response to the challenges of the site. He wanted powerful, even brutal forms, with a blank façade to screen out visual noise from a crowded neighbourhood. Although the materials chosen were plain with rendered walls off-white, the local resource of craftsmanship meant that the eucalyptus latte could be mounted on copper wire like handcrafted jewellery; in the same way the polished concrete screed in cloudy white is studded with rock crystals and amethyst. Says Seth: 'Right back at the beginning Lucille spoke about encasing the bedrooms in a box that floated out above the fynbos with an enhanced view over the bay. That was the conceptual basis. The first level is on a 40 per cent cantilevered slab with shadow gaps between floor and walls, a space illuminated at night.' The pulley system on counterweights is intended to give flexibility in the house's response to the changing light. Tug a cord and the effect is rather like a Mexican wave.

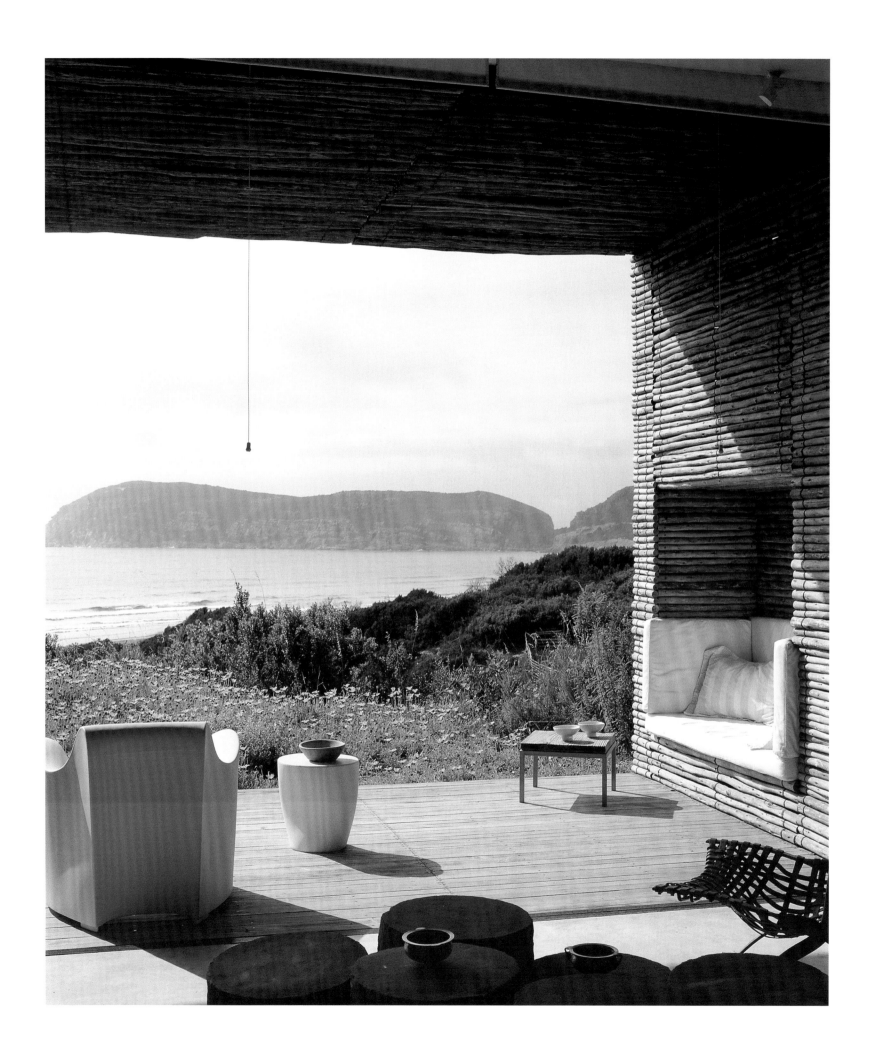

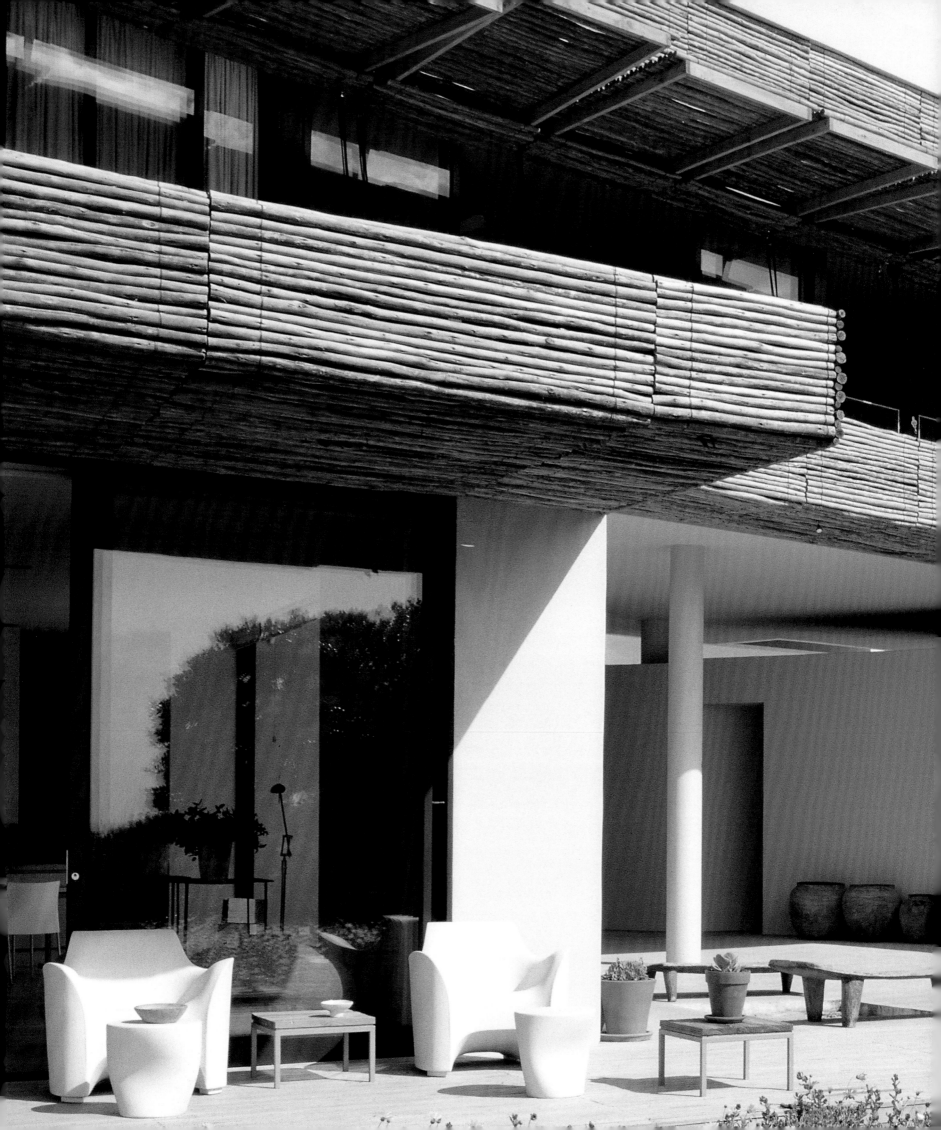

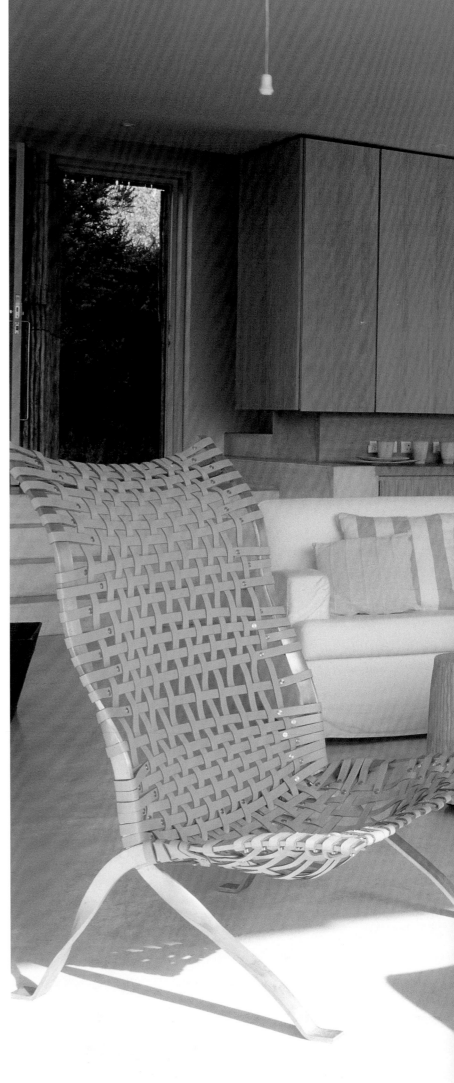

Above: In the courtyard, clay pots from Limpopo.

Opposite: The living area has seating that includes cotton duck slipcovers and stone tables from Life. The webchair was brought from the owners' London home.

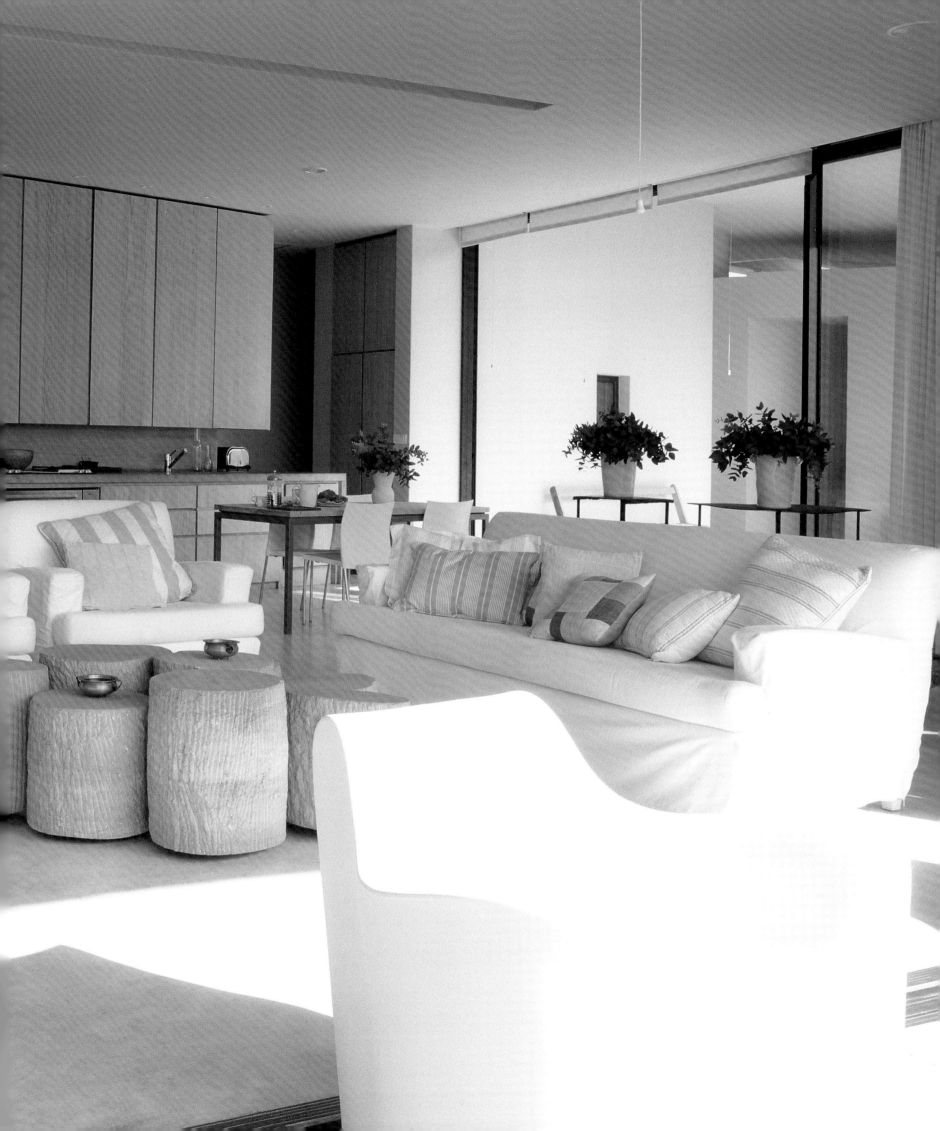

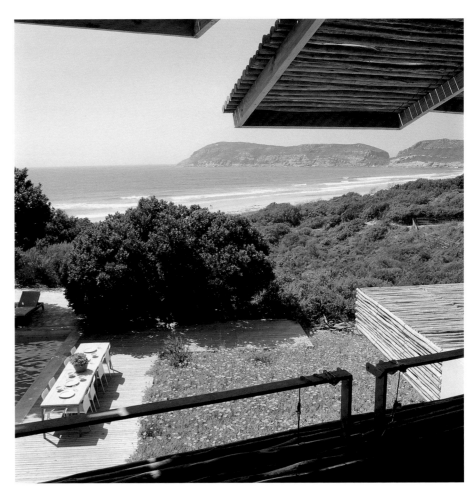

Above: From the top terrace views are towards the beach and the Robberg Peninsula.

Below: Despite its proximity, the house is secluded from the beach.

Opposite: A lounging eyrie on the roof of the house.

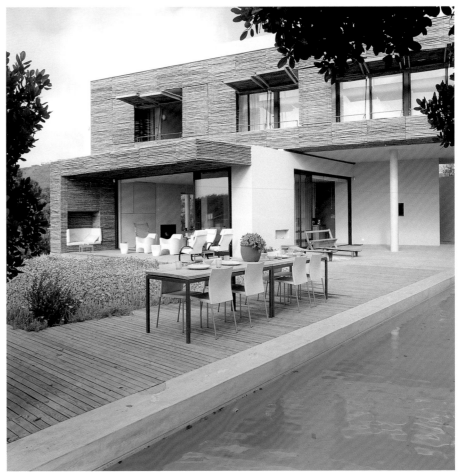

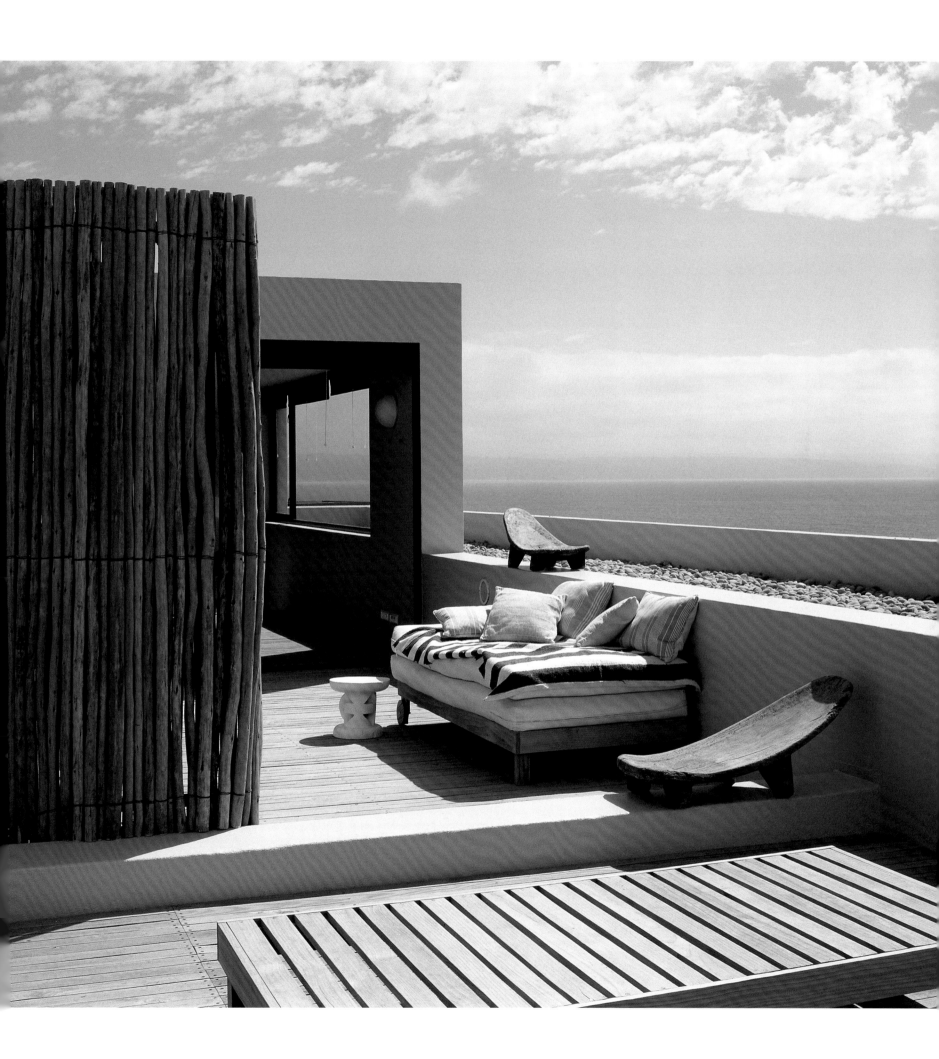

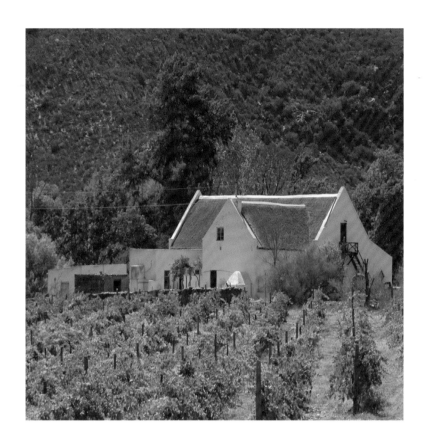

Klein Doornrivier
Little Karoo

Above: Farmhouse viewed across the vineyards.

Opposite: The house's original kitchen is still intact and the '50s Aga still works. On the wall the Mission chairs are from Lesotho. Baskets are from the Blind Society. The jacaranda wood-chopping board is actually a piece of paving from the garden. It has '50s lino on the floor and an ancient poplar wood ceiling. The table has always been here and it's covered with battered zinc.

Klein Doornrivier is an old whitewashed homestead at the heart of a once flourishing fruit farm situated somewhere between Barrydale and Calitzdorp in the Little Karoo. It's surrounded by a huge *werf* that's enclosed by a dry-stone wall, and it once straddled the old wagon road to the interior. Ancient barns and cottages, craggy oaks and orchards, pepper the landscape all around and to the south-east the huge, secret Langeberg shield it from the sea. On the other side, over the river and beyond the ridge, is the great, grey interior that stretches on and on, it seems, for ever until finally you hit the Plains of Camdeboo. Although the building's origins seem to be 18th century, its character today is mid- to late-19th century when it was embellished by the owners and enlarged. Inside, the floors and ceilings are of poplar wood, the electricity is antiquated and the plumbing prehistoric. There's a yellow Art Deco bath in the bathroom, a magnificent Aga in the kitchen and an old teak-built telephone kiosk in the pantry that was rescued from Ladysmith Railway Station in the '50s and turned into the grocery cupboard. Freezing in winter, it's also cool inside in the searing summer when all the shutters are closed early-morning to shut out the sun and keep in the cool, and left that way until dusk settles in when they're thrown open once again. Four square bedrooms face a deep east-facing stoep; two of them each open onto it via a set of lovely double doors, and a third set is the main entrance which opens onto a square hall leading to a 20-foot room that takes up the bulk of the building's interior. Everywhere the walls are painted in an off-white, no-nonsense enamel and the furniture's a mix of things that have always been in the house – some heirlooms and a variety of chairs, tables and cupboards that found there way here intermittently over time. Some are appropriate for their setting: big squashy sofas for the dogs, a bit of riempie from the Oudtshoorn district, the bones and skulls of dead creatures of the veld found on walks and brought inside, some Mission cupboards and seats possibly from nearby Zoar, old carpets from Hans Niehaus in Cape Town and pictures and maps of the area hunted down in sales and warehouses throughout the district and further afield. Today this is a comfortable weekend home that's still in the possession of its original family, and inhabited by a descendant, and it has a cheerful provenance enlivened by full-on weekend suppers and lunches (slow roast lamb) for the neighbours.

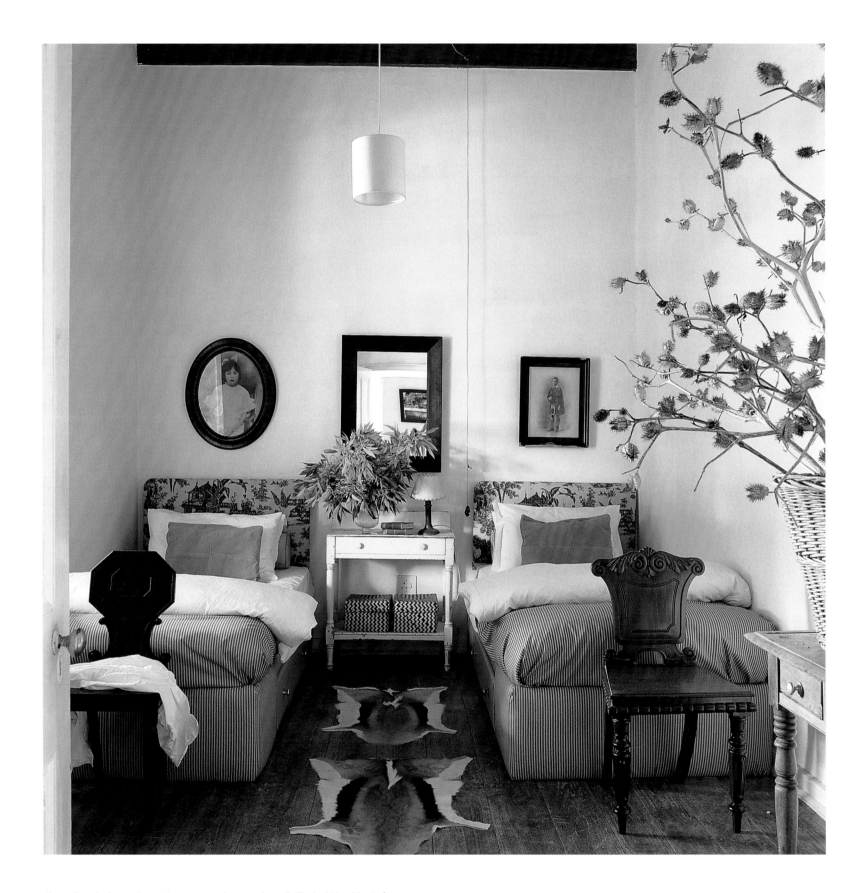

Above: Guest bedroom. Here various ancestors hang on the walls. The bedside table – in fact a washstand – came from Robertson, and the two English hall chairs from Hans Niehaus.

Opposite: The furniture is simple but robust. 'I often come up here by myself and just push furniture round all weekend, creating new views and settings. This is not about decorating. It's about creating stage sets,' says the owner.

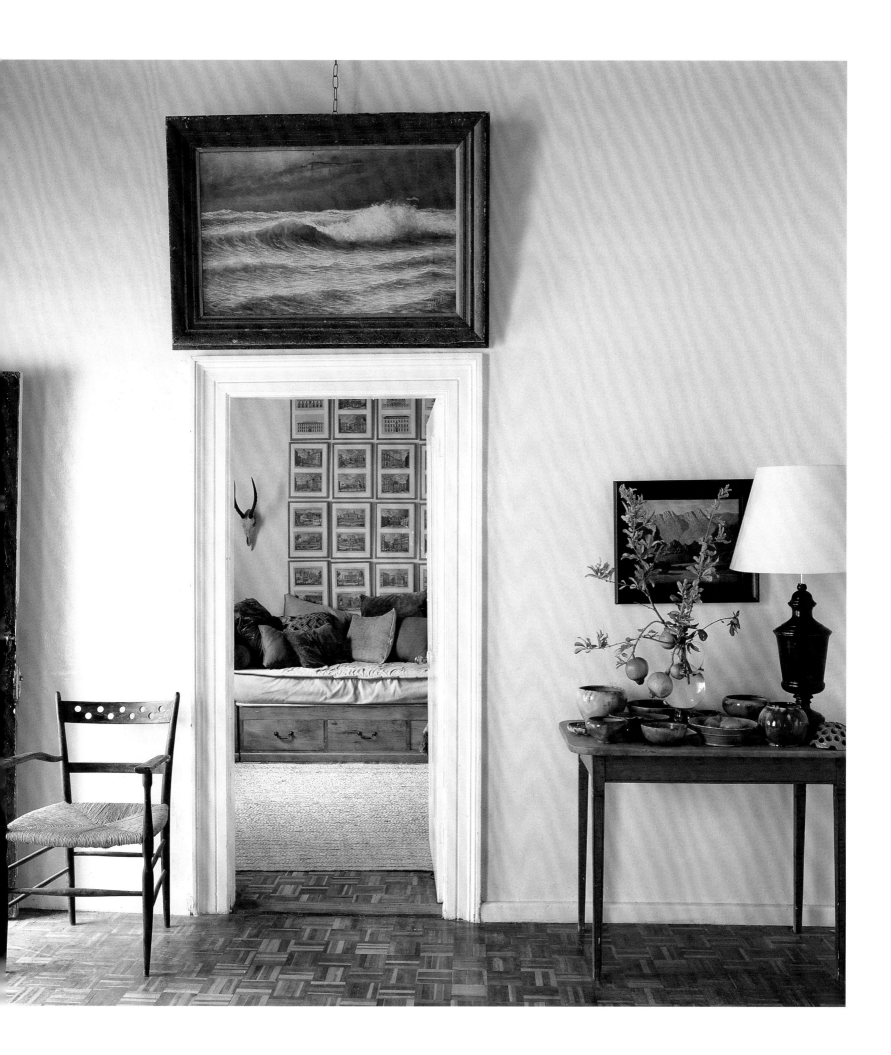

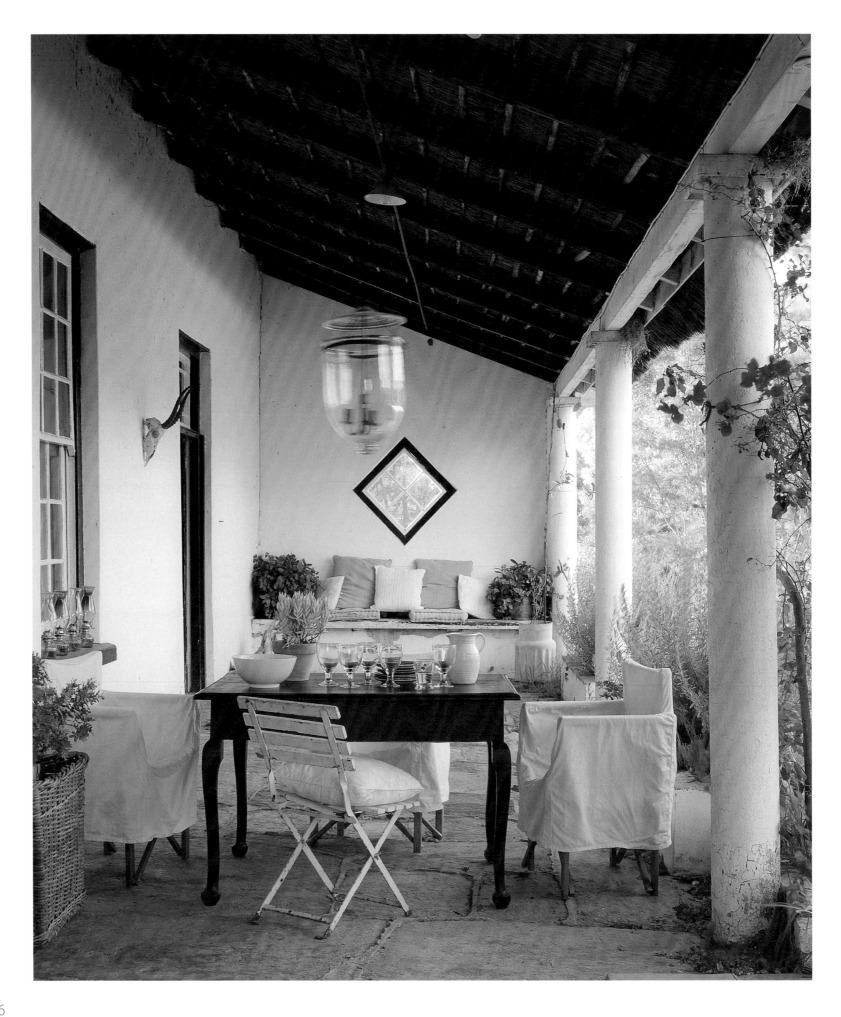

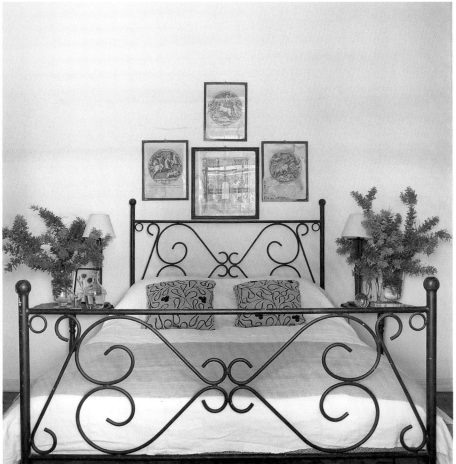

Opposite: The stoep under thatch.

Above: Pantry with phone box: 'The rusbank was discovered peeping out of the door of an office equipment warehouse in the Voortrekker Road. The laundry basket came from a deceased estate (of a basket collector) in Wellington.'

Below: Simple furniture for an unpretentious interior.

House Methven
Faure

A few turns off the R102 en route to Stellenbosch takes you to Faure. Lined up along a dirt road are a church and graveyard, a handful of tin-roofed homes, a school and a dead end. In this enclave of run-down rural charm, Michael and Anthea Methven have created a home filled with African pieces, his famous wire-and-paper animal sculptures, her off-beat charm and a fated sense of belonging. Behind an unassuming corrugated enclosure, the simple farmhouse hints at a rich past, layered with Victorian broekielace, sash windows, and a Georgian columned stoep. 'This used to be the original Voortrekker Road; our living room was the General Trading Store servicing coaches on their way to and from Cape Town,' confirms Anthea. 'That was the first church designed by Sophie Grey in 1848,' she adds, pointing down the road. 'It's an African story. I recognised the façade from a faded family picture when we came to bury my grandmother's ashes in that graveyard in 1997. It turns out that my mother grew up in this house.' Adds Michael: 'We also felt ready to leave Cape Town.' The Pan African Art Market was a dream inspired by West African markets,' he continues, speaking of the Long Street landmark he founded with Anthea in 1996. 'Eventually however, we couldn't manage its commercial success and maintain personal creativity.' They left in 2002 and Michael once again devoted himself to his signature wire-and-paper sculptures, earning him a following that includes Madonna, Donald Trump and the Osbournes. He also created a collection for Fendi Casa in Milan. 'At first we were a bit intimidated by the size and ramshackle state of this house,' confesses Anthea. Missing windows and doors were restored and larger rooms were created. 'You really had to think twice before breaking down exterior walls of up to 70cm thick and internal ones of 50cm. Also, nothing is ever level or straight in an old building and we had to convince the workers not to plaster too neatly, which was difficult because they have their pride and don't want to plaster *krom*.' It took Anthea more than two years to paint the entire house in what appears to be a fashionable taupe, though she is quick to point out that the tone is modelled on Mali mud houses, a shade that also apparently repels flies. 'All the doors, shutters and frames are painted in pale blue gum and pink saffron, the colour of a winter sunset,' she adds. These tones are perfect for interiors suffused with the vibrant colours of Pan African craft. Only the wire-and-paper sculptures are white.

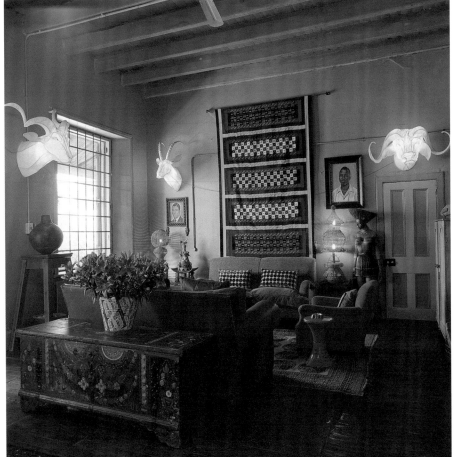

Above: Predatory paper sculpture of cheetah alongside concealed light sculptures in kitchen.

Below: In the living room sits a Black Forest wooden painted chest (1901) and a wedding cloth from Mpoti hangs on the wall.

Opposite: The outside dining area alongside the pool. Wire and papier maché by Mwande Mtini is against a wall with Chinese prayer papers.

Pages 132-133: Two oryx sculptures next to the swimming pool. In the distance, Table Mountain.

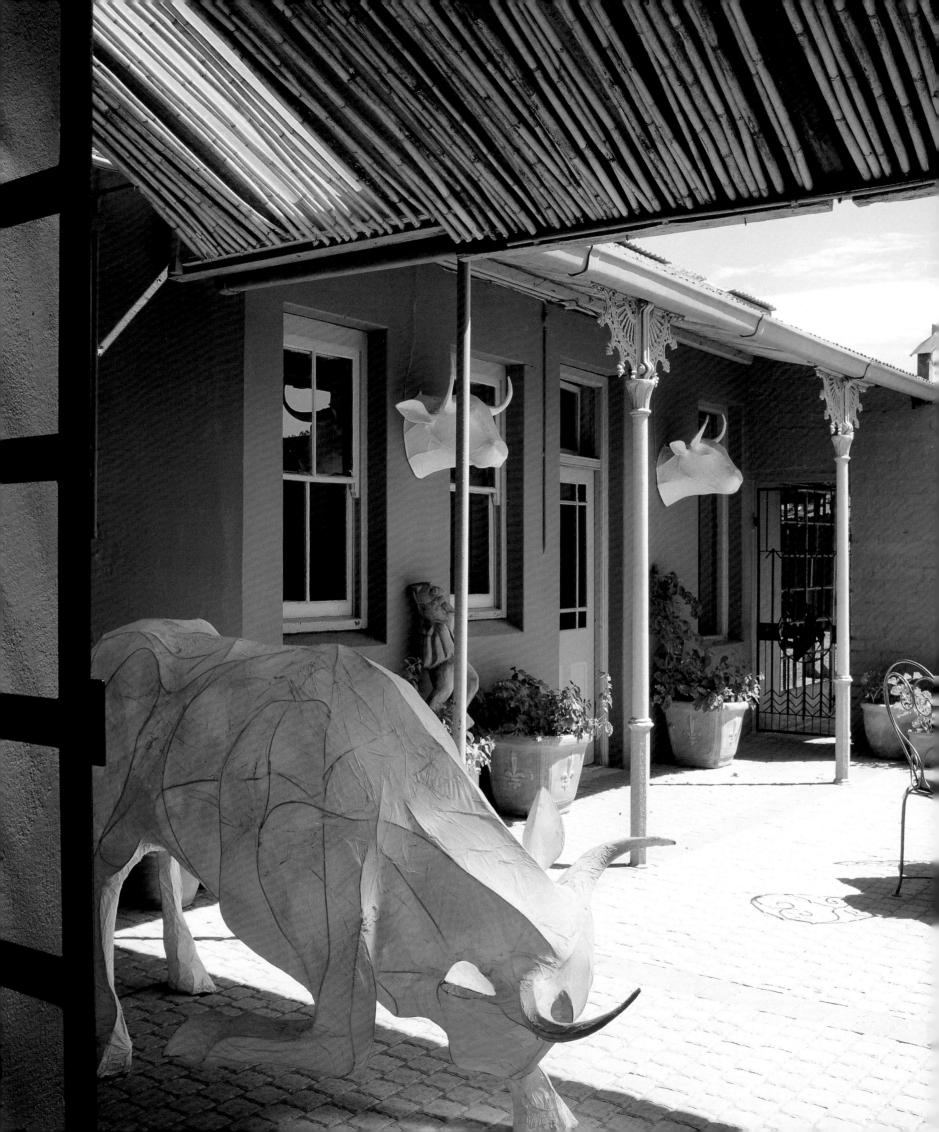

Opposite: The internal courtyard with broekielace detail and a grazing bull.

Above: In the sitting room the urn on its pedestal lights up.

Below: In the bedroom artefacts collected from across Africa and Madagascar.

Prospect House
Constantia

Set in amongst the vineyards of Constantia, the design of this house complements its magnificent aspect. Although only built in 1997, it was recently transformed and given a new lease of life. Says the owner, 'Fashion never stands still and neither should interiors. Life changes and all kinds of influences come to bear on how we choose to live at any given time. Anyway, how boring to look at the same picture in a familiar place – even an old cane chair can get a new lease of life in a different spot.' And so a large, fair-weather stoep was enclosed to become an informal sitting room-dining room perfect for entertaining. The stoep, an essential adjunct to any Cape house, was recreated, but you'd never know it was new. It has a lived-in look with sun-bleached cane chairs and seat cushions made from pink-and-white striped fabric recycled from old bedroom curtains. A bamboo blind strung over an iron pergola deflects the full glare of the sun and creates the right atmosphere for long summer lunches or dining under a starry sky. Big French windows open to the sitting room-dining room 'easily capable of seating 60 comfortably for dinner', where Pierre Cronje was commissioned to design a pair of cupboards recessed into the walls to look as if they'd always been there, an illusion enhanced by ageing the glass to make them look even older. Master paint specialist Freya Lincoln studied the detail of original 18th-century prototypes and found just the right shade of apple green with tortoiseshell panels and lined them with aubergine to match the (recycled) velvet curtains. Here too, old Indian tiles on the tables were brought in from the swimming pool, Walter Meyer paintings were shifted to a different context and an old Cape bench from the original stoep was brought inside. Other rooms also received a makeover. A smallish but high-ceilinged bedroom was redone in blue-and-white painted stripes enhancing the height of the space. Underlining this are swathes of gingham silk looped from the bedposts to an iron orb suspended from the ceiling. Another bedroom took shape with a small cache of Indian fabrics bought on a visit long ago and discovered in a chest: 'There was so little of it that the curtains had to be really small, but I had kept it for ages and knew its time had come.' Heightened formality was reserved for the drawing room. 'This has to be a strictly blue-and-white room,' said Nina Campbell on a visit. Curtain rails were replaced with pelmets and the result is a French drawing room: tailored, cool and refined.

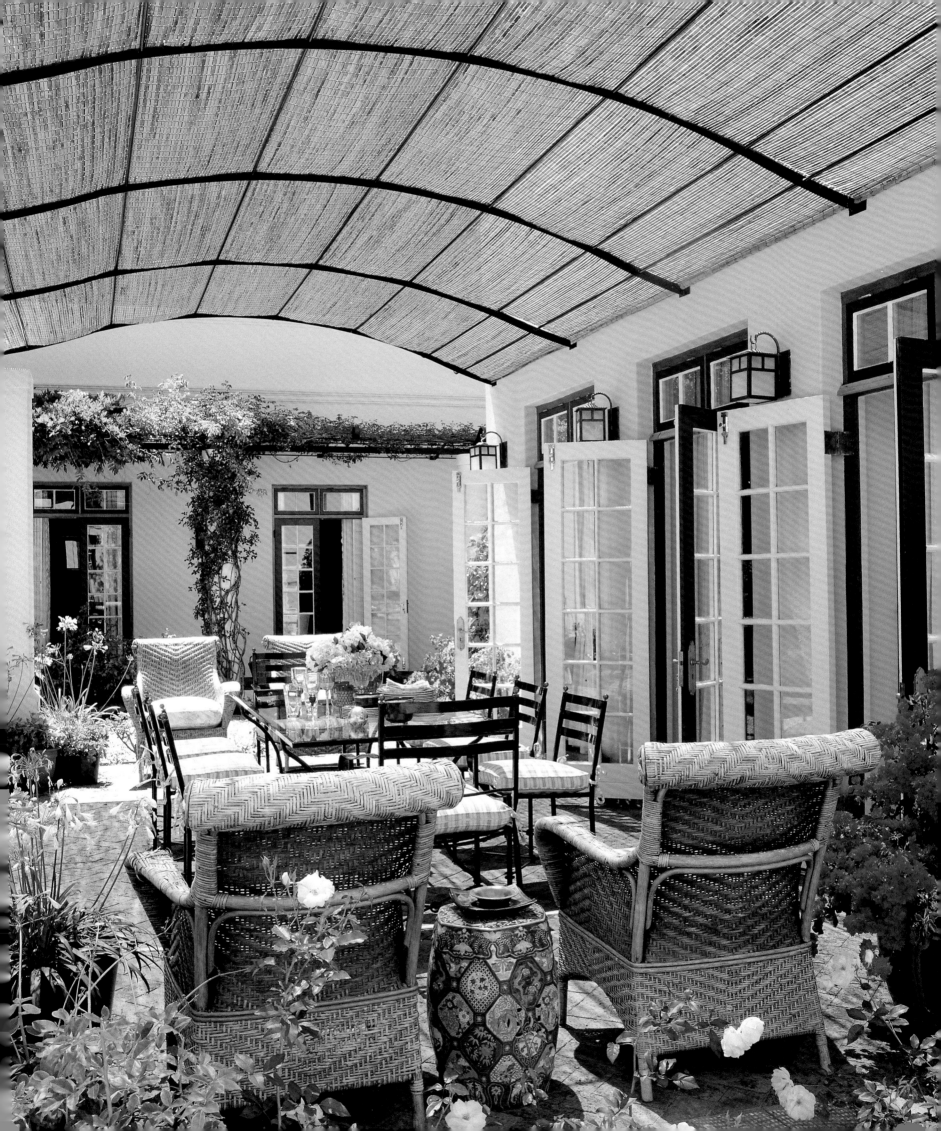

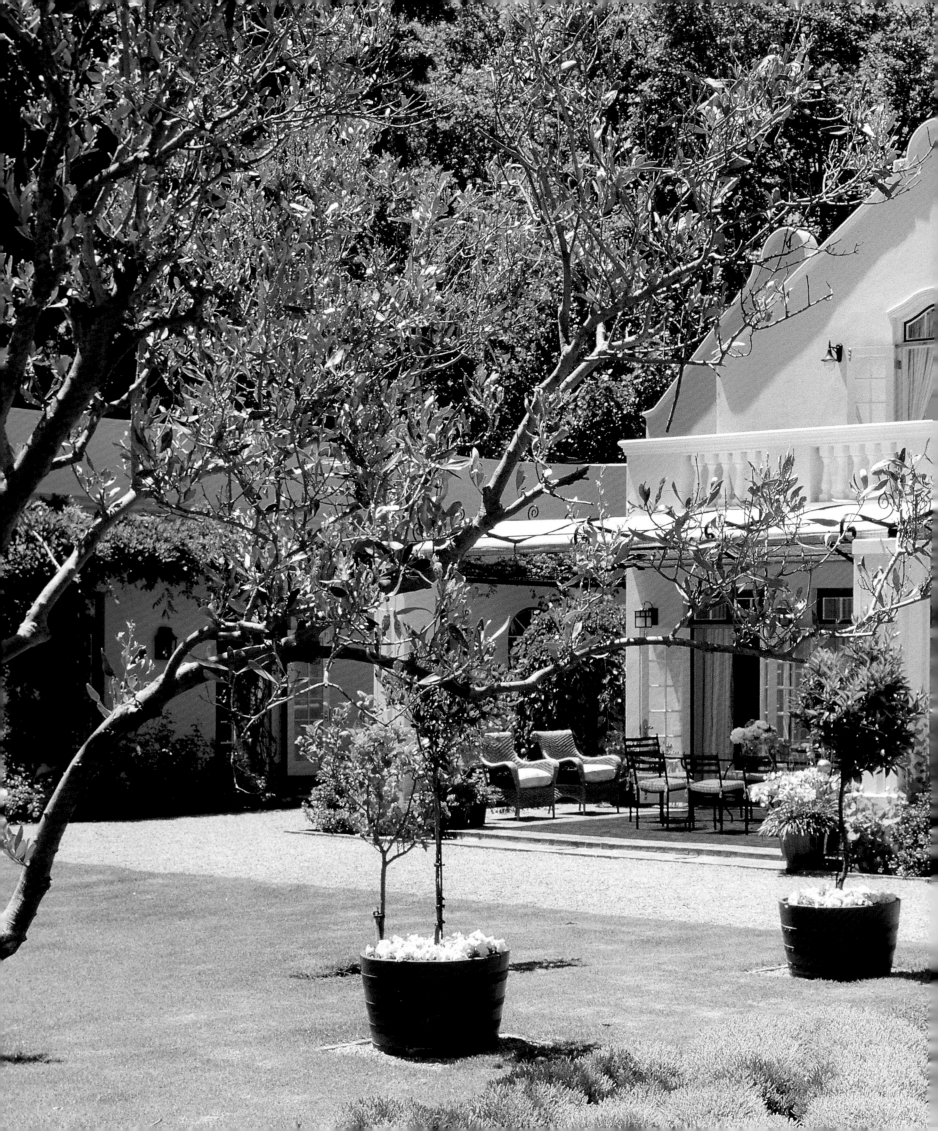

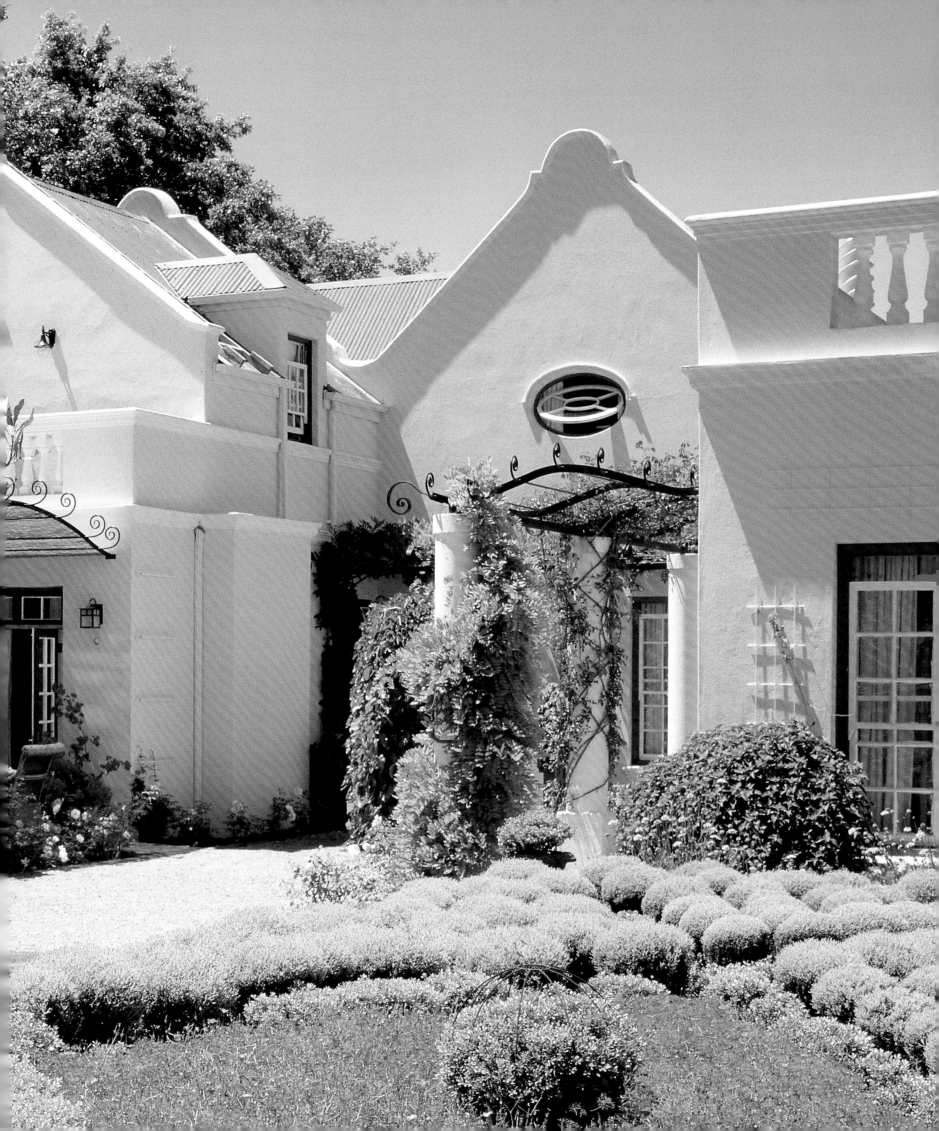

Above: In the dining-room, the ottoman covered in Nguni cowhide is from Nina Campbell and French pelmets are from Swain's Soft Furnishings.

Opposite: The Indian-styled and patterned bedroom with its embroidered eiderdown from Cotton Gallery.

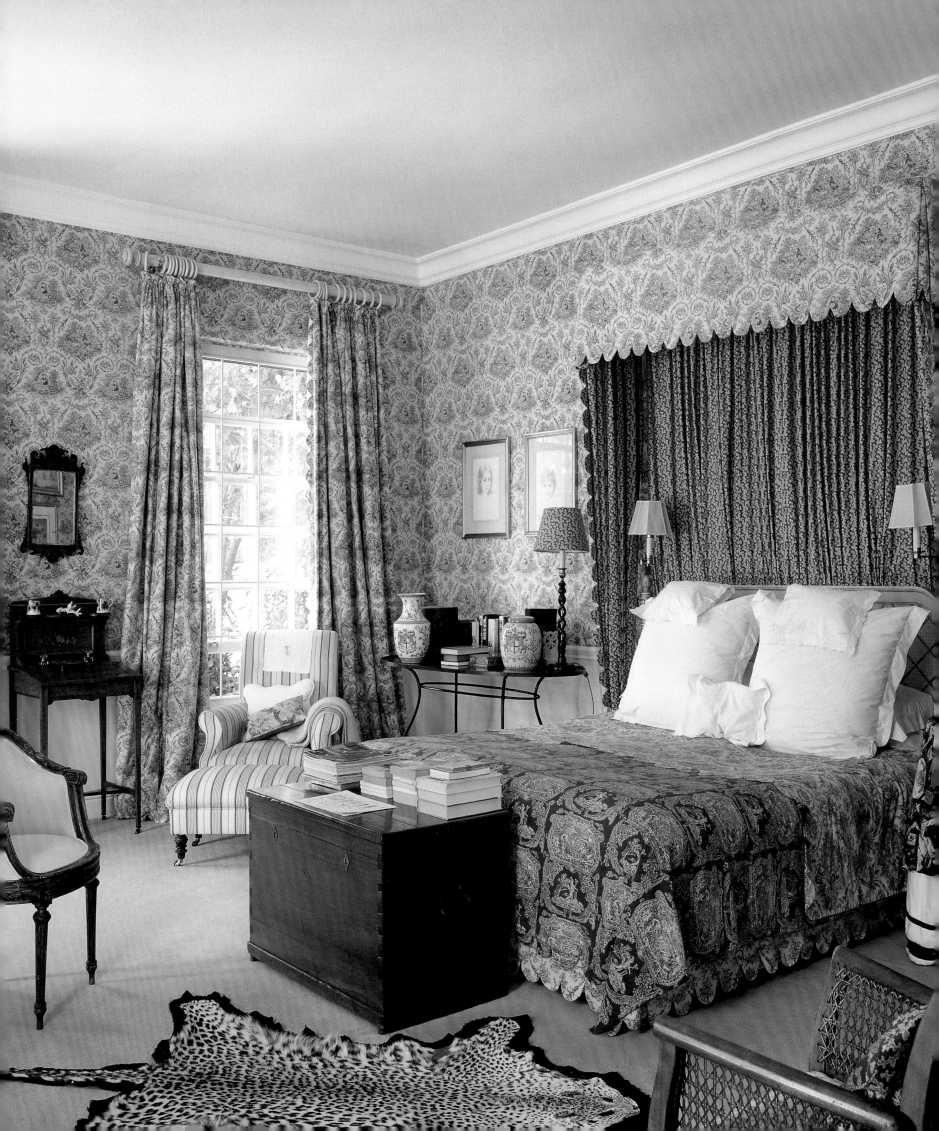

Petrava House
False Bay

Above: Upstairs, the unashamedly shell-strewn bathroom derives its inspiration from childhood fantasy and a sense of whimsy.

Opposite: View over False Bay from the balustraded terrace.

Page 144: It was the elegant stairwell in the entrance hall – worthy of Scarlett O'Hara – that first caught the eye of the present owners.

Page 145: A contemporary Chinese mural depicting the sun hangs imperiously above the Biedermeier sideboard in the dining room.

Overlooking the huge arc of False Bay to the south of the Cape Peninsula, Petrava House was built early in the last century for an Edwardian admiral who wanted to spend his retirement gazing down at his beloved former base at Simonstown with its conflict-free harbour and the expanse of ocean beyond. In the 1920s and '30s it had its share of flapper parties and hedonistic scandals as locals and foreigners holidayed at the Cape Riviera; then faded a little as did the coastline's appeal in post-World War II years. Today it's the summer home of the Davies family, based in Hong Kong and London, who fell in love with its worn-out demeanour and went on to revive its glamorous pre-war elegance redolent of a life of leisure and entertainment, of balmy evenings and steamy soirées. Graham Viney was the catalyst: 'It was a challenge to incorporate 20-year-old furniture from the Davies' Hong Kong home into the context of a pre-War Georgian/Cape Riviera-style house,' he says. 'We tried to cross-reference the furnishings from different cultures while keeping the whole light-hearted.' The aesthetic sensibility gracefully combines Oriental with Occidental with respect shown to both decorating traditions. Petrava is situated on a stretch of coast overlooking Muizenberg and St James, once the holiday destination of choice for smart South Africans – and still the only place left with brightly painted bathing boxes. The charm of False Bay itself has never palled. You could be somewhere delightful on the Côte d'Azur; the distant blue haze is right and so are the palm trees, the vivid bougainvillea and the yachts bobbing about to the right near Simonstown. And inside Petrava House there's a raffish glamour you don't often find in South Africa – the high staircase hall with its shiny spiralling stairs, white-painted balustrade and ebony banisters, 1930s German furniture, even the entrance portal adorned with lotus capitals smacks of an iridescent end of Empire sociability, martinis and gin slings. It's also a little Hollywood, made for dramatic entrances and gestures, but with a delicacy and exotic flair that exemplifies the best of chinoiserie, traditional Chinese furnishings and modern Asian style.

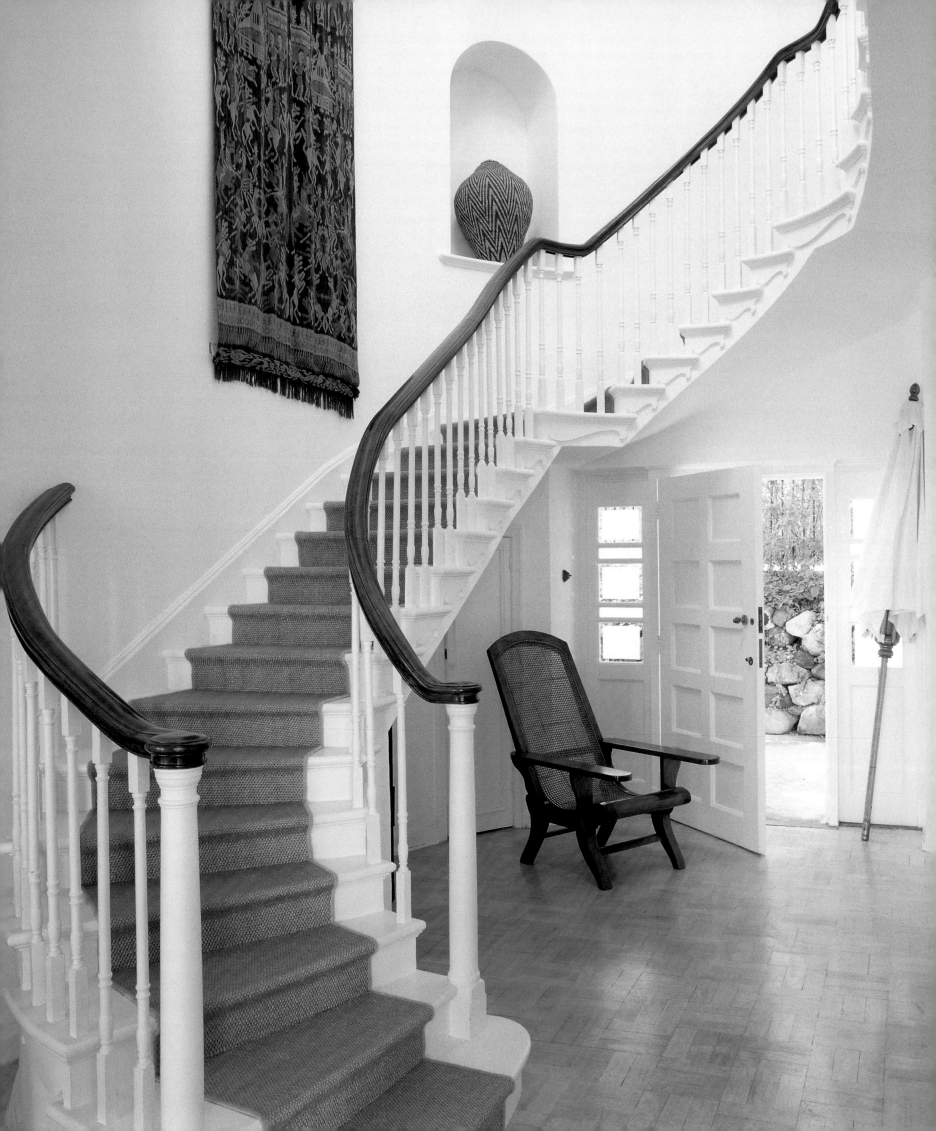

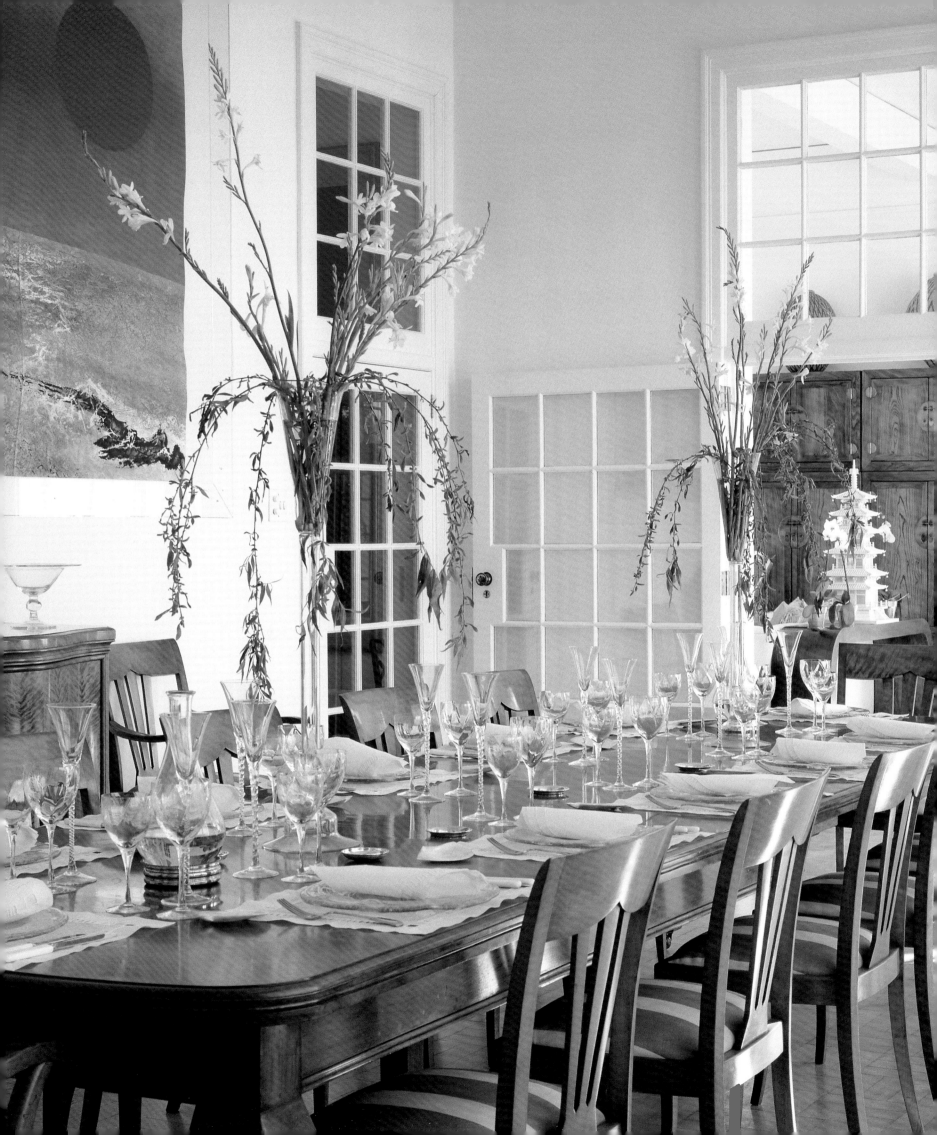

Montpellier Farm
Franschhoek

Above: A solid exterior gives this home the look of a French mas.

Opposite: The living room, French provincial urns above the fireplace and walls cladded with natural stonework.

Page 148: The spacious kitchen is an extension of the family room: in the background, artwork Windows to my Soul *by Jacqueline Crewe-Brown.*

Page 149: The Red Bedroom in both opulent and ascetic fabrics: 'Regatta Stripe' from Mavromac and Country Life toiles from St Leger & Viney.

The location is magnificent and high-risk: a mountain slope high above the Drakenstein Valley looking down on the Franschhoek vineyards, a small plateau dotted with olive trees, a river and narrow bridge, and the new Berg River Dam. Despite having the impregnable and massive appearance of a fortress, the property is especially vulnerable to fire and flood. Veldfires that devastated the Franschhoek Valley last year threatened the house and it took all the water in the lap pool to keep the flames at bay. Owner Jacqueline Crewe-Brown takes all this in her stride and has the curtains and fabrics dry-cleaned of smoke and soot, then goes back to painting in her upstairs studio. On the *krantz* above the house, there are two warring troops of Chacma baboons kept at bay with the odd firecracker. Eagles glide overhead as Jackie works in the newly established garden of fynbos and succulents, itself vulnerable to bulb-munching porcupines and the interminable rockfalls. Yet inside, the ambience is relaxed, warm and gracious. It's an interesting house that falls somewhere between a rustic French *mas* or country farmhouse and a monastery of virginal scrubbed stone and echoing cloisters. With help from the client, architect Tony Doherty designed an overscaled, thick-walled European barn on a mountainside. His architecture has a basic integrity – reflected in the use of less 'pretentious' materials such as natural stone, slate, Hessian, raw concrete and local timbers complete with imperfections. The end result, intended as a family home, is larger than life: 'My brief from the clients, old friends, was to keep it simple. They have a striking collection of antiques from Europe and Africa, including Ethiopia, and I would work around that.' Decorator Tessa Proudfoot worked with Crewe-Brown to create interiors that speak of comfort, ease and sophistication able to embrace elements from sources as diverse as Europe and Ethiopia. There are oversized sofas, massive refectory tables, carved headrests and Moroccan kelim or grass matting to connote Africa. Here the metaphors of a rustic pioneering spirit, a love of natural stonework and opulent hedonism come together with breezy insouciance. In the living room an eclectic French influence – think *Manon des Sources*, not overdone Provençal – is evident, with terracotta urns perched on the mantel of the huge vaulted fireplace. As in the sitting room and elsewhere, colour choices were inspired by the brilliant raw colours of Africa: turmeric, saffrons and deep reds.

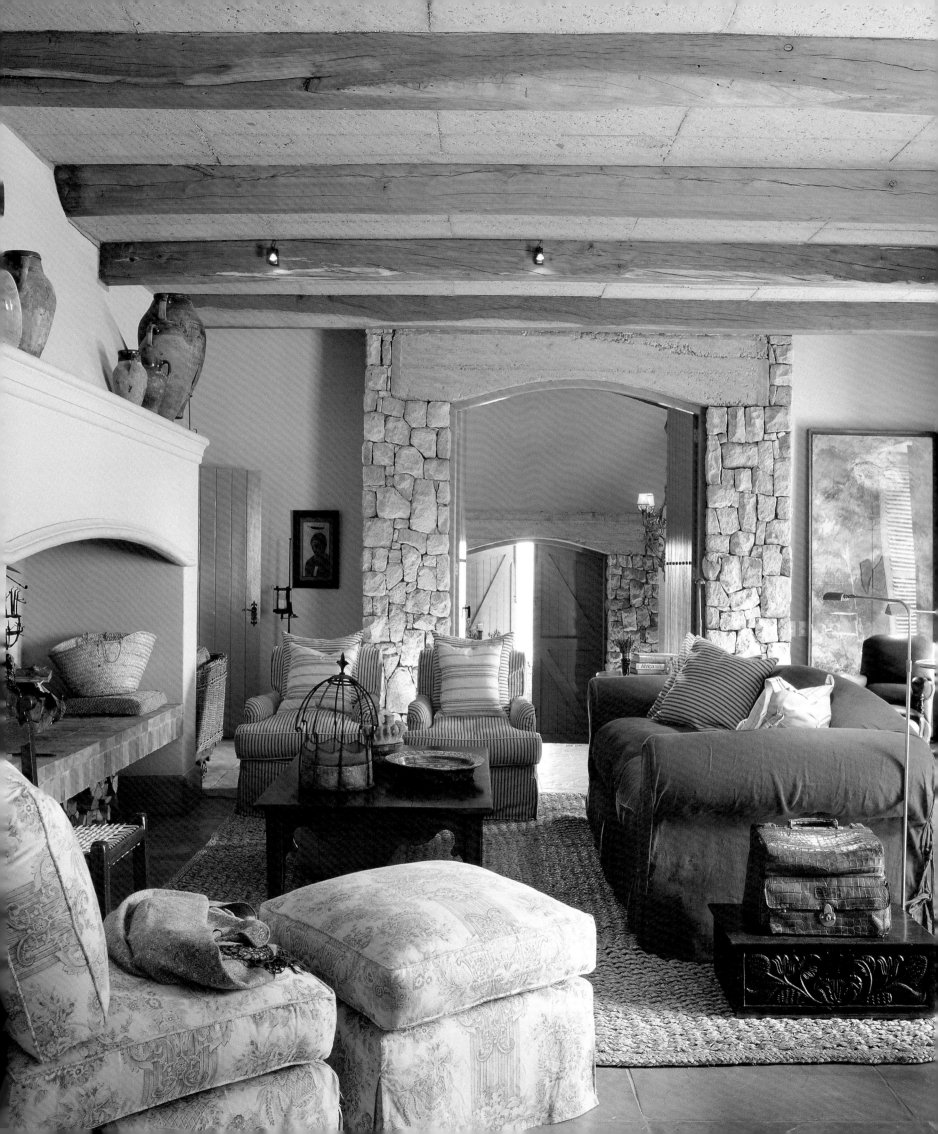

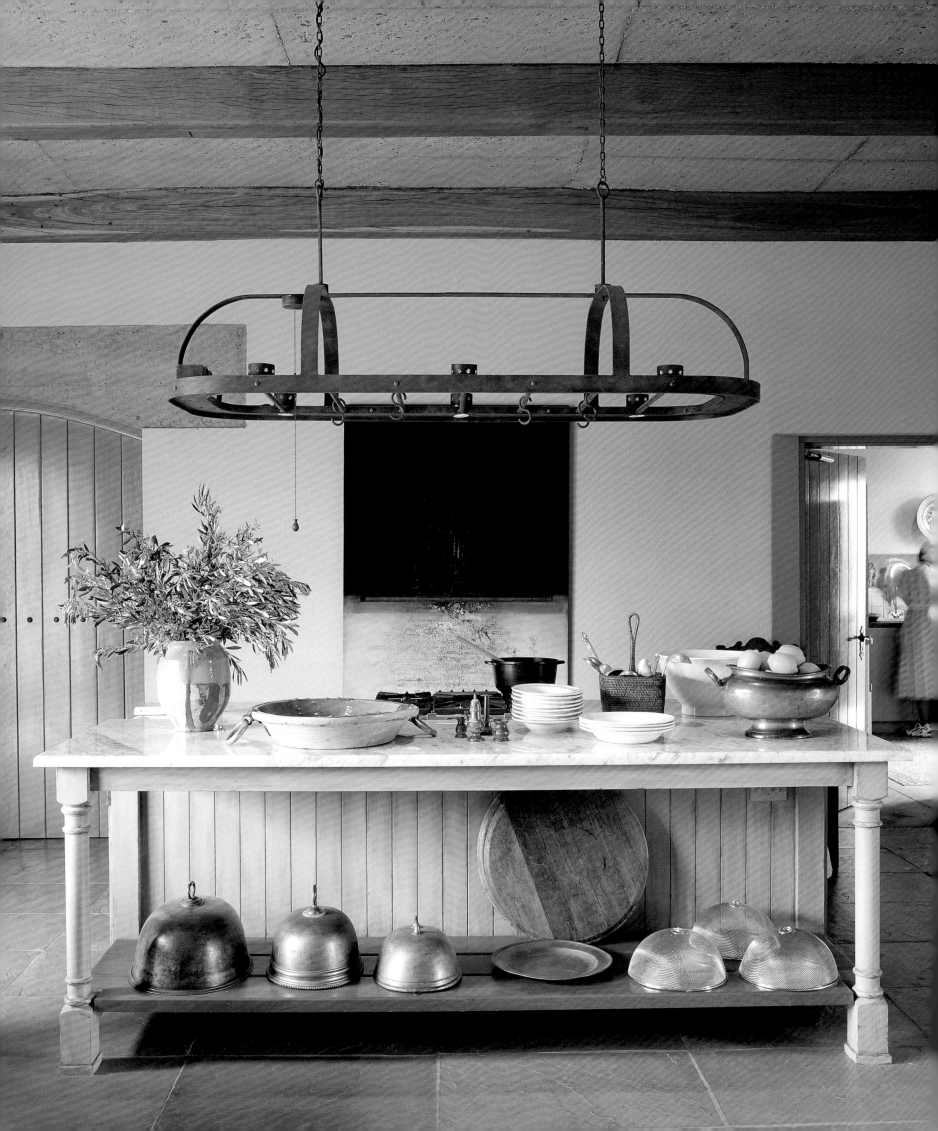

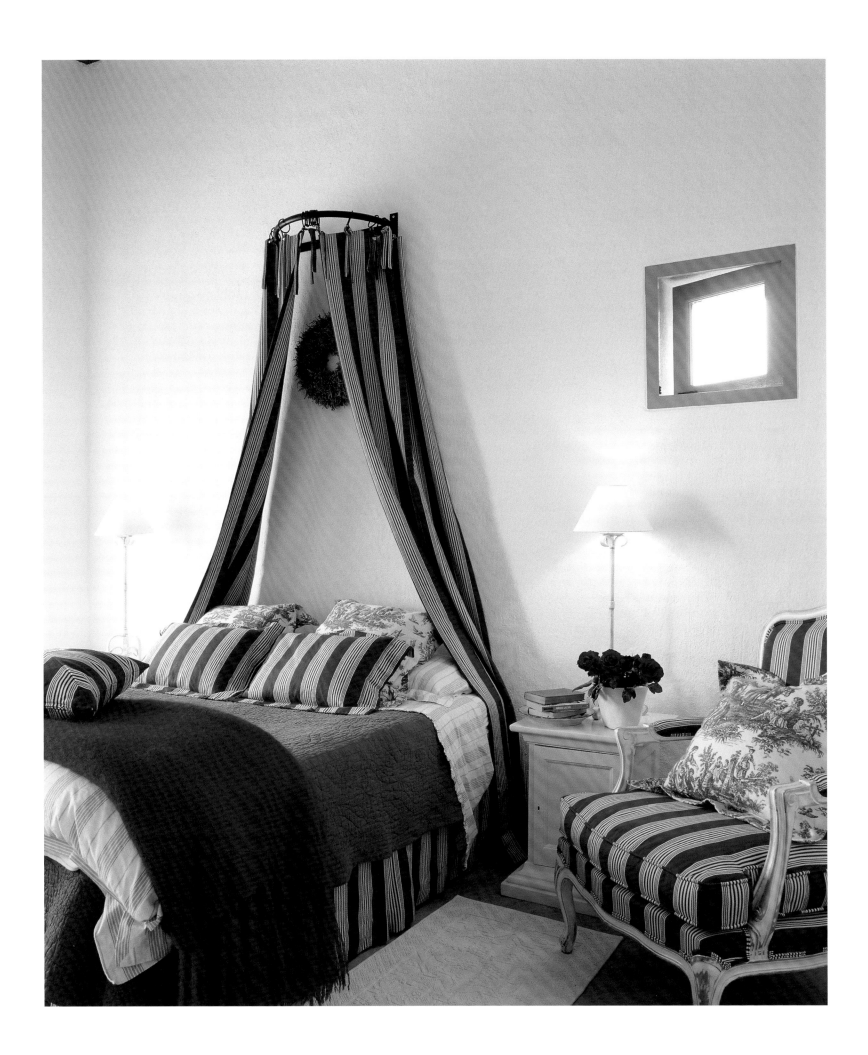

Jack's Camp
Botswana

Above left: Genuine fossils and wind-scoured skulls are among artefacts found in each tented area.

Above right: An outside view of the exotic, Arab-influenced tented camp.

Opposite: The library tent, connected to the dining tent by a covered walkway. Etchings on the wall all concern history and exploration. The wooden throne chair is from Tanzania. Peter Beard posters were gifts from Peter. The library is a treasure trove of years of Botswana Notes and Records. The guns hanging above the display case were used by slave traders.

Page 152: Historical and personal mementos.

Page 153: The swing bed is the most comfortable and hotly contested seat in the camp.

Safaris at Jack's Camp attract people of a particular mettle. This tented camp at the heart of the vast Makgadikgadi Salt Pans does justice to the Swahili term for 'journey', derived from the Arab *safara*, synonymous with adventurous expeditions into unknown Africa. Visitors here have included scientists, San/Bushman activists and Hollywood stars who are drawn not by the promise of the Big Five, but by the vagaries of nature in all its abundance and aridity, and an enigmatic landscape bearing the imprint of time. Managed since 1992 by the original Jack's son Ralph Bousfield and his partner Catherine Raphaely, Jack's Camp inspires through integrity and fabulous style. 'My father fell in love with the Makgadikgadi Salt Pans,' says Bousfield, who looks like someone reared in the wild with a leopard cub tugging at his nappies. Descended from a lineage of swashbucklers, his leonine mane, piercing blue eyes and deep tan once prompted director Anthony Minghella to describe him as 'straight from central casting'. 'We are the last small family-run organisation in Botswana,' he explains, 'free to operate across 40 000 square kilometres without boundaries, extending to where no modern man has been. There's an amazing feeling of being out there, on the remains of the largest ever super-lake in Africa, that once covered the whole of Botswana, portions of Namibia, Zimbabwe, Angola and Zambia. We're at the terminal point of the Rift Valley system, a tectonically unstable area in which faulting originally created the Victoria Falls and blocked the Okavango and Zambezi from flowing into the Makgadikgadi.' Raphaely continues: 'Jack's Camp is one of the last proper tented camps. Even the kitchen is under canvas. Our tents are subjected to the elements and have been repaired ten times over.' The green canvas, dyed to match an old jacket Bousfield wore as a child, is lined with printed fabric in burnt sienna tones; tents are layered with maps and North African textiles, and furnished with original colonial booty, military and campaign chests. 'We were inspired by the early campaign officers' mess from the Anglo-Zulu war in which Ralph's grandfather served. And there's also a touch of the eccentric professor absorbed in research projects,' she adds, alluding to the extraordinary items on display in every tent. 'My family were great collectors,' explains Bousfield. 'My great-grandfather was the amateur collector Richard Granville Nicholson.' The family museum includes three of the largest hand axes ever found and curios abound.

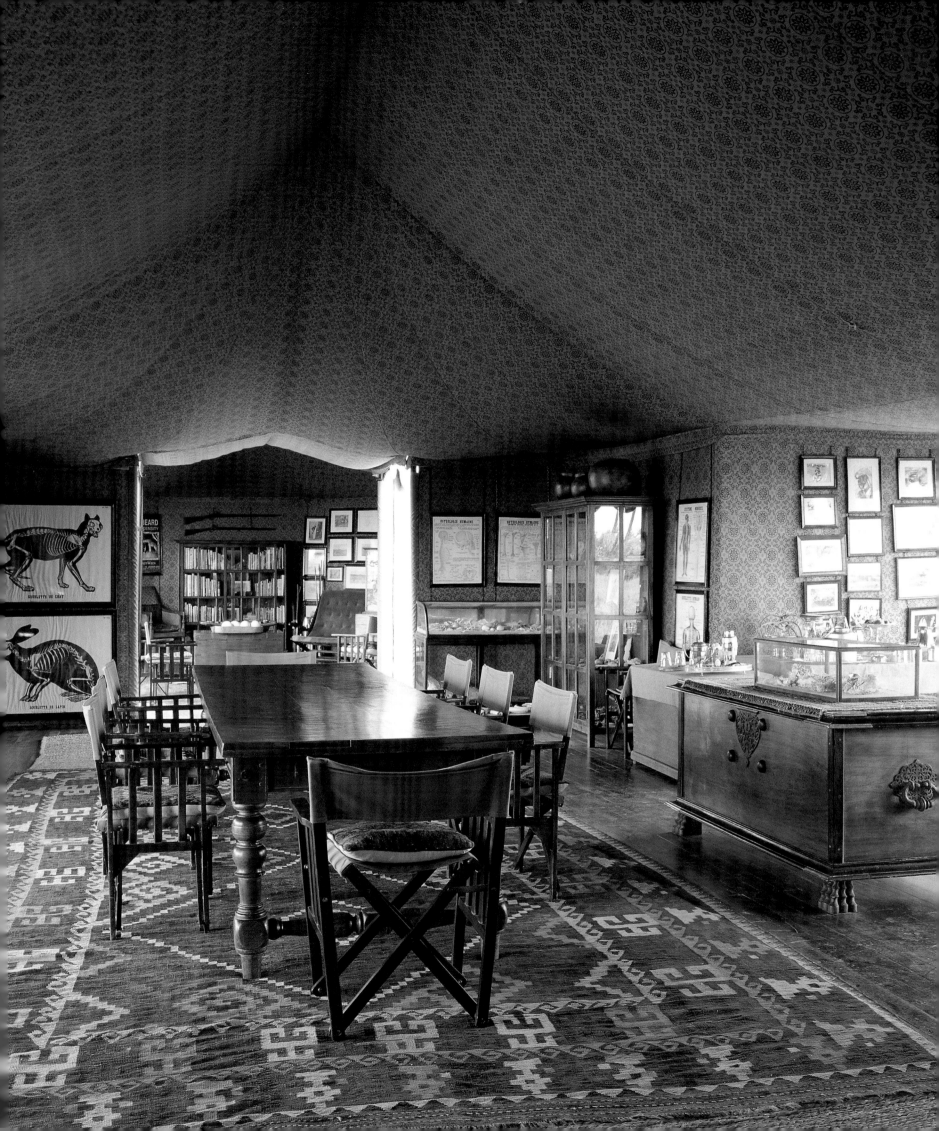

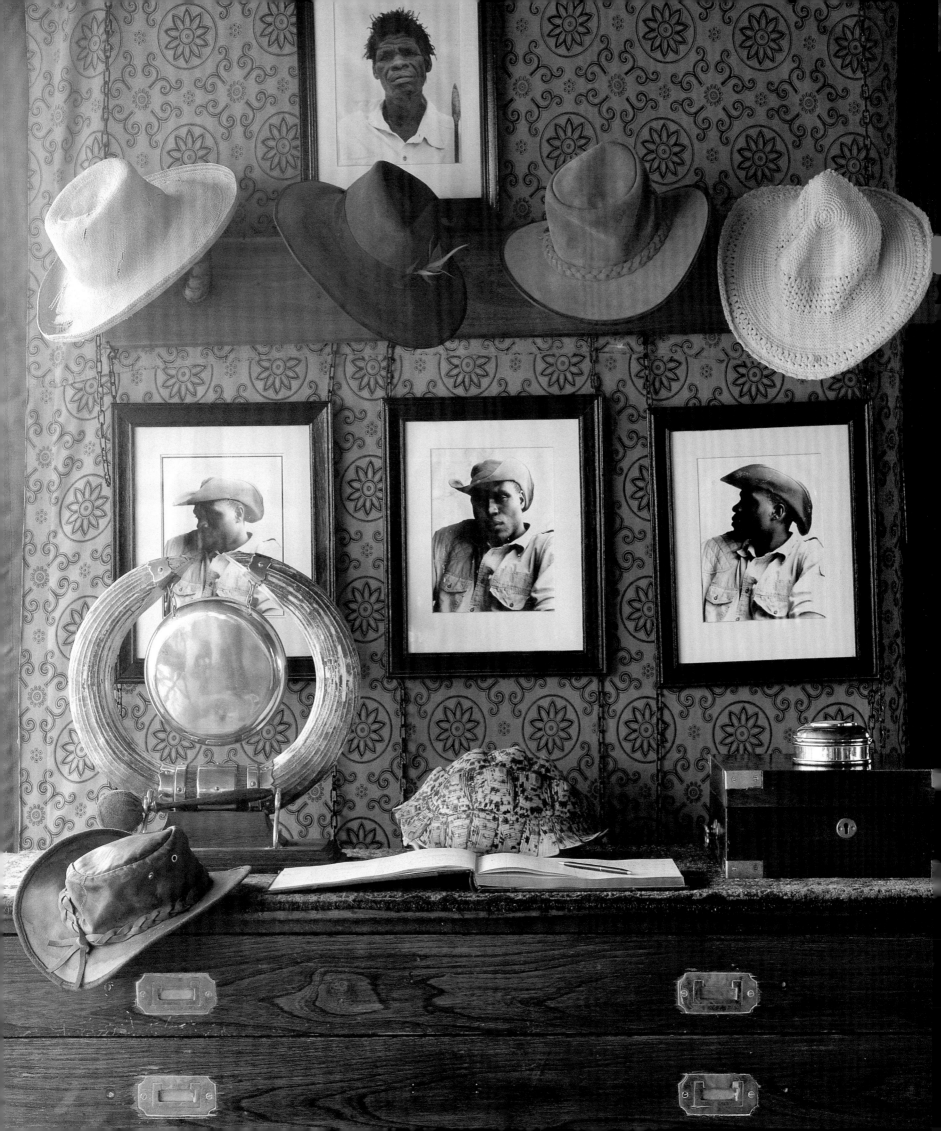

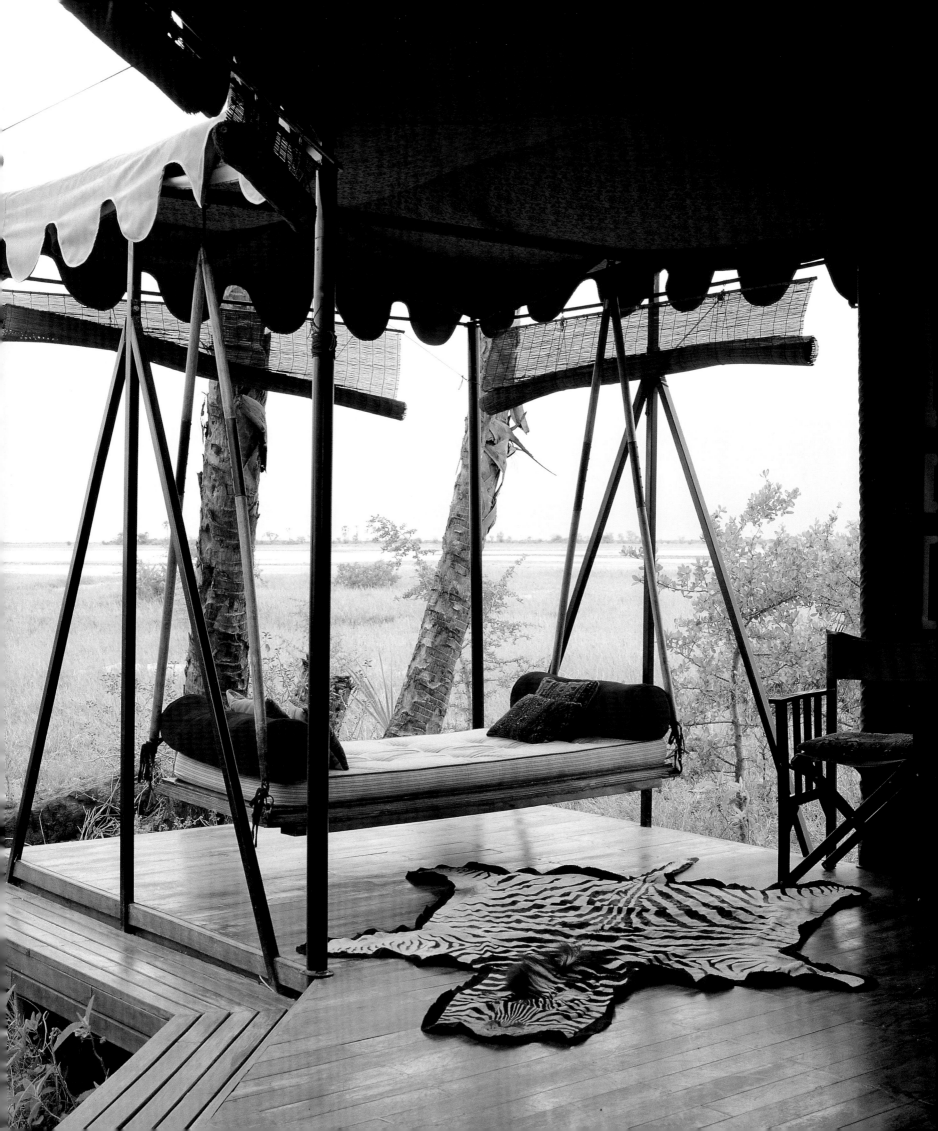

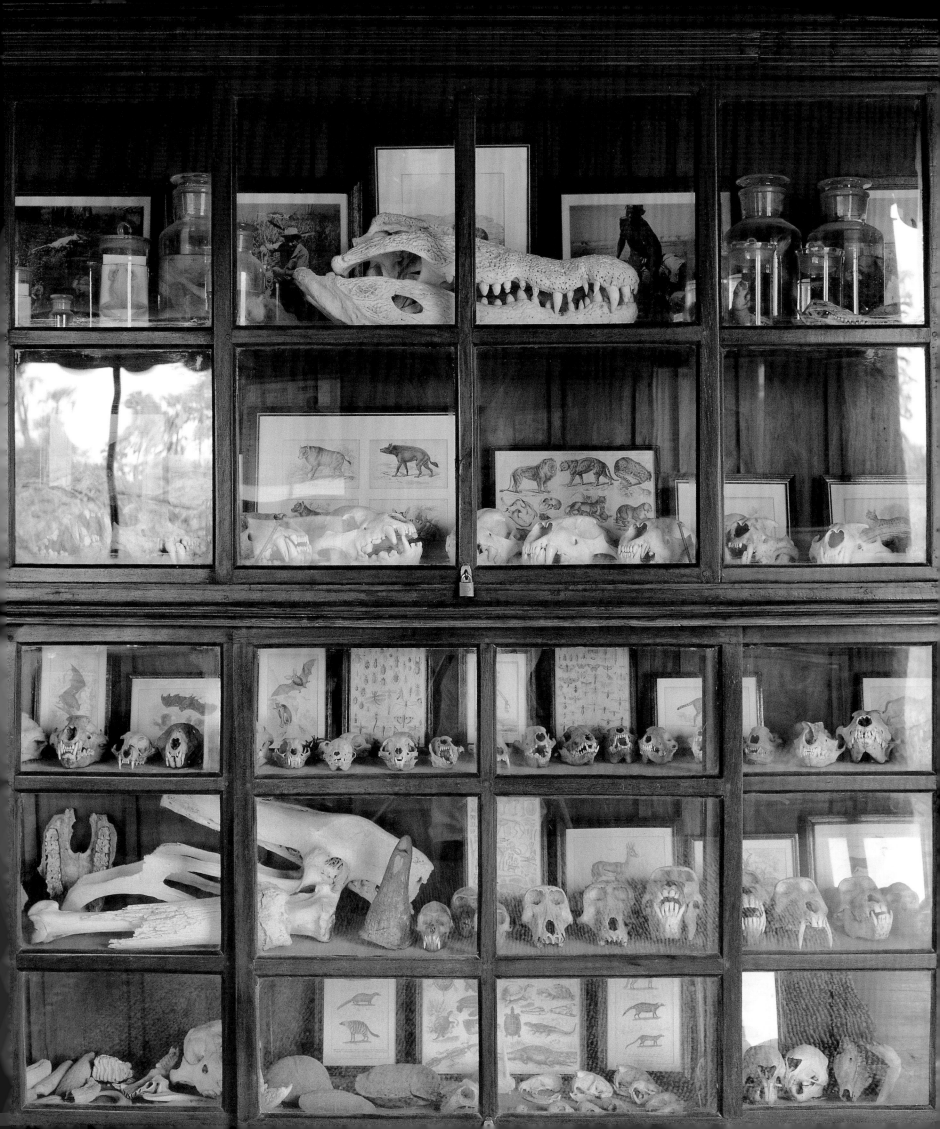

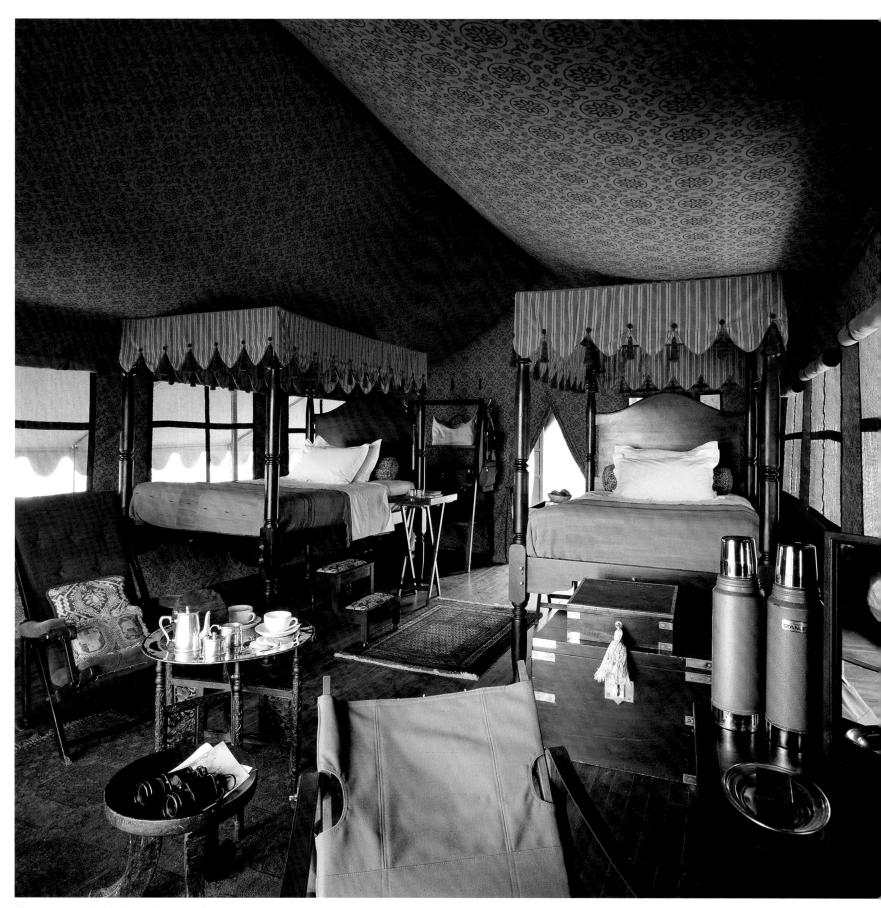

Above: Four-poster beds with striped canopies. The red-velvet trim and tassels are eccentric, 'camping up' the camp. The tufted campaign chair is a copy of an antique.

The carpets are Baluch rugs and Afghans.

Left: A display case with mammal skulls, including a huge crocodile shot by Jack, who is listed in the Guinness Book of Records *for shooting 54 000 crocodiles.*

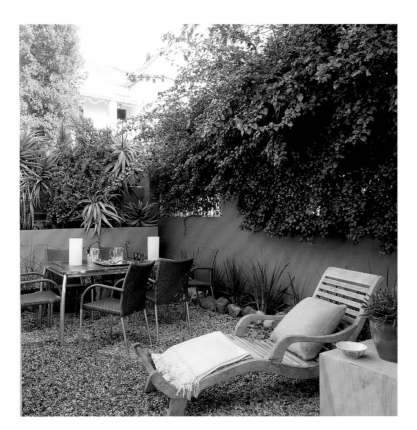

House Ferguson
Green Point

Above left: The small but secluded and lush garden is perfect for alfresco entertaining.

Above right: Designer and owner Geordi Ferguson.

Opposite: The living room with armless sofas from Cecile & Boyd's. The Perspex table is from Lim, the jacaranda stools from Life, and artworks are by Douglas Portway and Peter Eastman.

What kind of home does a stylish designer create for herself? Geordi Ferguson of Cécile and Boyd's chose a setting entirely personal and unselfconscious when she set out to renovate a single-storey Victorian cottage for herself, helped out by her partners Boyd Ferguson and Paul van der Berg. She took a long hard look – the project took two years to complete – at the shell of the interiors and opted for spaciousness, ceilings as high as a loft, almond and off-white luminous tones and pale sea-grass floors. The central living space is generous enough for elegant entertaining – the mark of an inherent classicist who describes herself as drawn to blond tones and light airy spaces: 'My preferred habitat is definitely serene.' There are whitewashed African stools conceptualised by Boyd Ferguson for Singita Lebombo, ruffled-trim linens from the Conran Shop, Starck chairs and a bleached-ash drinks cabinet. A chest of drawers was designed by Geordi Ferguson in heavily grooved and white-paint-rubbed teak, inspired by Jean-Michel Frank. The gentle buttery ambience is sharpened however by raspberry pink, sage green and French blue accent colours. Unexpected strong visual interest is provided by a watercolour-print Cole & Son wallpaper in the bedrooms as well as a startling turquoise-and-scarlet figure in enamel on canvas by Peter Eastman, the Douglas Portway above the fireplace, an abstract by Cameron Platter and elsewhere a visually arresting portrait by Pieter Hugo from his acclaimed but disturbing *Albino* series from Michael Stevenson Contemporary. Approaching the cottage with its pale grey walls and black gloss London door, you would never suspect the height and depth of available space, the warmth and unstinted volumes of maximised light, or the very strong and individual signature of a designer who knows how to balance her neutrals so perfectly and play them off against accents and strong graphics.

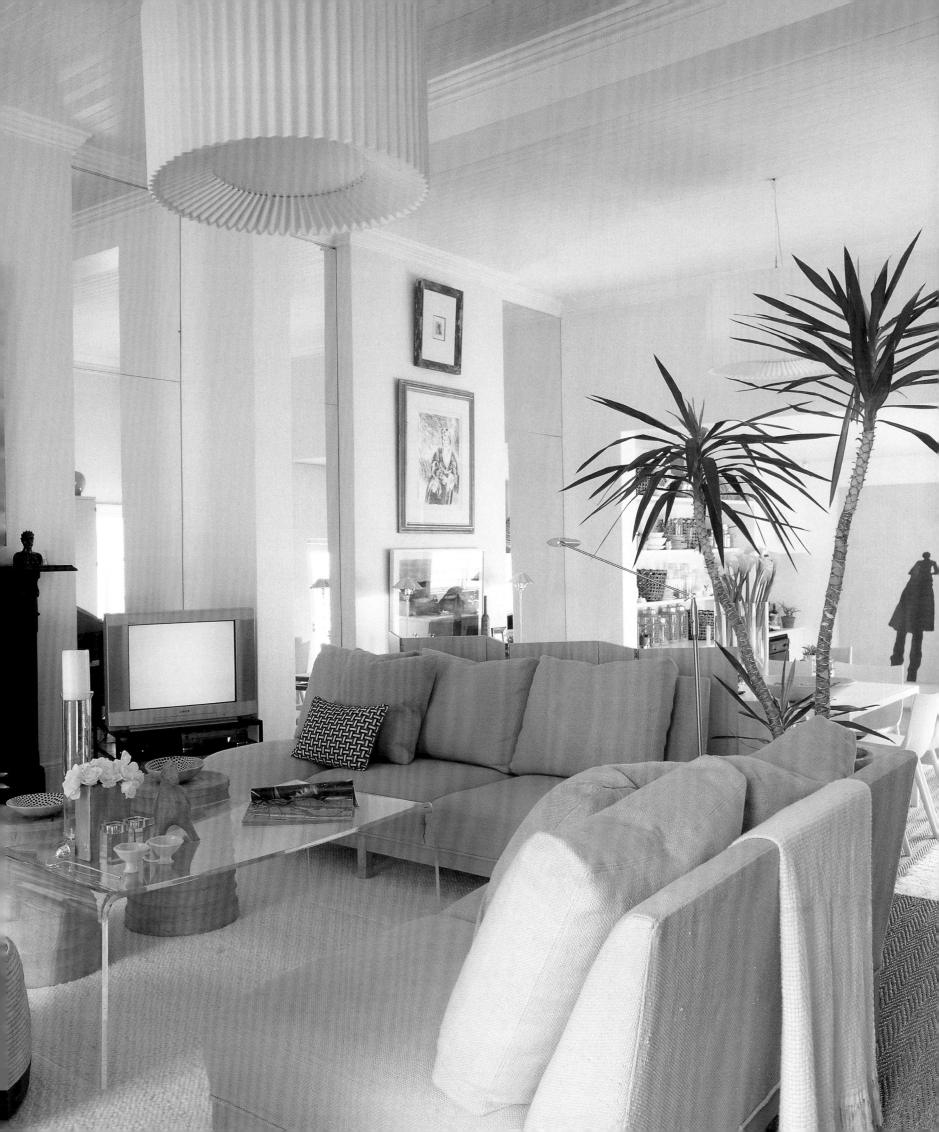

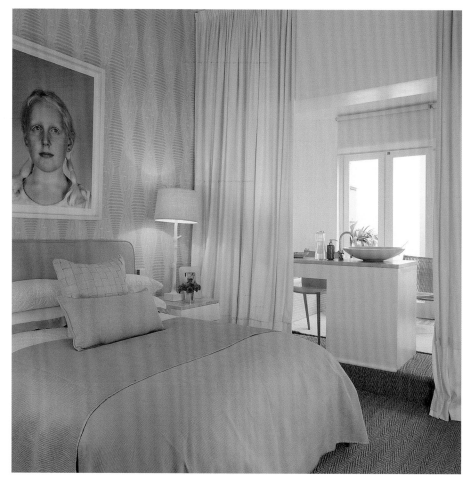

Above: Master bedroom with Pieter Hugo's photograph Danielle. *Twig lamp from Cécile & Boyd's and linen basket-weave cushion – Geordi Ferguson's own design.*

Below: Chest of drawers inspired by Jean-Michel Frank and custom-made for jewellery and accessories. The twig-framed make-up mirror is antique.

Opposite: The dining and living areas abut each other and are separated simply by a low concertina screen.

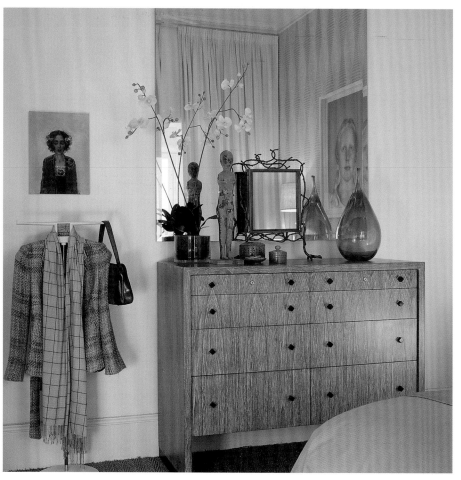

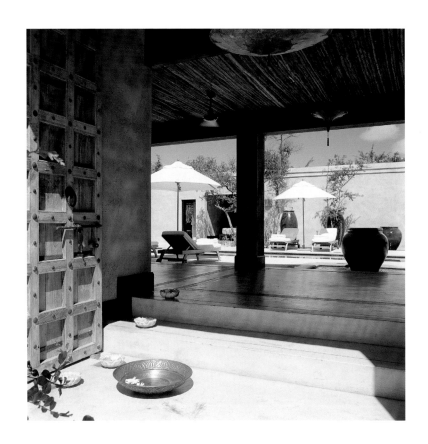

The Waters at Royal Malewane
Mpumalanga

Above: The massive entrance door forms a barrier between the wilderness outside and the serenity within.

Opposite: At night the pool courtyard is lit by lamps.

Pages 162-163: Sybaritic doesn't come any better than the poolside lounging under blue African skies. The interior courtyard of the spa overlooks the 25-metre-long heated lap pool.

Page 164: For privacy, curtains shield the poolside and treatment room.

Page 165: There are four bush casitas, each semi-open to the bush. These may be used for private treatments or for pre- or post-treatment relaxation and privacy.

Royal Malewane is arguably the most luxurious and beautiful of the Timbavati game lodges, its six private suites with their individual pools and spacious decks offering an experience that must rate as seven-star. But even that is not enough for the ever-innovative Liz Biden, who has fitted it out as she would her own home, down to the French antiques and Persian carpets. It is hardly surprising that in just a few years Royal Malewane has established itself as the favourite lodge of, among others, Elton John and some of the richer Silicon Valley billionaires. Now, in her quest to stay ahead of the field in luxury safari travel, Liz has added something even more special: a spa. As with everything Liz does, this is no ordinary spa, but a super-luxury, cool and relaxing oasis in perfect harmony with the surrounding bush. Set in the trees a short way from the house, it is invisible as you approach along the wooden walkway. Then suddenly there it is: a large wooden doorway through which you step into a different world, a Moroccan-inspired courtyard with a long indigo pool, cool curtained-off resting places and big marble paths full of rose petals. Nothing could be more inviting after the dust and heat (and excitement) of a long game drive. Apart from unkinking the body with a bit of exercise, the main purpose of the spa is the variety of relaxing massages and therapeutic treatments it offers. Indeed, one is almost spoiled for choice. There is something rather wonderful about lying somnolently on the massage table looking out at the bush and the friendly nyalas that graze right up to the edges of the spa. A large bronze Buddha epitomises the peaceful, cool nature of the place, and the Moroccan lamps, pots and bronze bowls emphasise the exotic touch. The spa just rounds out the perfect bush experience on offer at Malewane. After a day of dust-clogged tracking the Big Five and perhaps more intriguing smaller buck, leguans, and catching sight of nesting birds, the luxury promises nothing if not a deep sleep.

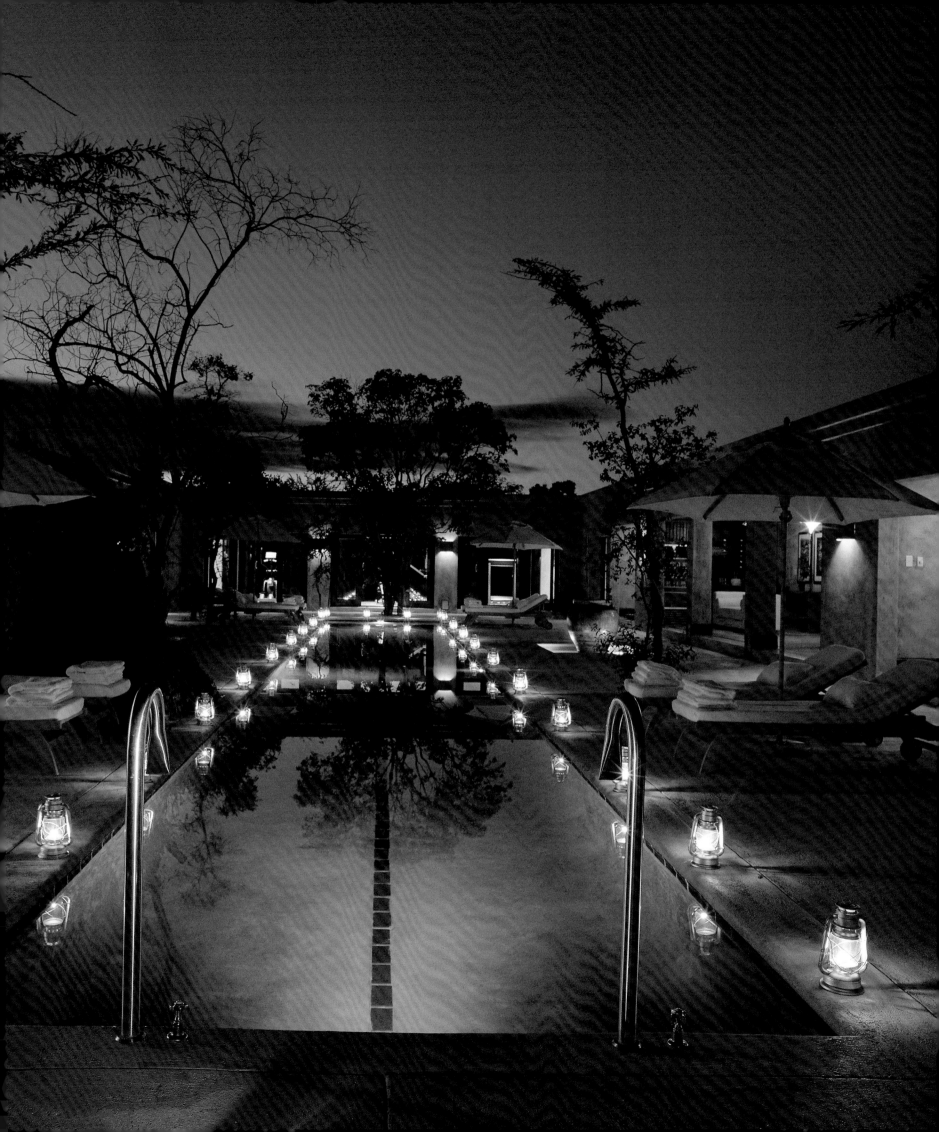

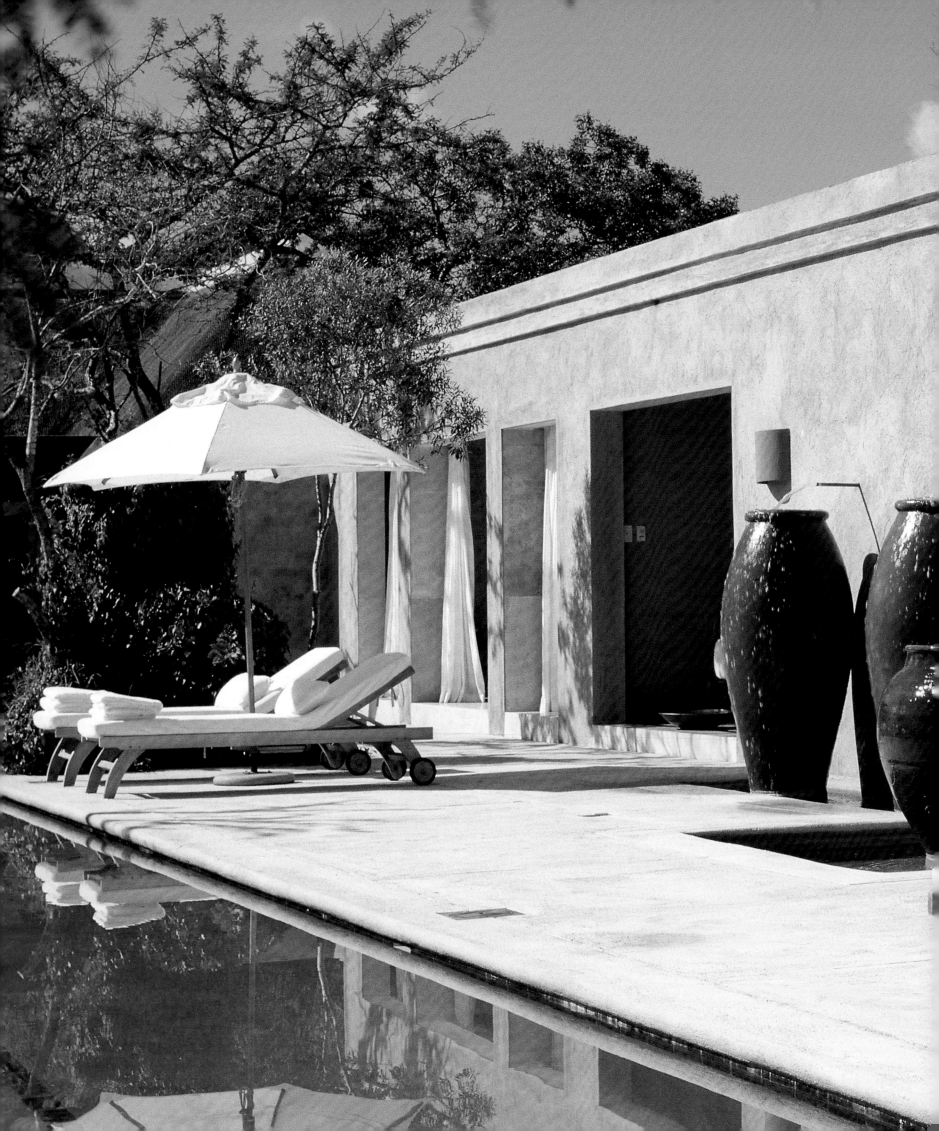

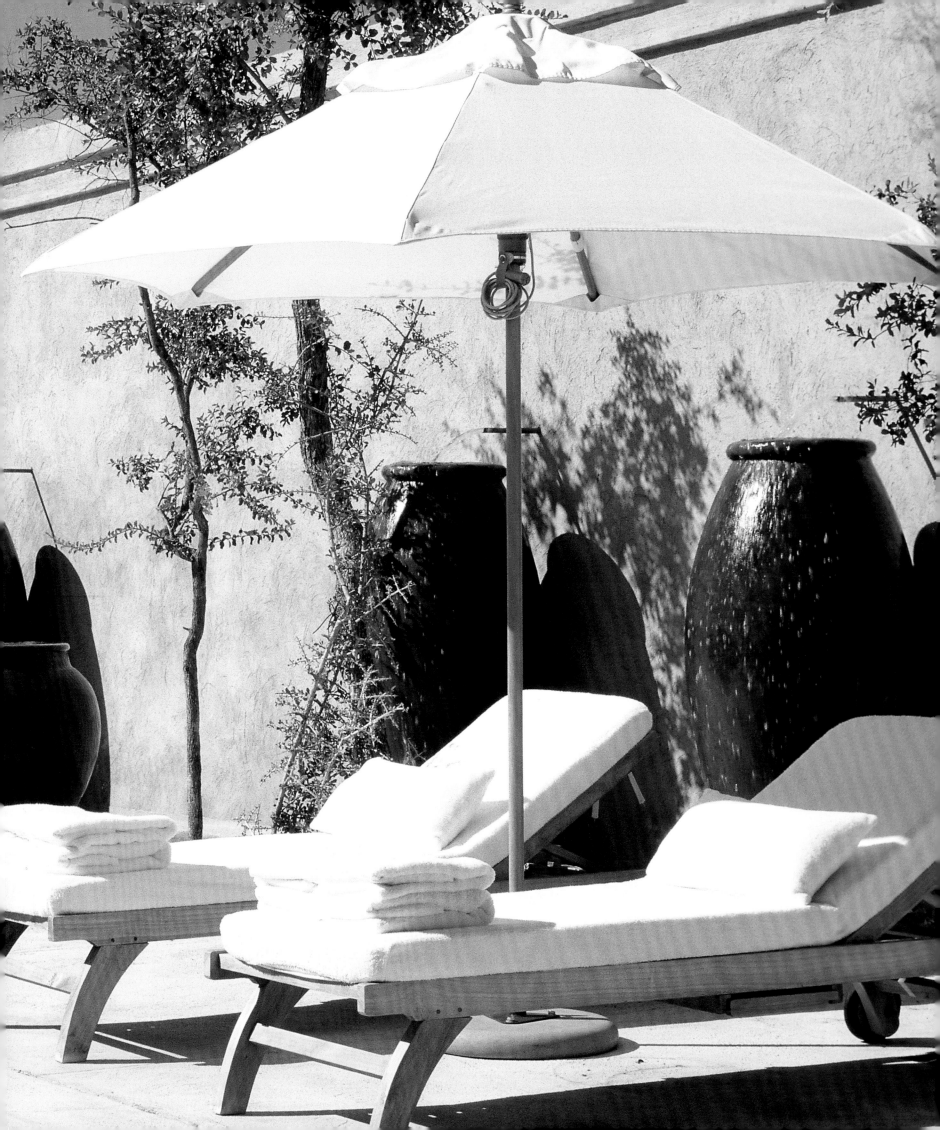

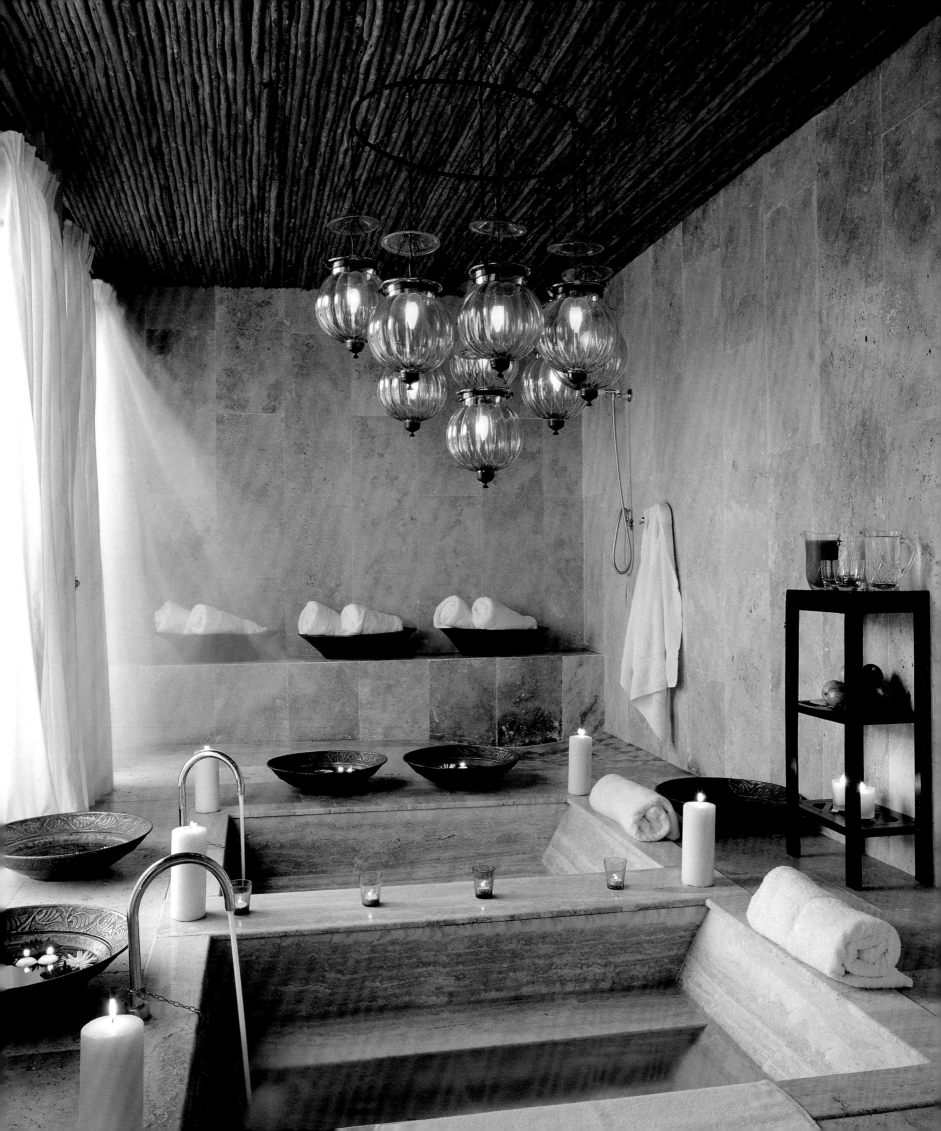

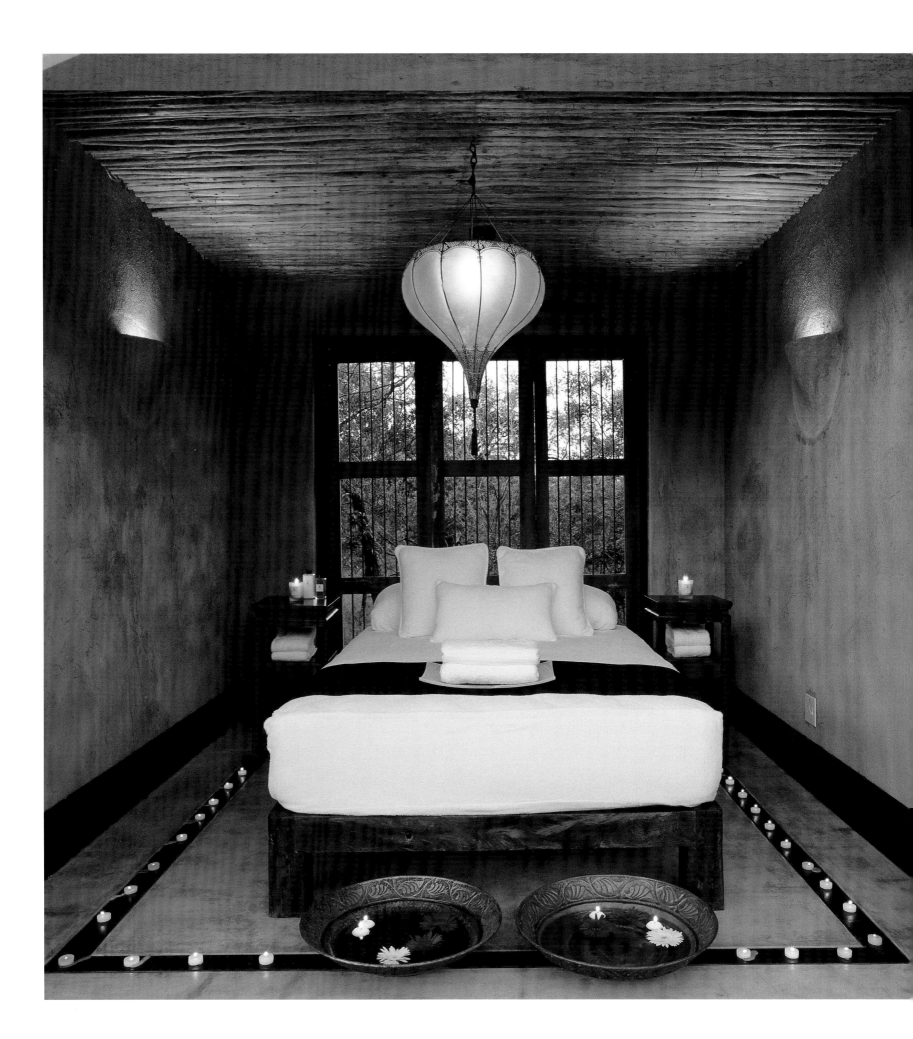

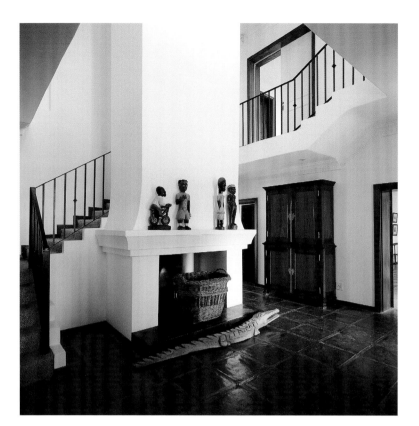

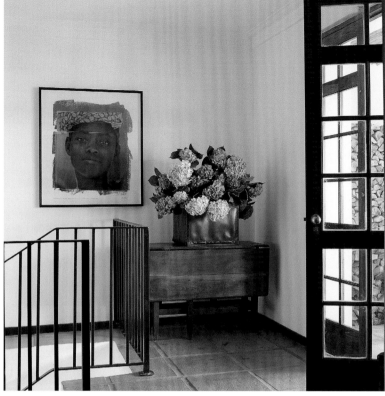

House Newman
Johannesburg

Above left: This play on the voorkamer in the entrance hall is animated by a selection of 'Colon' figures from the Ivory Coast, an early 19th-century Cape cupboard and a view through rooms at the back.

Above right: A stairwell corner with leather vessel and hydrangeas from the garden.

Opposite: Corner of the stoep.

Sited on a terraced property below the ridge, this Westcliff home is something of an anomaly. 'What attracted me to it was its interconnectedness,' recalls the architect and owner, Karen Newman. 'My husband grew up in a well-known Cape Dutch homestead and loves being able to come in the front door and look right through the house.' The first alterations enhanced this flow by opening up the spaces, creating living areas that provide a handsome backdrop in terms of scale and proportion for her bold, simple decorating style. A stone courtyard with a fountain was built to visually connect three sets of double doors that align from the entrance to the patio at the back where a stone kopje 'emits a glow into the living room and entrance hall with those amazing colours of baked earth that remind you that you're in Johannesburg,' says Newman, adding that the stonemason spent six months on the property sourcing on site all the materials for the patio, the retaining walls and the terraces. 'This house had good bones. When you do alterations, you should stay true to their language without following it slavishly,' she explains. 'But the horizontals and verticals lacked proportion, so a colonnade was added to break the façade and soften the elevation.' Rooms that only have their coming out on special occasions and corners that quietly gather dust are nowhere to be found and every space is functional: her desk stands in a passage, the spacious upstairs landing serves as the family room where the kids watch TV after their bath and the enormous family bathroom has an integrated dressing room. Loose adaptations of rural life are also found in the prominent fireplaces in the kitchen, the hall and the stoep, the latte cladding on the stoep ceiling, coir matting and, naturally, the abundance of vernacular furniture that restrains the palette to natural tones on a white canvas. 'I'm not very good with colour,' she confesses. 'We're mad about South African vernacular furniture which we started collecting for sentimental reasons when we lived in London,' she continues. What began with a few kists and chairs has expanded to include tables, armoires, more kists and chairs. 'Most of our pictures are also South African,' she says, pointing to a painting by Gerard Sekoto in the dining room flanked by two Bamileke masks from Cameroon. The functional simplicity of these heritage pieces is perfectly suited to her decorating style which favours few, bold elements: 'I like masculine furniture – it goes with the house which is strong.'

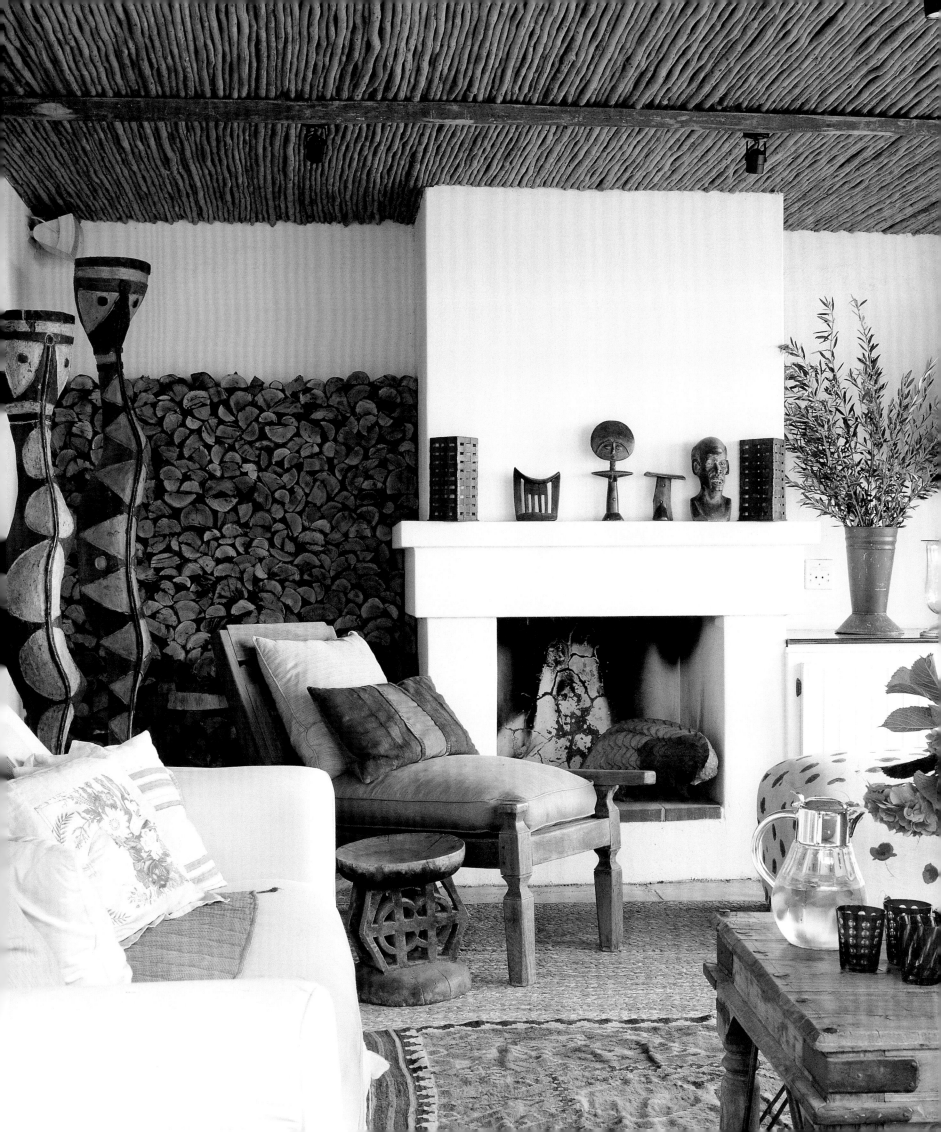

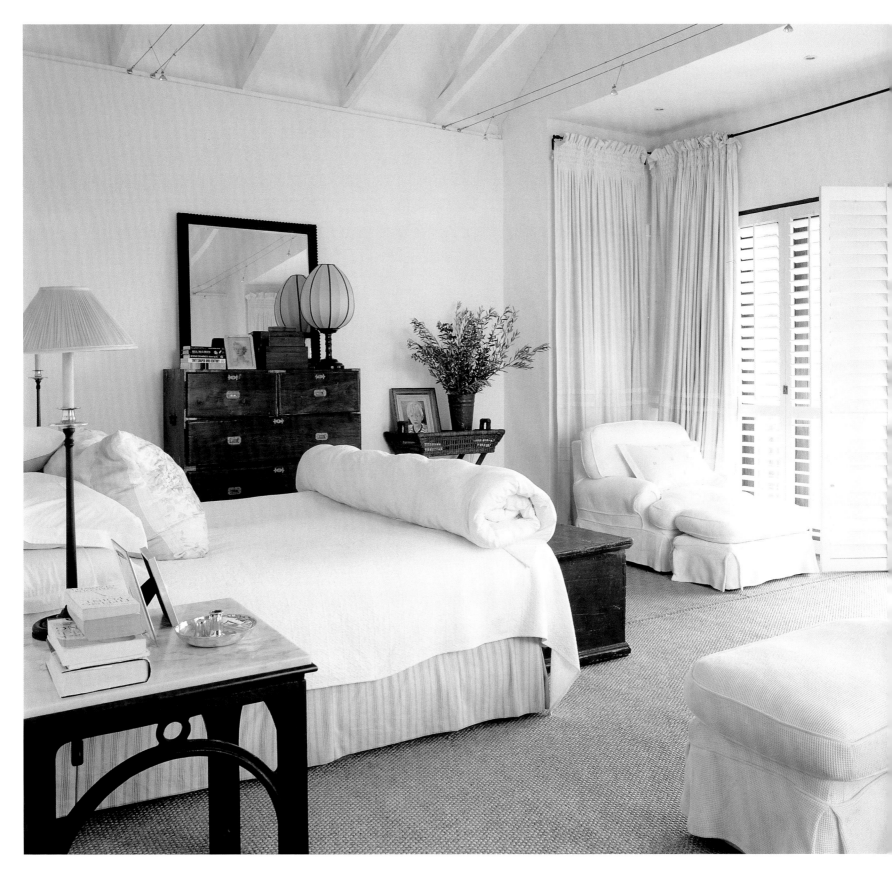

Above: The bedroom is in white, stone and black tones and has plantation shutters that lead onto a small balcony with a view of Johannesburg. In the room is a military chest, a Shanghai Tang lamp, a butler's tray from The Great Zambezi Trading Post and sisal matting. The cast-iron table in the foreground was originally used in the coinage department of the South African Mint.

Opposite: The expansive kitchen hugs the heart of this house and is of the entertainment-while-cooking variety. It is hugely practical (children, dogs), handsome and comfortable, all in one.

House Brink
Johannesburg

Above: Oversized planters with red geraniums add a French-style formality to the gravel garden. The interiors take their cue from the red of the flowers.

Opposite: Main living area – eclectic and warmed by red blinds and armchairs. Clever juxtaposition of colour, scale, pattern and texture, and sudden and surprising choice of disparate objects and furniture bear testimony to the fact that Stephen Falcke is the best in the business.

In a second project done for friends in Greenside, Johannesburg, designer Stephen Falcke has created a home that honours the owner's love of authentic French Provençal and entertaining, as well as providing space for an artist's studio. Says Falcke: 'I'd seen an Italian courtyard set out with red umbrellas and geraniums, so when I said to the client that I wanted to use red as the main thread, I really meant red – a pungent, strong red that brings everything together and shows off the weathered, textured patina of the timber and furniture beautifully. A very Mediterranean effect.' He explains that this project had to tackle one of those older Greenside houses built with tiny, poky rooms and the whole thing had to be swung around. 'Although I didn't do the architecture myself, I worked closely with the client on the colours and textures while the client, in turn, worked closely with the builders, assisting them with the finishes and paint techniques.' Owner Adrian Brink admits to feeling more than a little anxious when Stephen first suggested red as the dominant and recurring shade. 'I don't think anyone else in the world could have created such a comfortable space with so much red,' he says. 'His magic made the red come across as a deep and resonant neutral in the way that it was used in different fabrics, patterns and textures. Now, seeing how well it has worked, any other colour would have seemed boring.' The odd theatrical gambit didn't go amiss. The stag-horn chandelier in the living area was brought from the owner's previous house, which had four-metre-high ceilings. Falcke found an old stone table on site and decided to create a focal point with it by hanging the stag-horn chandelier just above it in the L-shaped entrance area. The Art Deco staircase was original, but the timber on the wall and ceiling is new – the house is totally unrecognisable from what it was before. Stephen Falcke has used a number of large pieces in small spaces throughout the interiors, using symmetrical rows as well as reflective surfaces to create the illusion of space: 'Quite often I put big things into tight spaces, a gambit that paradoxically makes the space look larger. In this house I placed a very large Mexican mirror above the French day bed. I also used some large, high-backed sofas for generous proportions. I placed things in rows to make the space seem bigger – a row of lights over the refectory table and a series of storm lamps above the bed create architectural groupings that alternate energies with freer groupings, not unlike yin and yang.'

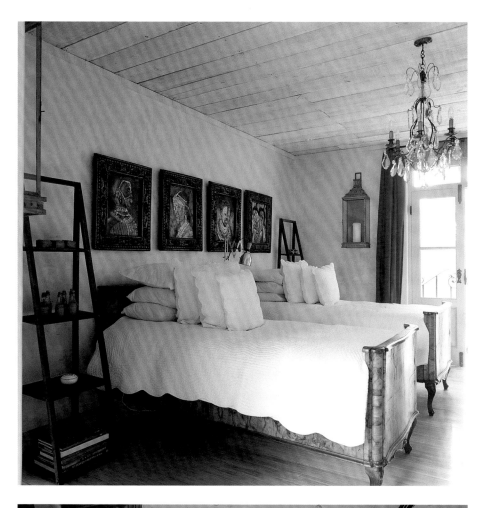

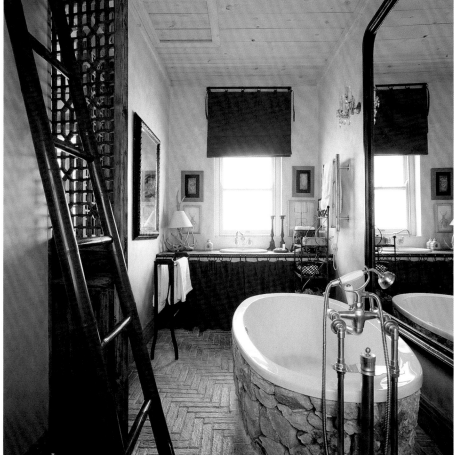

Opposite: Strong red throughout the house provides the foil against which the interior unfolds. The 'Tonic' chair is in 'Waterbury' in Cherry from The Fabric Library.

Above: Falcke remodelled the house entirely – even the timber on the bedroom ceiling is new.

Below: Big things in tight spaces increase the perceived size of that space – as in the guest bathroom.

Pages 174-175: Nguni skins bring an African texture into the sitting room while the mirror broadens the scale of the space. The owner sourced the French stone urns abroad while the framed mirror and Matisse prints are from Alive Art. The Victorian iron day bed is from Hadeda.

Page 176: The Art Deco staircase is original.

Page 177: Falcke has broken down the traditional barriers between kitchen and other rooms. This kitchen could be part of the living room, or it could be the dining room.

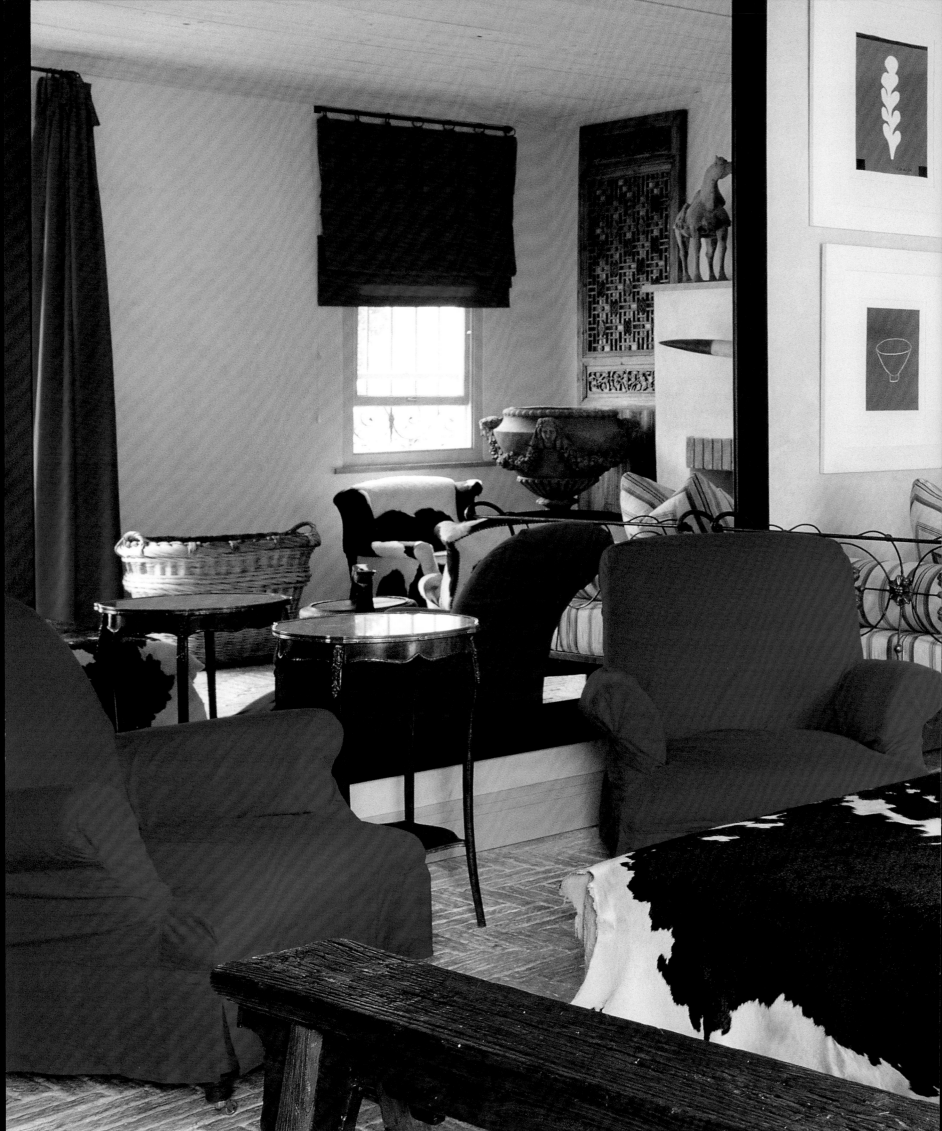

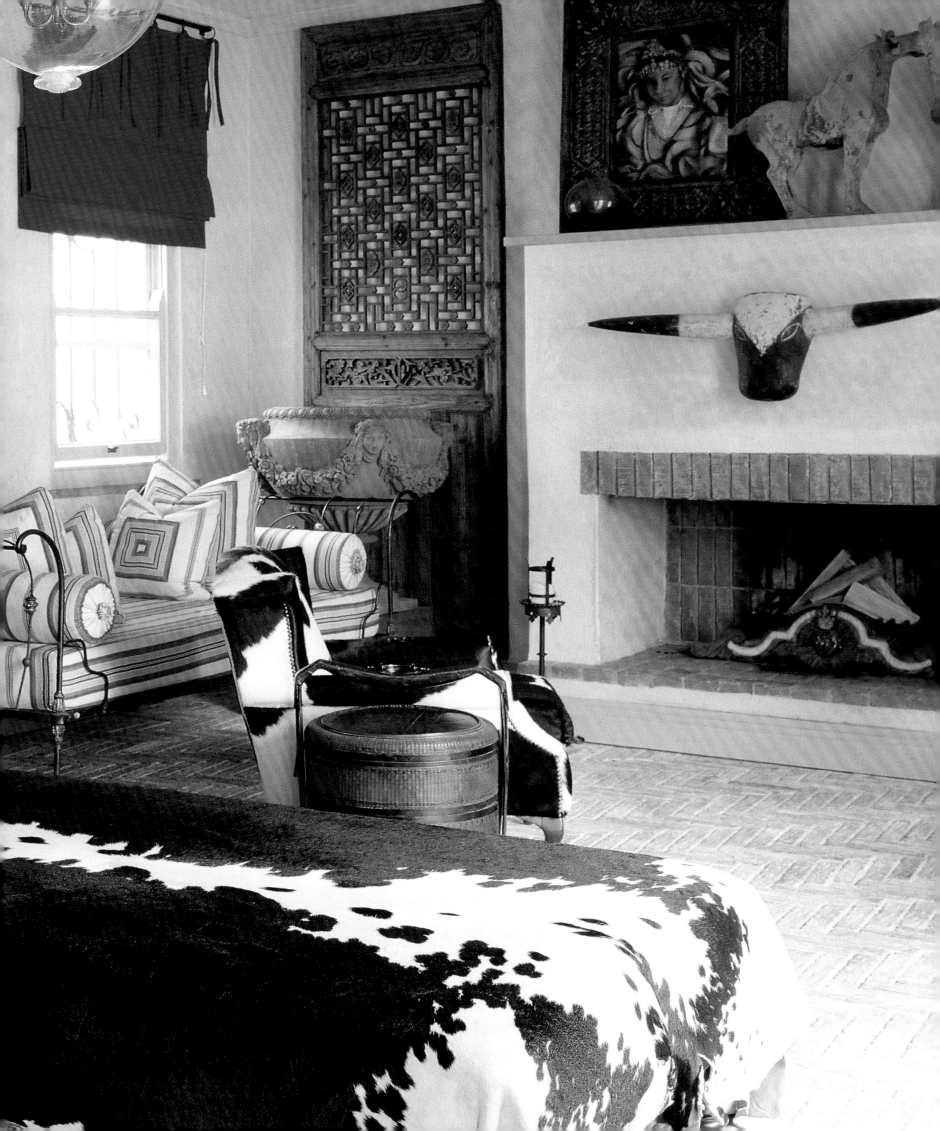

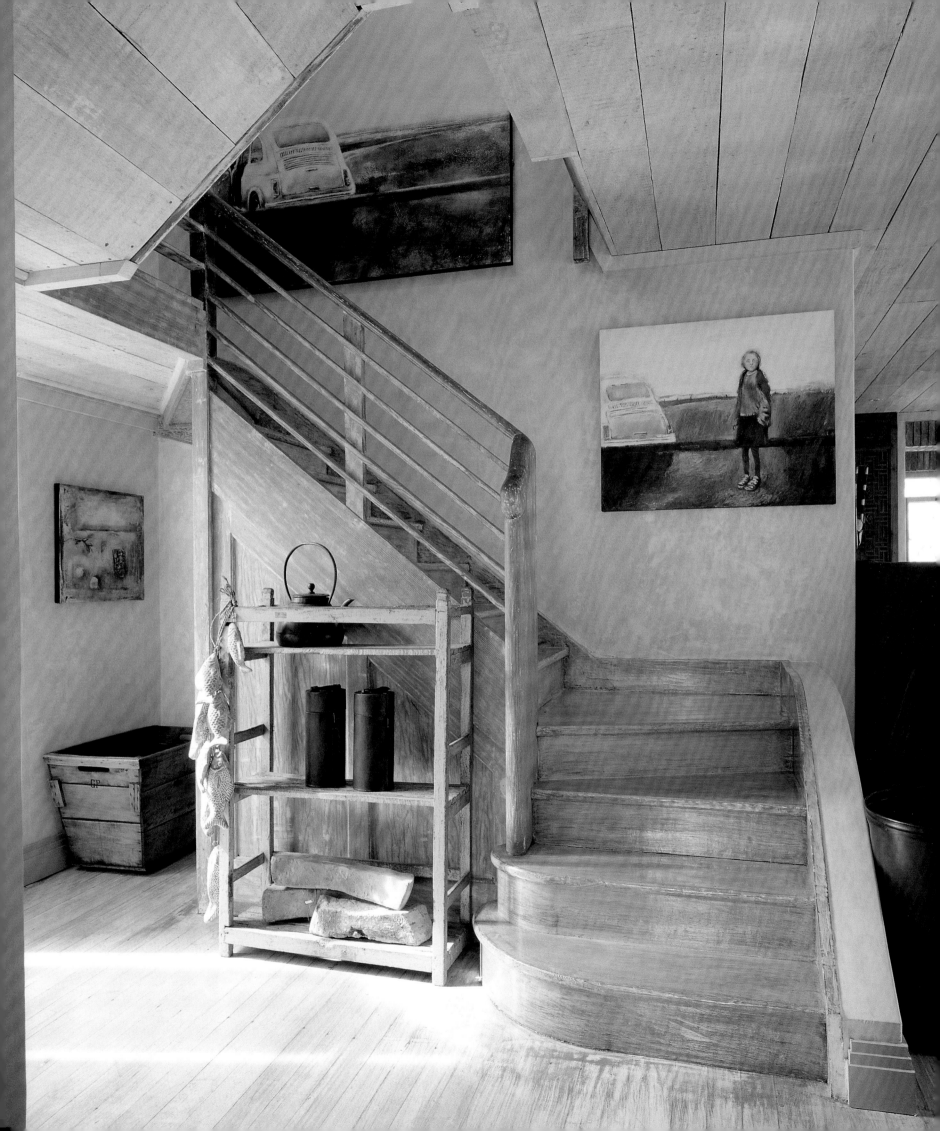

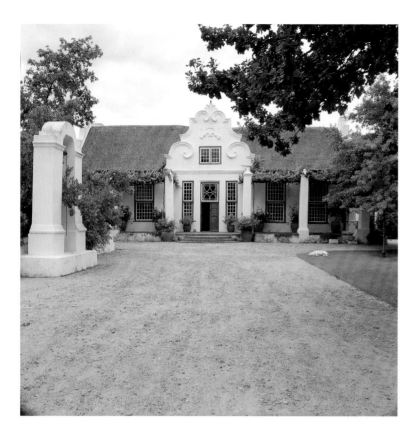

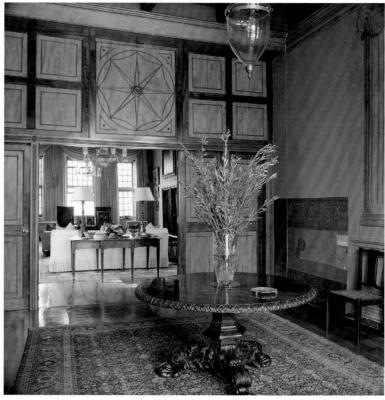

Morgenster
Somerset West

Above left: Beautiful Cape Dutch Morgenster with slave bell on the left.

Above right: A Georgian five-leafed screen of stinkwood with yellowwood panels divides the voorkamer *from the* gaanderij. *An Anglo-Indian Cape Regency lamp hangs above a mahogany pedestal table.*

Opposite: The drawing room, left of the voorkamer, *which the owner has called the 'Colonial Room' and decorated accordingly.*

One of the Cape's best-known Cape Dutch homesteads has settled into its hybrid identity. Morgenster's whitewashed gables rise up against the Hottentots Holland Mountains and the sweeping curves of its florid gable, reputed to be one of the six most beautiful in the Cape, crown the stark symmetry of its façade. At the heart of a famous eponymous wine and olive oil-producing estate, it's one of those iconic Cape Dutch settings – rich and fertile lands, white stucco gables, Cape mountains in the distance. Morgenster was built in the early 18th century and over the years went through several Cape dynasties, from the Van der Stels, the Malans and the Morkels to the Cloetes. Each family invariably adapted the original structure to the prevailing fashion and by and large it went the way of many Cape Dutch houses, becoming layered with accretions and contradictions over the course of two centuries. When the current owner took over Morgenster, he faced two challenges: 'I wanted to restore the proportions. My study was divided into three small rooms with 10-foot ceilings.' He sought the expert advice of architect Revel Fox, already acquainted with Morgenster, to return the floor plan to its H-shape. Peeling away the layers proved not just a metaphorical process. Early Cape interiors, under neo-classical influence, made restrained use of architectural or floral ornaments, and the restorers were keen to probe beneath the most recent white painted layer. In the entrance hall they uncovered first a warm grey tone, then Victorian brown marbled effects and, finally, a green and sienna Regency palmette, all of which concealed the two original architectural entablatures *en grisaille*. The second challenge was to refurnish a house which was entirely bare, and thus began the converse process of re-layering. Here the owner, assisted by Graham Viney, took an original approach: 'We decided not to restrict ourselves to Cape Dutch, but to furnish it with European pieces from that same period, principally Italian and English 18th-century,' the owner says of the tireless search which took them to antiquarians and auction houses from Cape Town to London, and Rome to Edinburgh. And yet there is order and method to this overwhelming array of beautiful things. A consistent effort has been made in the placement of furniture and decorative objects to achieve symmetry and to align items with structural elements. The end result is a skilled and tonally adroit composite of periods, cultures and textures.

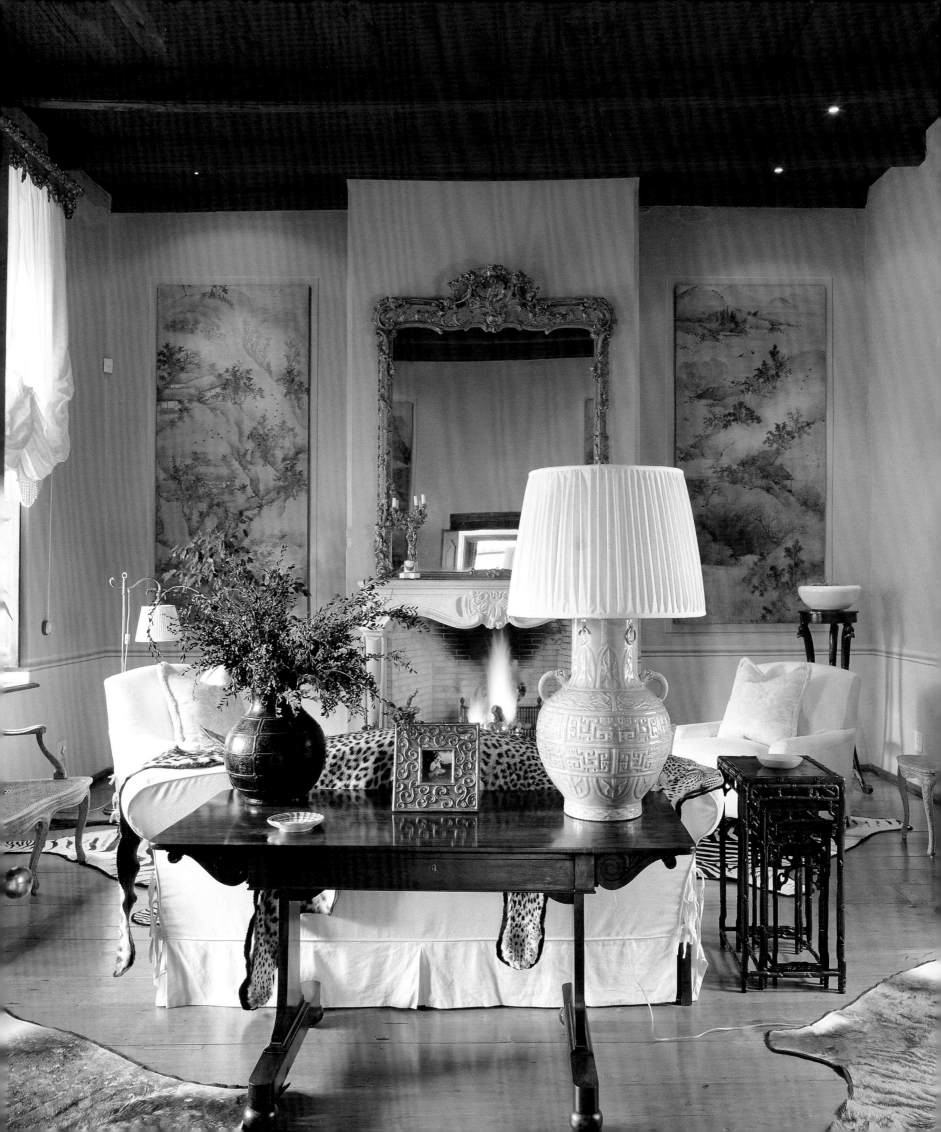

Above: The stately formality of Morgenster is enhanced by its Cape Dutch vernacular.

Below: Back hall passage covered in a linen toile de Jouy linking the H-shaped house to its extensions. Floors polished to an oxblood colour.

Opposite: The master bedroom, rustic beamed ceilings made of camphor wood – prized for its durability, colour and grain – from the arboretum of 300-year-old trees on the estate.

Page 182: A Cape Dutch stinkwood chair recalls the neo-classical detail of the column in the restored grisaille.

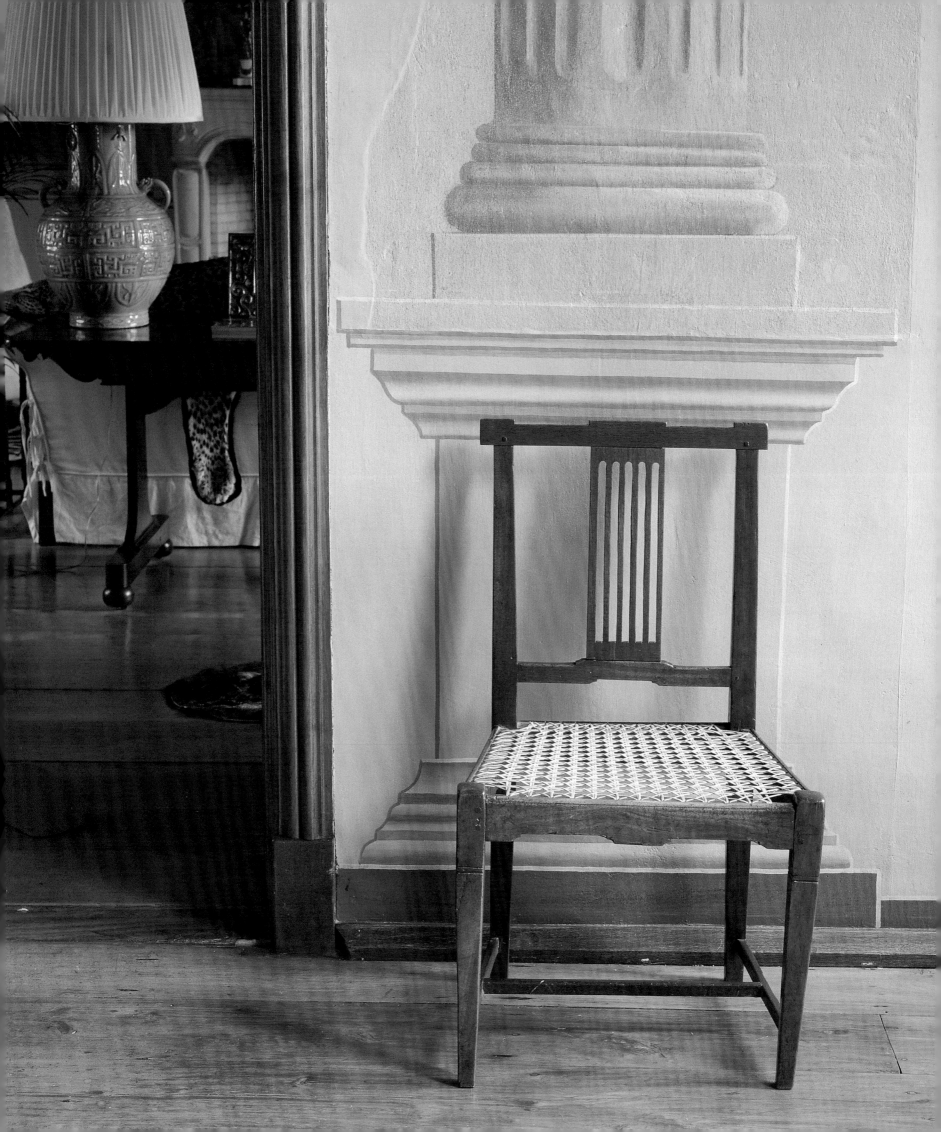